T0151849

**PAJ Books**
Bonnie Marranca and Gautam Dasgupta
Series Editors

**Art + Performance**
*Meredith Monk,* edited by Deborah Jowitt
*Rachel Rosenthal,* edited by Moira Roth
*Reza Abdoh,* edited by Daniel Mufson
*Richard Foreman,* edited by Gerald Rabkin
*A Woman Who . . . : Essays, Interviews, Scripts,* by Yvonne Rainer
*Gary Hill,* edited by Robert C. Morgan
*Mary Lucier,* edited by Melinda Barlow

# Mary Lucier

**Edited by Melinda Barlow**

A PAJ Book

The Johns Hopkins University Press    Baltimore + London

9 8 7 6 5 4 3 2 1

The Johns Hopkins University Press
2715 North Charles Street
Baltimore, Maryland 21218-4363
www.press.jhu.edu

Library of Congress Cataloging-in-Publication Data will be
found at the end of this book.
A catalog record for this book is available from the British
Library.

ISBN 0-8018-6379-1
ISBN 0-8018-6380-5 (pbk.)

*Frontispiece:* Mary Lucier. Photo by Mauricio Laranjeira

For my parents

# Contents

**IV Interviews**

### V  Essays, Talks, and Notes by Mary Lucier

*Photograph gallery follows page 206.*

## Acknowledgments

I am grateful to Bonnie Marranca for inviting me to be part of this series, and for allowing me to create a format for this collection which could accommodate Mary Lucier's rich and varied body of work. Bonnie's interest in the archival nature of my research, her willingness to let so much previously unpublished material see print for the first time, and her openness to my desire to write lyrically about my experience of Lucier's installations made assembling this volume a very satisfying experience.

I would also like to thank Maura Burnett, Humanities Editor at the Johns Hopkins University Press, for her extraordinary kindness and flexibility during the editing stages of this manuscript, and Carol Ehrlich for her careful copyediting and useful comments about so many different aspects of the book.

This project would not have been possible, of course, without the commitment, energy, and constant good humor of Mary Lucier. A running joke between us over the last nine years has been that I deem whatever we discover in her studio as "absolutely crucial" to my research and to the public's right to know about the breadth of her oeuvre. This volume is the culmination of those declarations and makes each one of them absolutely true.

Several friends have been constant sources of support throughout the preparation of this book. Ulla Dydo, Professor Emeritus, Bronx Community College, CUNY, and an authority on the work of Gertrude Stein, taught me everything I know about how to read an artist's original manuscripts and how to interpret the creative process revealed in those manuscripts. I am grateful to her not only for answering all my grammatical questions over the phone but also for providing me with a place to stay each time I come to town. I am also grateful to Kathleen

Fuentes and Shelley Stamp, both of whom have listened to my ideas, tolerated my anxiety, and wined and dined me for many a year. My sister, Amy Barlow, also deserves my deepest thanks for always being there when I need her and always being willing to call me back during one of my rare breaks from writing.

Research for this book was made possible by two grants from the University of Colorado at Boulder: a Travel Grant from the Graduate Committee on the Arts and Humanities, and an IMPART Award (Implementation of Multicultural Perspectives in Research and Teaching) from the Vice Chancellor's Awards and Grants Advisory Committee.

And finally, I would like to express thanks to my husband, Phil Solomon, who knows what it is to be obsessed, gives me the freedom to write, and understands just how long it takes to produce good work.

**Mary Lucier**

## Introduction

### Getting There

The dwelling is intimate, immediate, a resonant chamber, a mirror of the self, opening up in infinite perspectives, depth, and reflection. Soul, body, and dwelling are but expansions and projections of each other. For the house is not merely walls, doors, and windows, but a doorway to things beyond, a "capacity" of the senses and spirit. Finally, there is no distinction between outward and inward. We dwell in the home; the home dwells in us.

—Anne Troutman, "Inside Fear: Secret Places and
Hidden Spaces in Dwellings"

*Charleston, South Carolina, May 1997.* It is midmorning. The sun is high, the sky, hazy, the air already heavy with moisture. In this subtropical climate, the city still sleeps. I wander through the streets alone, past the hotels and empty storefronts, the shells of buildings no longer in use, past the boarded-up doors and windows to a warehouse off a pedestrian alley near upper King Street. Following the curve of the alley, I come to a grate concealing a door. The door is locked; I don't have a key. Perhaps inside lies *House by the Water*, the video installation by Mary Lucier I have come here to see. For the moment, however, I can't get in, so I walk back along the side of the warehouse, around the block to a street on its other side, in search of a smaller, nearly hidden alley—the route, Mary told me, to a "spectacular ruin."

At the end of this alley is a formidable building—scorched, abandoned, marked by three doors. I stop in fear but propel myself further, entering a strangely familiar interior where rooms don't have walls, ceilings become floors, and crumbling roofs make eaves from debris. Overhead a staircase cascades into space, beneath it a door swings on a hinge.

Beams, cables, planks, and nails litter the ground beneath my feet. All is precarious; more might collapse. This feeling returns me to *Oblique House (Valdez)*, an installation Lucier created in Rochester, New York, in 1993. There, inside a small sheetrock house, with images of Valdez projected on the roof overhead, I listened to tales of homes lost to earthquake and imagined what it might be like to have a house collapse.

I remember *Oblique House* while standing in the ruin because Charleston, like Valdez, is no stranger to natural disaster. Hurricanes, cyclones, earthquakes, and annual floods have leveled its historic buildings many times, making ruins like the one near upper King Street as integral to the urban environment as the numerous antebellum mansions whose luxury was permitted by the institution of slavery. Past and present coexist in Charleston, and the process of restoration hangs in delicate balance with the presence of decay, sometimes within the same structure. This balance is part of the city's essence—its *genius loci*, or spirit of place. To build here is to have one's building imbued with this spirit; to dwell here is to move fluidly between time frames, acutely aware of the fragility of shelter, sensitive to the impermanence of every abode, and with a new appreciation for the ephemerality of installation, a medium which "dematerializes" when disassembled.

I think these things in the ruin on upper King Street, reminded of the mood of *Oblique House (Valdez)*. But *Oblique House* was intimate, resonant, safe. In this ruin there is no intimacy, only an overwhelming sensation of decay. Welling up like a vision from my unconscious, the ruin gives form to a primal fear; it symbolizes the absence of shelter and powerfully evokes the loss of a home. If, as Gaston Bachelard suggests, "we bring our lares with us"[1]—if we are, as human beings, everywhere we have lived, we are also, just as deeply, everything we have lost and all that we fear, from the houses we have left to homes that have disappeared. The ruin behind the warehouse containing *House by the Water* is a doorway to shelter's repressed other side. Maybe this is what Mary meant when she said that, in her mind, the ruin is a part of her piece.[2]

### Geometry and Gesture

A house that has been experienced is not an inert box.
Inhabited space transcends geometrical space.

—Bachelard, *The Poetics of Space*

When I go back to the doorway in the side of the warehouse, the grate is up, the door is open, and recessed in the middle of the

warehouse's darkened interior is a small white house on stilts surrounded by cyclone fence. Evoking several forms of architecture found in the low country—weather station, slave dwelling, winnowing house—this elevated structure is literally aglow, illuminated on all four sides by video projections one must circle the work to see. Moving continuously around its periphery, I piece together fragments of a mysterious tale which unwinds in two distinct yet related locations animated by ghostly inhabitants. In the decaying interiors of an antebellum mansion, in front of an ornate, full-length portrait, a girl in a white dress spins and spins until she is absorbed by a whirling vortex, a radar image of Hurricane Hugo, slowly approaching the Carolina coast.

In the sparsely furnished rooms where slaves once dwelled, the atmosphere is entirely different. At night at the end of a deep blue corridor, the shadow of a man appears. He starts to run, darts into a room, retrieves his hat, and, as he reaches the camera, disappears. His urgency suggests insurrection, or perhaps slave rebellion—maybe he is meeting his female companion, also African American, who runs down the same corridor projected on another side of the house.

On yet another side, the corridor is empty; during the day it seems less mysterious, more austere. Windows recede at regular intervals; squares of sunlight line the floor. This new starkness is familiar and arresting. In its simple, minimal geometry, the corridor now resembles a sculpture—it recalls the many "stacks" made by Donald Judd, those arrangements of identical iron or steel elements which hang on a wall from ceiling to floor.[3] How this happens is perceptually interesting; that this happens is more significant, for it happens quite often with Lucier's work. Suddenly, perception shifts, and an image or object seems to disassemble, then reassemble into a configuration of geometric shapes or dissolve into a field of pure abstraction. Here in Charleston, a corridor in a slave dwelling on an urban plantation momentarily resembles a minimalist sculpture while retaining its power as metaphor for the endless corridors of memory.

In a video installation of many compelling images, this particular one stands out; in a body of work as rich and varied as Mary Lucier's, *House by the Water* commands special attention. In the image of the corridor is a gesture I recognize, a way of framing the world that is a signature of Lucier's style and that appears in her work as early as 1969. In the installation as a whole, themes and concerns coalesce which have emerged in her work over the last thirty years.

The most powerful of these themes has to do with habitation, with the way we experience and remember intimate forms of architecture— rooms, corridors, houses, home. If Lucier's memories of such spaces are as vivid as her installations are affecting, perhaps it is a testimony to the way memory feeds creativity: still haunted by homes in her own family history, she understands how houses become ambiguous symbols, at once comforting and threatening, able to offer protection while emblematizing fear. In her work she often draws upon this full range of feelings, creating installations which suggest how inseparable our contradictory attitudes toward domestic architecture really are. She also draws upon a deep understanding of how intimate spaces contain phantom inhabitants or may be inhabited solely by memory.

A video artist who grew up in a home without television, Lucier is also an installation artist who keeps building houses and including images of houses in her work, although she has never owned a house.[4] A longtime apartment dweller who has rented the same small studio in New York since 1975, Lucier was born in Bucyrus, Ohio, in 1944, the middle child of Margaret L. (Beer) Glosser and Francis M. Glosser. Although she had what she has described as a classic American childhood, playing outside, going for walks in the woods with her father, learning to whittle, whistle, and build, she also spent a lot of time indoors, reading, drawing, and listening to the radio in the drafty old Victorian house where she lived with her parents, older sister Jessie, and younger brother Francis (Pete).

In "Virtually Real," a memoir about her somewhat unorthodox relationship to modern technology, she locates a precedent for her interest in video in her childhood relationship to an architectural feature of that house, the ornate air registers designed to release heat from the lower level to the chilly second floor bedrooms, but which she and her siblings used as a way to spy on each other, in the process overhearing family secrets and quarrels. The result, she writes in a passage which sounds remarkably like a description of one of the images in *Room* (1969), her first *Polaroid Image Series*, was that she developed a taste for voyeurism, "for viewing life through a rectangular metal frame with vertical slats and curious patterns and a picture that was sometimes nothing more than an empty sofa and part of an armchair."

That rectangular frame became all-important when Lucier was studying photography at the Boston Museum School in the late 1960s, and she has remarked elsewhere that learning to compose within it— learning to take responsibility for everything within its borders—was a

turning point in her evolution as an artist.[5] It is precisely this sense of a world delimited by a frame, a world perceived by an eye attentive to shape and form and able to see formal beauty in the most unexpected places, that makes Lucier's compositions so visually arresting and lends her installations their sculptural elegance. The exquisite sequence of shots at the end of *Wilderness* (1986), for example, their dramatic creakings skillfully processed by Lucier's longtime collaborator Earl Howard, caused reviewer Christopher Knight to remark that "it isn't often that a television picture makes you gasp, but the sight of shimmering, crystalline, slowly heaving icebergs on a frigid sea . . . is a breathtaking finale."

That Lucier points to the partial and somewhat abstract view of a room glimpsed through an air vent in her childhood home as a source for this lifelong way of perceiving the world suggests her aesthetic kinship to an American artist whose interest in architecture also began in childhood, and who is known for his depictions of houses and carefully cropped views of architectural details. Often drawn to particular buildings because of their visually absorbing shapes, Edward Hopper found the American home such a fascinating subject that he painted it from every angle and in all its endless variety, from simple frame houses to Victorian mansions, sometimes focusing on individual features, sometimes including solitary individuals, often painting vacant interiors inhabited solely by memory.[6] Ranging in tone from celebratory to melancholy, Hopper's paintings capture that transitory moment in twentieth-century American culture when the house began to lose its power—when it no longer represented absolute security but evoked, instead, a loss of prosperity, an absent community, and elicited a wistful remembrance of things past.

*Ohio at Giverny* (1983), one of Mary Lucier's best-known and most loved video installations, opens with an image of a house from her own history which looks like it belongs in one of Hopper's paintings. Dappled by sunlight, surrounded by trees, this stately Victorian mansion is a "repository," she has said, "of family mythology,"[7] perhaps, in part, because it is no longer owned by her family. A landmark house now on the historic preservation list in Bucyrus, it serves as the starting point for an imaginary journey from rural Ohio to Monet's gardens at Giverny, in France, which begins and ends with the sound of a train— the train whose wail filled her bedroom as a child, and which recalls a deeply personal loss. Dedicated to her Midwestern gardener uncle, who lost his French wife to an oncoming train, *Ohio at Giverny* is one of Lucier's most autobiographical and elegiac installations. How appro-

priate, then, that the single-channel tape derived from it, *Ohio to Giverny: Memory of Light* (1983), begins with the final passage from *Swann's Way,* whose subject is the elusiveness of the past and the fleeting nature of memory:

> The places that we have known belong now only to the little world of space on which we map them for our own convenience. None of them was ever more than a thin slice, held between the contiguous impressions that composed our life at that time; remembrance of a particular form is but regret for a particular moment; and houses, roads, avenues are as fugitive, alas, as the years.[8]

What Proust so eloquently expresses in this passage is the same yearning for permanence in the face of transience which runs through so many of Lucier's installations, namely *Dawn Burn* (1975–76), *Asylum* (1986/91), *Oblique House (Valdez), Last Rites (Positano)* (1995), *Floodsongs* (1998/99), and which one feels so intensely while dwelling in those installations. It is a desire for the work to remain assembled in object form; an awareness that installation is a fugitive medium; and an understanding that with disassembly comes documentation and a whole new way of experiencing the work through the range of materials brought together in this collection—photographs, essays, reviews, interviews, drawings, proposals, excerpts from original manuscripts, and statements by the artist.

The first in a series of installations investigating the history of America's complex relation to landscape, *Ohio at Giverny* was followed by *Wintergarden* (1984), *Wilderness,* and *Asylum*, three more works examining the significance of the garden as icon in American culture. As both Charles Hagen and Kerri Sakamoto have pointed out in reviews included here, however, *Ohio at Giverny* is also an important precursor for *Last Rites (Positano)*. Both installations are concerned with the persistence of memory, and in both Lucier sees how archetypal American dreams have played themselves out in her own family. Foremost among these is the search for a vicariously realized antiquity which frequently leads to an idealization of Europe. When Lucier's mother, Margaret Glosser, left Ohio for Europe in the mid-1930s, for example, she married a charming German war correspondent with whom she had a child (Lucier's older sister, Jessie), and the three lived for several months in the small Italian seaside town of Positano. After Glosser was diagnosed with cancer some fifty years later, she began to reflect on the

course of her life, often singling out that brief period in Positano as her primary source of adventure. "The *idea* of Positano in my mother's recounting of her youth," writes Lucier in her description of the piece, "came to have almost mythic resonance as an icon of exalted but ambiguous status. It came to signify the fulfillment of an American romantic longing and the ultimate failure of that ideal to sustain a productive and rewarding life."

The house, the garden, the continent of Europe—all three might be described as "exalted but ambiguous" icons through which American artists and writers from Thomas Cole to F. Scott Fitzgerald have expressed and negotiated a fundamental struggle between the real and the ideal for more than two centuries. That Lucier has made a sustained exploration of these icons is perhaps no surprise, as she is a Brandeis graduate with honors in English and American literature and a longstanding love of Romantic poetry, and in that literature and poetry both house and garden figure prominently as metaphors—the house, in Bachelard's phrase, "for the "topography of our intimate being";[9] the garden, as Lucier suggests in her statement for *Asylum*, for our ongoing attempt to "accommodate death within a familiar living structure." In her landscape works from the 1980s, and in her more recent installations featuring house imagery or using houses as sculptural elements— *Oblique House (Valdez)*, *Last Rites (Positano)*, *House by the Water*, *Floodsongs*—Lucier deepens our understanding of these metaphors by revisiting such classic American conflicts as that between the wild and the civilized, technology and nature, the dream of security promised by shelter and the primal fear of the loss of a home. Discussed in the interviews with Nancy Miller, Margaret Morse, and Nicholas Drake reproduced in this collection, this range of interests makes Lucier's "legend," as Arlene Raven puts it, "peculiarly American."

It is precisely this sense of something uniquely American which drew me to Lucier's work eight years ago. In the New York gallery where *Asylum* was installed in early 1991, a withering indoor garden led to a dimly lit toolshed whose collection of rusted farm implements and other discarded objects seemed not only American but familiarly Midwestern. Similar to the kinds of small buildings found behind the main house on many American farms, and reminiscent of one I knew especially well in south central Illinois, the shed was part of a complex sculptural arrangement which filled the room with an overwhelming sensation of decay. It was in this room that I learned the value of kinesthetic experience and discovered what it means to *dwell;* it was in this

room that I first read one of Lucier's prose "scores" and began to have a sense of its relationship to her work; and it was in this room that, by chance, I first met Mary Lucier and realized how conversation with a living artist could enrich my understanding of that artist's work.

This experience inspired two important insights which ultimately influenced the process of assembling this collection: one, that attempting to evoke in language the nature of one's experience on-site while lingering in the atmospheric here and now of a given installation helps convey an otherwise elusive sense of that installation's atmosphere; and two, that each form of documentation contributes something different to the continued life of any ephemeral work, from installations to earthworks to collaborative performances. Thus, for example, an earthwork like *Salt* (1971), installed for two days on the grounds of a Connecticut estate but not photographed in final form and never recreated, is represented in this anthology through the invitation Lucier designed for her work, a letter she wrote to Vaughan Kaprow explaining her intentions in creating *Salt*, and a review—her first—in a local newspaper. Printed here, side by side, for the first time, these documents not only let us imaginatively experience a work long since gone, they also provide an important context for Lucier's more recent landscape and ecological video installations, allowing us to see those installations as part of a longstanding interest in the environment. Read in conjunction with Eleanor Heartney's thoughtful essay on *Noah's Raven* (1992–93), an excerpt from Lucier's proposal for that installation entitled "Landscape, Culture, and the Fossil Record," her "Notes and Journal Entries" for the installation (seen here in their original, longer form for the first time), and Peter Doroshenko's interview with Lucier, conducted while *Noah's Raven* was in progress, the three documents representing *Salt* let us see how the themes and concerns animating Lucier's later works may be discerned in "embryonic form," as Heartney puts it, as far back as the early seventies.

While many artists who came of age between 1965 and 1975, during the heyday of conceptual art, documented their works through photographs and written descriptions, Lucier has used both forms of documentation consistently, and somewhat uniquely, for thirty years. Already a skilled photographer exhibiting her early *Polaroid Image Series* in projected slide form by 1970, Lucier began to document her installations and performances regularly a few years later,[10] and she has continued to do so up to the present day. It is because of her diligence that there are some especially striking and historically significant pho-

tographs in this collection, from the widely circulated offscreen image of *Dawn Burn*, to the little-known shot of *Antique with Video Ants and Generations of Dinosaurs* (1973), her first video sculpture, to the mysterious, almost abstract "portrait" of her friend Cecilia Sandoval, one of three remaining offscreen images from the unrestored videotape made for the mixed-media performance *The Occasion of Her First Dance and How She Looked* (also 1973).

Lucier did not only document her own work during this period, however. While continuing to use photographs in projected slide form in a number of her environments and performances—*Color Phantoms* (1971), *Journal of Private Lives, Second Journal (Miniature), Red Herring Journal (The Boston Strangler Was a Woman)* (all 1972), *The Occasion of Her First Dance and How She Looked*—one of the ways Lucier earned her living throughout the 1970s was as a freelance photographer, shooting performances, concerts, installations, and offscreen images for Nam June Paik, Shigeko Kubota, Charlotte Moorman, Beryl Korot, Steve Reich, and Viola Farber, among others. A number of these photographs appeared in *Video Art* (1976), the seminal volume of documentation and criticism edited by Korot and Ira Schneider for which Lucier served as managing editor.[11]

Especially attuned to the implications of working in ephemeral media from the outset of her career, Lucier crafted most of the works she would eventually document through photographs on paper, in notebooks, before realizing them in physical form. In the process, her notebooks became a "conceptual studio," a place where she developed her ideas over extended periods of time. Since 1971, many of the ideas crafted in this studio have been expressed in more polished form in scores—prose renderings of almost every installation, performance, and sculpture made after *Salt*. As a result, the paper trail for each of her works is extensive, primarily because she has retained her notebooks and scores, as well as sketches, jottings, drafts of proposals, and other forms of documentation in her small New York apartment, in the process transforming it into a veritable "living archive" which is, of course, a video historian's dream come true. Many of the most fascinating documents reproduced here—the original typed manuscript text for *Fire Writing*, for example, or any of the wonderful sketches from her creative notebooks—surfaced during my numerous visits to this archive over the course of the last eight years. Each offers a unique conduit to an otherwise inaccessible past, enabling one to experience imaginatively installations that are no longer assembled in object form,

videotapes that no longer play, and performances that haven't been performed in many years.

Among the most interesting and important documents in Lucier's personal archive are the prose scores written for each work created since 1971. Ranging from purely descriptive sets of instructions which, theoretically, anyone can perform—*Air Writing* (1975), *Fire Writing* (1975), *Dawn Burn, Paris Dawn Burn* (1977), *Equinox* (1979)—to evocative essays in miniature, like the one for *Denman's Col (Geometry)* (1981), Lucier's installation exploring architectural form inspired, in part, by the writings of Gaston Bachelard, these scores were, early on, similar to those written by composers of electronic music during the 1960s and 1970s, but over time they have become more idiosyncratic, offering a uniquely literary twist on the conceptual art aesthetic favored by many artists of Lucier's generation. Compare, for example, the spare prose focused on procedure used in both *I Am Sitting in a Room* (1969), by composer Alvin Lucier, Mary Lucier's former husband, and *Hymn* (1970), which the Luciers composed together, with the more lyrical turns of phrase and occasional biographical information found in the scores for *Planet* (1980), *Ohio at Giverny, Asylum,* and *Last Rites (Positano).* The earlier scores *instruct,* while the later ones *describe,* but both illuminate the "conceptual context" surrounding each work—the ideas informing a given performance or installation which deepen one's understanding of that performance or installation, allowing one to imagine an experience one has never had, or helping one to remember an experience that was all too fleeting.

Because Lucier frequently makes her scores available at her installations, they provide a way of introducing her work which is at once personal, conceptual, and ultimately invaluable. That is why a score introduces each work documented in this collection. Reading these scores while dwelling in the works themselves enriches and deepens one's experience on-site, permitting new insights drawn from an awareness of the ideas informing a particular work's making. When reading these scores in an anthology like this one, it is best to examine them in tandem with the photographs, sketches, and other visual material included here, for between images of the work and the ideas behind the work one gets a better sense of what the work is like.

This collection brings together as many different kinds of documentation as possible and presents that documentation in sections which best express Lucier's extraordinary interdisciplinarity as an artist, cover the

full sweep of her oeuvre, and showcase previously unpublished material. One major goal in doing this has been to open up the little-known period from 1970 to 1975, a period which begins with two collaborations with Alvin Lucier (*Room/I Am Sitting in a Room* and *Hymn*) and ends with *Dawn Burn*, the video installation which secured Lucier's position in the canon of video history. During the years in between these three works, Lucier explored a variety of different media and experienced a surge of tremendous productivity. She created nineteen new works during this five-year period, several of them complex multimedia performances. During this same five years she also began to use video: in 1973, she shot her first videotape with a camera borrowed from Shigeko Kubota and included that tape in the *The Occasion of Her First Dance and How She Looked;* the same year she created her first video sculpture, *Antique with Video Ants and Generations of Dinosaurs;* and two years after that she made *Air Writing* (1975), her first multichannel video installation, and *Fire Writing* (1975), the first of several works exploring the phenomenon of vidicon burn.

At the outset of this period Lucier was still peripherally involved in the world of electronic music. Married to composer Alvin Lucier in 1964, she toured with him throughout Europe in the late 1960s as a performer in the Sonic Arts Union, a group Alvin formed with fellow avant-garde composers Robert Ashley, David Behrman, and Gordon Mumma. Over the next few years the Luciers occasionally collaborated and sometimes performed in each other's work. Mary, for example, performed in *Hymn* (a rare photo of her in performance is reproduced here), while Alvin performed with Mary in *Journal of Private Lives*, her contribution to a multimedia concert also featuring one of his compositions as well one by English composer Stuart Marshall. "Concerts in Slow Motion," Tom Johnson's review of this evening of work, and "Mapping Space, Sculpting Time: Mary Lucier and the Double Landscape," my overview of Lucier's sculptural and photographic work through 1972, suggest some of the ways that the musical avant-garde shaped Lucier's early orientation as an artist. While Johnson focuses on the visual style of the new music, noting that the "minimal, slow-motion approach" shared by all three works allows one to become involved in the images each work creates "in a very personal way," I attribute Lucier's interest in the transformation of landscapes to her exposure to the idea of process so important to the avant-garde.

As Lucier moved away from this avant-garde and began to come into her own as an artist, she was briefly involved in a multicultural

women's performance collective modeled after groups like the Sonic Arts Union. Calling themselves *Red, White, Yellow, and Black* (Cecilia Sandoval, Mary Lucier, Shigeko Kubota, and Charlotte Warren), the members of this group met through the world of new music: Cecilia Sandoval was the cousin of Douglas Mitchell, Visiting Artist in American Indian Music at Wesleyan University, where Alvin Lucier had joined the faculty in 1970; Mary Lucier and Shigeko Kubota met in 1964, then toured with the Sonic Arts Union a few years later, during the period when Kubota was married to composer David Behrman; and Charlotte Warren was a friend of Belgian composer Jacques Bekaert.

While Lucier has said recently that the idea of forming an all-female performance group was originally Kubota's, it was an idea she and Kubota discussed extensively through the summer and fall of 1972.[12] By working together, they thought, perhaps they could secure a power base for women in the art world; or perhaps, Lucier hoped, their group could provide a "feminist focal point" in the avant-garde. With this as a goal, it is no surprise that the works Lucier created for *Red, White, Yellow, and Black*'s two multimedia concerts reflected her own budding feminism, or that they were the two most explicitly feminist works produced by any of the group's members. For *Red Herring Journal (The Boston Strangler Was a Woman)*, for example, Lucier distilled and juxtaposed statements from several well-known studies on female criminality, among them *The Female Offender* (1896), by Caesar Lombroso, and read the resulting text herself throughout the performance. Meanwhile, three slide projections in vertical format continuously presented "colorized" portraits of some eighty female criminals, organized in red and black, white and black, and yellow and black groupings. At the same time, another female performer sitting at an overhead projector wrote a prepared text describing a strangling, followed by a description of a sexual or criminal act. An astute examination of the way rebellious women have often been perceived as criminal outsiders and a bold reclamation of outlaw status on behalf of the four women in the group, *Red Herring Journal* is represented in this collection through its prose score and through the text Lucier read during the performance.

Reading these documents in conjunction with the scores for *The Occasion of Her First Dance and How She Looked*, a collaboration with Cecilia Sandoval for *Red, White, Yellow, and Black*'s second multimedia concert, and *A Portrait of Rosa Mendez in 1975* (1971–74), an unrealized performance conceived around the same time, reveals a lot about a fre-

quently mentioned, but virtually unexamined, period in Lucier's oeuvre. While both *Rosa Mendez* and *The Occasion of Her First Dance* are concerned with issues of sexual and cultural identity, like *Red Herring Journal*, and while all three works fit loosely within the genre of portraiture, *Rosa Mendez* and *The Occasion of Her First Dance* feature a motif which first emerged in 1969 and has continued to haunt Lucier's work for almost thirty years: that of the *fugitive* or *phantom*. As Lucier explains briefly in the score for *Rosa Mendez*, and then in more detail in the essay "Organic," she discovered while making her *Polaroid Image Series #1: Room* that visual technologies have built-in limitations which often produce startlingly beautiful imagery. A Polaroid photograph, in other words, is unable to preserve a precise 1:1 ratio through multiple generations of copying, so as its original image gradually disassembles, it seems to release previously invisible shapes and figures—ghosts, chimeras, mysterious phantoms, and evanescent, increasingly abstract forms.

Lucier used a more complex version of this copying process—photographing images from the original videotape onto slides, projecting the slides, and then revideotaping them—in *The Occasion of Her First Dance* to transform video images of the Thunderbird Dancers into shadowy semblances of their former selves. For *A Portrait of Rosa Mendez*, she planned to use closed-circuit video surveillance systems in apartment lobbies, banks, and stores to reveal the elusive presence of a phantom individual. Each work gave the idea of the fugitive a slightly different resonance: in *The Occasion of Her First Dance*, ghostly images of the dancers on clusters of monitors flanking both Cecilia Sandoval as she sang to members of the audience in Navajo, and Lucier herself as she read a text distilled from Sandoval's memories of growing up on a reservation, suggested the disappearance of Native American culture. In *Rosa Mendez*, however, a person invented by a company Lucier used to work for to endorse certain products in their mail-order catalogue became the focus of an elaborate but ultimately impossible search through New York City. In performance, Lucier envisioned the juxtaposition of three distinct portraits—one topographical, one drawn live by a police artist, and one composed of different aspects of audience members recorded live with closed-circuit cameras. As Lucier remarked in 1996, the resulting composite portrait of a phantom would also inevitably have become a portrait of the audience whose fingerprints and other distinguishing physical characteristics were being captured, live.[13]

What is perhaps most significant about the score for *A Portrait of*

*Rosa Mendez* is that it reveals Lucier's interest in an approach to video technology that, in fact, she has rarely pursued. Only in the performance of *Fire Writing* (1975) and the installations *Laser Burning Video/Lasering* (1977) and *Untitled Display System* (1977/1997) has she used a closed-circuit camera to exploit video's capacity for live transmission. What the score for *Rosa Mendez* suggests, however, is that, like many of her contemporaries in the late 1960s and early 1970s, Lucier was interested in video's closed-circuit capabilities, and one of the first works she conceptualized on paper which would explore those capabilities took as a central theme the phenomenon of surveillance. In theme, then, and, to a certain extent, in proposed structure, *Rosa Mendez* resembled many of the multiple monitor matrix installations dating from the same period, such as *Wipe Cycle* (1969), by Frank Gillette and Ira Schneider, or *Bank Image Bank* (1973), by Bill Viola, both of which also examined video's relationship to surveillance and sought, in Gillette and Schneider's phrase, to "integrate the audience into the information."[14]

If the capacity for live transmission was perhaps video's most frequently explored property during the first decade of video art, it was one of video's most significant technical limitations—the susceptibility to burn—which became the primary focus of Mary Lucier's explorations of the medium during the same period.[15] Sometime after Lucier first began using video in 1973, she discovered that when a video camera receives prolonged exposure to an intense source of light, the photosensitive material on its vidicon tube is irrevocably altered and ultimately destroyed. As this happens, the tube is scarred, and the scar remains as a memory trace of past trauma in each image subsequently recorded by that camera. If the light source is a laser beam, the scar is delicate, white, calligraphic; if it is the sun, the scar is thick, dark, and blunt.

Starting in the mid-1970s, Lucier made a sustained investigation of the phenomenon of burn as it is produced by both forms of light. In eleven works created between 1975 and 1981—*Fire Writing, Dawn Burn, Paris Dawn Burn, Untitled Display System, Laser Burning Video/Lasering, A Burn for the Bigfoot/Sasquatch* (1977), *XY* (1978), *Bird's Eye* (1978), *Equinox, Planet,* and *Denman's Col (Geometry)*—burn yielded a strangely compelling imagery manifesting aspects of its own generation and decay. An "emblem of video's capacity for self-reflection," burn is, as Lucier suggests in her essay "Light and Death," perhaps also "a template for our own."

In this view, one Lucier has expressed repeatedly since 1969, humanity and technology are perceived as equally organic: both are suscepti-

ble to trauma, haunted by memory, and inescapably mortal; and as each moves toward mortality, each also experiences decay. From the gradual disassembly of the image in *Room* to the calligraphic inscriptions made by the laser beam in *Fire Writing;* from the dark scar carved by the sun in *Dawn Burn* to the scarred bodies and landscapes in *Noah's Raven;* from the crumbling ruins near the estate in *Wilderness* to the rustic toolshed which forms the centerpiece of *Asylum*, the infinite variations on the process of entropy have preoccupied Lucier since the beginning of her career.

When she was preparing to reinstall *Asylum* in New York in 1991, Lucier spoke at length about the nature of this preoccupation. At that time, while reading *The Writings of Robert Smithson*,[16] she began to think about how things acquire an allure as they age, developing a kind of morbid beauty that assuages the anxiety brought on by knowledge of mortality. In a single phrase she summed up the theme which underlies so much of her work, namely, "the art of death is decay."[17]

Lucier's interest in decay is inextricably linked to the motif of the fugitive—with the tendency to evoke human presence through absence or to represent the human body in phantomlike form. Especially true of her works concerned with landscape, this tendency is also inseparable from one other signature element of her style: her use of the camera as a surrogate human eye. For many video artists in the late '60s and early '70s the camera became an extension of the human body, a personal tool used to examine physical movement, specific gestures, and the process of perception. While artists like Vito Acconci, Bruce Nauman, and Peter Campus turned the newly portable video technology upon themselves, incorporating their own bodies or those of viewers into the image, Lucier personalized the camera by anthropomorphizing it, using it as a stand-in for the human eye, and exploring its memory and mortality rather than using it to record her own image.

In one early slide series from 1971, a number of these signature elements—the motif of the fugitive, a focus on landscape, the theme of mortality—coalesce for the first time. *Color Phantoms* was a series of 35 mm sandwiched slides superimposing color landscapes and black-and-white television imagery, projected in miniature on the lid of a coffin. Rich layers of light and texture, alive with the illusion of movement, the *Phantoms* were named for the ghostly figures released through the process of superimposition, viewed by a visitor lying down like a corpse.

In the landscape video installations created during the next decade, these ghostly figures take a variety of different forms, and sometimes, when absent, are something we imagine: shrouded figures slip through the snow (*Denman's Col [Geometry]*), mysterious reflections lurk in Monet's lily pond (*Ohio at Giverny*), colonial interiors await their inhabitants (*Wilderness*), overgrown cemeteries suggest our end. *Asylum*, however, finally gives us a human being. Rearranging debris at a fire site, this spectral figure resembling the trash has a body as wrecked as the place where he labors. In *Noah's Raven* and *Oblique House (Valdez)* we see something similar: people who bear the imprints of their environment, who have been invaded, wounded, and scarred, like the land. In *Noah's Raven* we see closeups of two female torsos; in *Oblique House*, however, four longtime residents of Alaska share their stories of surviving disaster in slow motion closeups that let us examine every nuance of their expressions. What is perhaps most astonishing about the transition between these two works is that while Lucier was shooting and editing *Noah's Raven* she remarked that she had not yet figured out how to represent the human face.[18]

In fact, Lucier had been drawn to faces many years earlier, for her original interest in photography was in the genre of portraiture: several of the *Polaroid Image Serie*s were portraits, and *Red Herring Journal (The Boston Strangler Was a Woman)*, *The Occasion of Her First Dance and How She Looked*, and *A Portrait of Rosa Mendez in 1975* were each unique, mixed-media portraits that prefigured the video portrait galleries created more than twenty years later for *Oblique House*, *Last Rites (Positano)*, and, most recently, for *Floodsongs*, Lucier's installation commemorating the Red River Flood of 1997.

In the years in between these two periods, the human body disappeared from much of Lucier's work as she began to concentrate on the subject of landscape. At the same time, however, and if somewhat paradoxically, she became interested in what it means for human beings to "inhabit," creating three works inspired by the concept: *Media Sculptures: Maps of Space* (1972), *Antique,* and *Denman's Col (Geometry)*. She also collaborated with choreographer Elizabeth Streb on two dance/video works which focused directly on the human figure.

Known in the world of postmodern dance for her extraordinary physicality, Elizabeth Streb was once a member of the Viola Farber Dance Company, and it was in fact at a site-specific performance with that company at the Staten Island Ferry terminal that she and Lucier

met in 1974.[19] When they first collaborated eleven years later on *Amphibian* (1985), a live performance for which Lucier created two rear-projected channels of videotape, they created a work which reflected a shared sensibility committed to exploring the tension between entrapment and transcendence.

Because Lucier's collaborations with Streb have received much less critical attention than her landscape works, it was especially important to include in this collection Christine Temin's review of *In the blink of an eye . . . / (amphibian dreams) / . . . "If I could fly I would fly,"* the single-channel tape derived from the performance of *Amphibian,* and Tom Whiteside's insightful essay on Lucier and Streb's second collaboration, the video installation *MASS* (1991), entitled "Momentum, Balance, and the Violence of Gravity: *MASS,* by Mary Lucier and Elizabeth Streb."

Whiteside's contribution is especially valuable for the way it helps us see Lucier's dance/video collaborations as an integral part of her body of work, rather than as something entirely separate. When he notes, for example, that Lucier and Streb are both formalists who bring "an aura of cool refinement" to their presentation of colliding and rebounding muscular figures, one is reminded of the praise for formal elegance which Lucier's installations frequently receive. When he writes that the imagery in *MASS* seems to energize the entire room, one hears the echo of Martha Gever's remark that the light in *Planet* creates a "dazzling energy" that at once "embraces and consumes matter." And when he asks a more philosophical question prompted by the specific content of the work—"What do we know, on a molecular level, other than the gravity present on the earth's surface?"—he is responding to a tone, or better yet, an *orientation* which people often experience in Lucier's installations. It has to do with the way that her work consistently poses difficult questions rather than provides simple answers.

### Going Home

Man [*sic*] dwells when he can orientate himself within and identify himself with an environment or, in short, when he experiences the environment as meaningful. Dwelling therefore implies something more than "shelter." It implies that the spaces where life occurs are *places*, in the true sense of the word. A place is a space which has a distinct character. Since ancient times the *genius loci*, or "spirit of place," has been recognized as the concrete reality man has to face

and come to terms with in his daily life. Architecture means to visualize the *genius loci*, and the task of the architect is to create meaningful places, whereby he helps man to dwell.

—Christian Norberg-Schulz, *Genius Loci:*
*Toward a Phenomenology of Architecture*

If, as Le Corbusier once remarked, the purpose of architecture is to *move* us, then in her work Mary Lucier consistently realizes architecture's highest aim: she creates installations whose extraordinary power lies not only in how deeply they make us feel but also in how they let us see the complexity of our feelings, in meaningful environments which help us to dwell.

In a fascinating essay exploring the significance of peripheral spaces in dwellings, architect Anne Troutman notes that the word *dwelling* has its origins in the Old English word *dwellan,* which means "to go astray, to hesitate, to delay." A dwelling, she continues, is an *in-between* space where one may "hesitate between worlds." It is a "place of *delay.*"[20]

The activity of dwelling is therefore a contemplative lingering—a way of remaining in a space or location that is responsive to the nature of that particular place, and open to wherever it happens to take you— in your imagination, through association, through fantasies, daydreams, desires, or memories. To dwell, then, is to be willing to drift, to be able to pause, to let yourself *imagine* with some abandon. For the activity of dwelling involves *imaginatively inhabiting* the intimate spaces we invest with personal meaning—shells, nests, corners, chests, rooms, corridors, houses, home.

That our feelings about such spaces are often mixed, that we are often drawn to what both attracts and repels, these are things Mary Lucier understands intuitively, and are among her greatest insights as an artist. If in the intimate space of her installations we experience our own ambivalence about certain issues more intensely, it is because of the way, in theme and structure, her work so elegantly holds contradictory elements in tension. The strangely beautiful scar in *Dawn Burn* forges an organic link between creation and destruction; the motif of the garden, in a work like *Asylum*, accommodates death within a familiar living structure; *MASS* explores the relationship between liberation and confinement; and the installations featuring images of houses— *Oblique House (Valdez)*, *Last Rites (Positano)*, *House by the Water,* and *Floodsongs*—simultaneously inspire a wish for permanence and provoke a primal fear. What better medium for exploring these contradictions

than one which, like video installation, also holds contradictory elements in tension?

Poised between permanence and impermanence, ideally requiring bodily experience but often experienced solely through documentation, video installation has been Mary Lucier's primary medium for almost thirty years. By transforming ordinary rooms into chambers for rumination, Lucier's installations teach us to dwell. They also teach us to value experience and to accept impermanence while giving us an opportunity to dwell in possibility, which, as Emily Dickinson knew, is "a fairer house than prose."[21]

### Notes

1. Gaston Bachelard, *The Poetics of Space* (Boston: Beacon Press, 1969), 5.

2. While Lucier and the members of her construction team were building *House by the Water* in the warehouse, they opened the back door in the warehouse to let in light. This door opened directly onto the adjacent space containing the ruin, and everyone in the team had a view of it daily as they worked. This makes Lucier's remark all the more resonant: the ruin became something she imaginatively pulled into the piece, which "in my mind became a part of the piece," for a very specific reason. Mary Lucier, interview with the author, June 3, 1997.

3. I am thinking here specifically of a later Judd like *Unititled* (1978), consisting of ten steel and green anodized aluminum units, but Judd began making such sculptures out of other industrial materials like galvanized iron in the mid-1960s.

4. See Mary Lucier, interview with Cynthia Nadelman, typescript, Archives of American Art, Smithsonian Institution, New York, N.Y., April 18, 1990, 42.

5. Lucier, Nadelman interview, Archives of American Art, 82.

6. See Gail Levin, *Edward Hopper: The Art and the Artist* (New York: W. W. Norton with the Whitney Museum of American Art, 1980), 44, who notes that Hopper "apparently chose to paint buildings not for their beauty, but for their fascinating forms—a rather abstract sensibility that he tried to deny when it was brought to his attention."

Mary Lucier is similarly interested in the geometry of architecture, something I attribute, once again, to the minimalist sculptural sensibility that was in the air during the time she came of age as an artist. Note that the title of an installation from 1981 is *Denman's Col (Geometry)*.

7. Lucier, Nadelman interview, Archives of American Art, 11.

8. Marcel Proust, *Swann's Way,* trans. C. K. Scott Montcrieff (New York: Modern Library, 1928), 611.

9. Bachelard, *Poetics of Space,* xxxii.

10. Lucier learned the art of photography initially so she would be able to

photograph her early sculptures, so in fact she began to photograph her own work in the 1960s. See Lucier, Nadelman interview, Archives of American Art, 87. However, because there are a number of early works for which there is very little photographic documentation (there are no photographs of *Salt* as a finished work, for example), it seems most accurate to say that Lucier began to document her work regularly and thoroughly by approximately 1972. There are some photographs of the performance *Journal of Private Lives* and the installation *Second Journal (Miniature),* both from that year, in Lucier's possession.

11. See Ira Schneider and Beryl Korot, *Video Art* (New York: Harcourt Brace Jovanovich, 1976). Lucier's documentation of *Dawn Burn* (1975–76), including fourteen video stills, two from each of the installation's seven channels, is included on pages 88–89.

12. Mary Lucier, interview with the author, June 2, 1997.

13. Mary Lucier, interview with the author, June 27, 1996.

14. Frank Gillette and Ira Schneider, as quoted in Gene Youngblood, *Expanded Cinema* (New York: E. P. Dutton and Co., 1970), 341.

15. I am grateful to Chrissie Iles, curator of the Film and Video Department at the Whitney Museum of American Art in New York, for alerting me to the work of David Hall, who explored the phenomenon of vidicon burn in England at virtually the same time Lucier was conducting her own first experiments with burn in America. Hall made a single-channel tape and a video installation exploring the phenomenon. Both were entitled *Vidicon Inscriptions* (1974–75).

16. Lucier, Nadelman interview, Archives of American Art, 467. Lucier's relationship to Smithson is complex, as I explain in n. 33 of "Mapping Space, Sculpting Time: Mary Lucier and the Double Landscape," below.

17. Lucier, interview, Archives of American Art, 464.

18. Lucier, interview, Archives of American Art, 431.

19. Lucier made a single-channel black-and-white documentary videotape entitled *The Viola Farber Dance Company* in 1974. The tape is in the collection of the New York Public Library, Performing Arts Library, Lincoln Center, New York.

20. Anne Troutman, "Inside Fear: Secret Places and Hidden Spaces in Dwellings," in Nan Ellin, ed., *Architecture of Fear* (New York: Princeton Architectural Press, 1997), 149.

21. Emily Dickinson, poem 657, in Thomas H. Johnson, ed., *The Complete Poems of Emily Dickinson* (Boston: Little, Brown and Co.), 327.

# I  Early Conceptual and Performance Works

## Mary Lucier

### *Polaroid Image Series* (1969–1974)

*[Note: Alvin Lucier's score for* I Am Sitting in a Room *is included in this collection in Part 2, "Collaborations," because* Room *and* I Am Sitting in a Room *were presented together as a collaborative work starting in 1970, as Mary Lucier explains above. This particular statement for the* Polaroid Image Series *is included here, in Part 1, "Early Conceptual and Performance Works," because it describes the method used by Lucier to make all of the* Image Series, *each of which exists, and has been exhibited, as a separate work of art. Lucier wrote this statement recently to accompany an exhibition of several of her early photographic series at the Lennon, Weinberg Gallery in New York.]*

The *Polaroid Image Series* were begun in 1969 as a collaboration with the composer Alvin Lucier, based on his composition for voice and tape, *I Am Sitting in a Room.* Using a similar copying process, an original image was reproduced through a Polaroid copier, each subsequent photograph becoming itself a copy of the one before it—carried to as many as 131 generations. Slight errors in alignment, dirt accumulation, minute reflections, and the simple interaction of light and optics produced an ever-changing and often unpredictable landscape in which the original image was completely transformed many times over. The images were initially intended to be projected as black-and-white slides, simultaneous with the original thirteen-minute audio work. The first performance, utilizing the series called *Room,* took place at the Guggenheim Museum on March 25, 1970. Numerous other versions were produced between 1969 and 1974, including *Shigeko, Croquet, City of Boston, David Behrman, Three Points,* and *Anne Opie Wehrer.*

July 1997

## Nancy Princenthal

## Mary Lucier at Lennon, Weinberg

Mary Lucier's recent installations have been lush, richly colored, many-layered evocations of personal history and the broader cultural and physical landscape. The two projects shown at Lennon, Weinberg date back more than twenty-five years. Both works are rooted in Conceptualism and start from schematic premises. Technically unsophisticated, these projects lay bare some questions inherent in video and photography—questions that now mostly lie buried beneath washes of spectacle and irony.

Simplest to explain is the *Polaroid Image Series,* made between 1969 and 1974, at first in collaboration with her then-husband, composer Alvin Lucier, who was arranging scores for voice and tape. Mary Lucier accompanied him by rephotographing an original black-and-white snapshot—those shown here include a view of a group of croquet players, a portrait of a woman, and an abstract-looking composition with three points of light—and then rephotographing that second-generation image, and so on, in sequences of progressively degenerating images. This is the first time the results have been assembled and shown independently as photographs (rather than in slide form), and their lessons are simple and direct. When things fall apart, they go fast; the face loses coherence within the first ten of sixty-nine generations, the croquet players within fifteen of sixty-eight. What happens thereafter has a wholly unpredictable life of its own. A slight change in alignment, or the incidence of dirt, or changing light, creates altogether unforeseen compositions. The photos that began in abstraction and figuration are soon leveled, and indeed sometimes produce nearly identical images.

These parables of mechanical representation have not lost their fas-

Originally published in *Art in America* (May 1997): 123.

cination. A similar impulse is given a devious twist in *Untitled Display System #1 and #2*, which originated in the early '70s. In this case, Lucier took advantage of a susceptibility of early video cameras to permanent burn markings on their internal recording tubes from overexposure to focused light. Working with lasers (partly in performance of a work called *Fire Writing*), Lucier attempted to write, in midair and more or less blind, a text about fire, which resulted in seemingly automatist video "scars." The burned tubes were here remounted in monitors that simultaneously displayed, in ghostly overlays, the presence of viewers in the gallery as registered by surveillance cameras.

These works recall a time when video and Polaroid cameras were, in some senses, in their infancy. And just like real babies, these instruments were encouraged to babble in ways that still seem unaccountably engaging, funny, and—to viewers with even the smallest interest in the grown-up outcome—at odd moments oracular.

**Mary Lucier**

*Media Sculptures: Maps of Space*

**(1972–1974)**

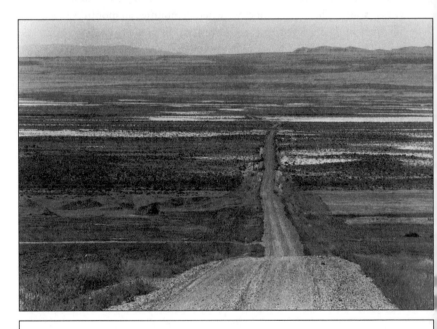

#2

Se-
lect
an image
of a long
vista. Con-
centrate on the
triangles, trapezoids,
rectangles, and circles in
this image, and by extending
one or several of these basic shapes,
build a bridge between yourself and the farthest point in the picture.

*Mary Lucier*

*Media Sculptures: Maps of Space #2* (1972–74). Photo by Mary Lucier

**Melinda Barlow**

**Mapping Space, Sculpting Time:**

**Mary Lucier and the Double Landscape**

To a recent publication devoted to landscape, Mary Lucier contributed two pairs of photographs, each provocatively titled *Maps of Time*.[1] In one pair of images the land is barren but luminous, a silken, grainy surface resembling sand or gray waves. In the image on the left a lunar expanse gives way to a basin worn down by a stream; in the image on the right a single, glistening ridge suggests a whole mountain range, rising up suddenly out of a desert. Maybe this is what remains after nuclear fallout; perhaps this once was inhabited terrain; maybe these are fossilized imprints, or artifacts from an earlier age. At once earth, stone, flesh, esker; valley, foothill, desert, moon, both soft and hard, old and new, vast, empty, open, forlorn, this is the geography of the aging human body, a strange and yet familiar terrain.

The photograph on the left is the last shot from the series of video-tapes that comprise the installation *Noah's Raven* (1992–93), Lucier's complex rumination on the environmental crisis and its impact on the human body. Situated where two parallel journeys converge, one from Alaska to the Brazilian rainforest, the other of a woman's body as it moves through various surgeries, this ambiguous image is in fact a wrinkled abdomen, and what appears to be a basin is a long, deep scar. The scar belongs to Lucier's mother, Margaret L. Glosser, and marks the site of her battle with a terminal disease. Paired, here, with its inversion—the same image simply turned upside down—the scar changes shape and dimension, shifts from representation to abstraction: lifted and flipped, what was once a depression becomes an elevation, while the circle of a navel becomes a triangular peak. The contours of the

Originally published in *Afterimage* (September–October 1997): 6–10.

27

body reveal their delicate geometry in this portrait of a person *as a location,* an imaginary landscape we are invited to inhabit.

*Maps of Time: Mother* (1995), however, is a compelling *double landscape,* a pair of images whose interrelationship is as significant as the meaning of either image alone.[2] In this work, inversion is the gesture that creates a second landscape, and juxtaposition is the strategy that suggests a relationship between the two. Side by side, the images are symmetrical; their relationship, organic: one is an inversion of the other; each completes and complements the other. As the scar on the left becomes a ridge on the right, the shimmering pixels seem to reassemble, and a new landscape emerges from the waves of video moiré. Together, the two landscapes map the space of the human body and record its movement through time. The scar suggests a history, and the diptych preserves a memory, of a woman whose body has returned to the land. As Lucier put it, "The scar tissue (i.e., memory) presents a visible sign which enables us to track the traumatizing event, following its map backwards in time to the source where the wounds are always fresh and the scabs of recovery and forgetfulness have not yet formed."[3]

*Maps of Time: Mother* provides a map back through the last twenty-five years of Mary Lucier's oeuvre, and serves as a template for much of the work that has developed more recently. In the video installations from the '80s and '90s and in the multimedia works from the early '70s, Lucier explores many of the themes and concerns expressed in this diptych: the intertwining of body and land; the parameters of an organic form of art; the relationship between landscape, imagination, and memory. Works that come both before and after the *Maps of Time* also explore the same form—portraiture—and make use of similar techniques, from juxtaposition and inversion to the trope of the double landscape.[4] This last formal element is perhaps the most significant, for Lucier has brought different landscapes together and asked us to consider their interrelationships so frequently since the early 1970s that the double landscape has become one of the recurring signatures in her work. In her description of *Ohio at Giverny* (1983) she provides a useful definition of this key feature. Her video installation, she writes, "deals with the convergence of disparate entities—geographies, periods in time, sensibilities; with transitions from one state of being to another; and how, within the frame of imagination and collective memory, these 'dissolves' take place."[5]

*Ohio at Giverny* investigates just such dissolves of memory by creating a journey for the camera from Lucier's birthplace in rural Ohio to

Claude Monet's gardens in Giverny, France. Moved by Monet's loss of sight to the very process that generated his art, painting outdoors facing the sun, Lucier used the familiar motifs from his late paintings as traces of art-historical memory, and fused them with a more personal journey through remembrance and lament. The two journeys converge in a cemetery on a closeup of a headstone engraved "A Mon Oncle" while a train whistles plaintively in the distance. Dedicated to Lucier's Midwestern uncle and the French wife he lost to an oncoming train, *Ohio at Giverny* ends in commemoration. A lyrical double landscape, both elegy and requiem, the piece seeks repose for the souls of the dead.

Other double landscapes take a range of different forms and express different moods: *Air Writing* (1975) and *Noah's Raven,* like *Ohio at Giverny,* bring together disparate locations; *Media Sculptures: Maps of Space* and *Media Sculptures: Maps of Time* (both 1972), like *Maps of Time: Mother,* are pairs or series of photographs; *Color Phantoms* (1971) and *FLOW* (1996) consist of two images which are literally superimposed; while *Salt* (1971) superimposes the memory of one place upon the physical reality of another. Some double landscapes like *Wilderness* (1986) are elegies, others like *Salt* and *Noah's Raven* are concerned with ecology, and *Last Rites (Positano)* (1995) celebrates differing perceptions of the same moment in time. *Media Sculptures: Maps of Space* and *FLOW* invite contemplation, while *Media Sculptures: Maps of Space* and *Media Sculptures: Maps of Time* incorporate text and are conceptually based.[6] Each double landscape brings together two images or locations, suggests the possibility of a journey, and blends time, memory, and geography into a coherent yet ambiguous whole. Each double landscape is an imaginary vista: "a comprehensive mental view of a series of remembered or anticipated events"[7]

Landscape emerged as an explicit subject in Mary Lucier's work in 1971. In that year, she created a performance, a slide series, and an earthwork, each investigating landscape, and she drove from coast to coast on a trip she has described as her "rediscovery of the American landscape."[8] Before that, landscape was something she became involved with indirectly, in the process of making a group of works called the *Polaroid Image Series* (1969–74). Begun in 1969 as a collaboration with the composer Alvin Lucier, and based on his composition for voice and tape, *I Am Sitting in a Room,* each *Image Series* copied and recopied an original photograph over multiple generations. "Slight errors in alignment, dirt accumulation, minute reflections, and the simple interaction

of light and optics," Lucier has written recently, "produced an ever-changing and often unpredictable landscape in which the original image was completely transformed many times over."[9] What began as a room, a face, a game of croquet, or a cityscape, in other words, became, in its movement toward abstraction, an evolving field of organic shapes and textures alternately resembling the earth, the sky, the clouds, and the heavens lit with stars.[10]

Landscapes emerged unexpectedly in these early *Image Series* through an organic process of transformation, and to this day Lucier perceives landscape as something that continually transforms—through the cycles of collapse and regeneration, because of different kinds of human intervention, and through contemplation, imagination, and memory. For Lucier, a landscape is something that *becomes:* an ever-changing field of information, both real and abstract, actual and imaginary, always organic, perpetually in flux. A landscape in this way resembles the world, and the world, as John Cage noted some years ago, is defined by movement and change: "the world, the real, is not an object. It is a process."[11]

When Cage wrote "Composition as Process" in 1957, he paved the way not only for a revolution in musical scoring, but for a complete overhaul of traditional attitudes concerning the relationships between art and life, performer and audience, and one art form and another.[12] Influenced by non-Western forms of thought such as the *I Ching* and Zen Buddhism, Cage developed new, open-ended methods of writing music that allowed for chance and change while removing considerations of craft, personality, and taste from the art-making process. Beginning with the ideas that all sounds are inherently musical and that one can become attuned to aural phenomena through careful listening, Cage evolved a form of "intermedia" between music and theater which gave new attention to the performative aspects of making sound, and allowed the performer free reign in interpreting the composition.[13] The result was an open-ended work that broke down the boundaries between music and the other arts and which, from composition through performance, explored the possibilities of change.

Cage's ideas have had enormous influence on the arts and especially on the world of "new music" for the last four decades, having been absorbed, directly or indirectly, by composers such as David Tudor, La Monte Young, Alvin Lucier, and Pauline Oliveros. Their impact was felt most forcefully and immediately, however, in works by the loose, international coalition of artists known as Fluxus. In 1962, George

Maciunas, the mercurial figure who spearheaded Fluxus activities until his death in 1978, echoed Cage when, describing the new tendency toward "concretism" in the arts, he wrote that "a truer concretist rejects pre-determination of final form in order to perceive the reality of nature, the course of which, like that of man [*sic*] himself is largely indeterminate and unpredictable."[14] Like Cage, Maciunas was interested in an art that was as unruly and ever-changing as nature. To highlight this, he often included the definition of the word *flux* in early manifestoes for Fluxus: "flux, n. Act of flowing: a continuous moving on or passing by as of a flowing stream; a continuing succession of changes."[15]

Mary Lucier came of age as an artist during the period when the emphasis on change and process was transforming traditional ways of making and understanding art. In 1962, while majoring in English and American literature at Brandeis University, Lucier studied music theory with composer Alvin Lucier. In 1964 the two were married. While making sculpture and learning photography over the course of the next several years, Lucier performed in compositions by both Alvin Lucier and Robert Ashley, traveled to Europe as a member of the Sonic Arts Union, collaborated twice with Alvin Lucier (first on the *Polaroid Image Series,* then on a live performance/sculpture titled *Hymn* [1970]), and created the earthwork *Salt,* for which Alvin Lucier designed the sound.[16]

The emphasis on change, process, and transformation in Mary Lucier's landscape work derives, in part, from this exposure to the world of new music. The ideas important to this world, however, were also explored in other arts throughout the '60s and '70s, and were expressed in different ways by artists working in hybrid, inter-, or multimedia forms made from new materials, exhibited in new locations, driven by ideas, and committed to allowing visitors to be active participants in experiences that endured in time. During this period, sculpture left the gallery for the land; it began to be made from everyday materials, like earth; and it might bring together elements for a short time, rather than produce a permanent object. During the same period in the world of new music, the space of a room became acoustical sculpture; musical notation could take the form of a single-sentence prose score; and composers like Oliveros wrote compositions asking participants to consider themselves part of "the poetics of environmental sound."[17]

During this period, Mary Lucier worked in a variety of different media, and, in 1971, began to investigate the genre of landscape. Three

early works, *Salt, Media Sculptures: Maps of Space,* and *Media Sculptures: Maps of Time,* express her orientation toward landscape at this time. Each work explores either photography or sculpture; each encourages contemplation or meditation; and each was developed on paper, in notebooks that served as a conceptual studio.[18] In each work, ideas and motifs that have recurred throughout Lucier's oeuvre for the last twenty-five years emerge in fully realized form for the first time. Among them are the trope of the double landscape, the staging of a journey, and the invitation to *inhabit,* through imagination and memory.

In July 1971 Mary Lucier drove from Connecticut to California, shooting 35 mm black-and-white photographs of the landscape. This trip provided material for both *Salt* and *Media Sculptures: Maps of Space.* In October 1971 Lucier constructed *Salt* on the grounds of the St. Clements Estate in Portland, Connecticut. Described on the invitation as a "realsculpture," *Salt* used materials available in the East—snow fencing, tobacco cloth, marble chips, and amplified bird calls—to evoke an image she had seen in the West, that of the Great Salt Lake. Like the *Color Phantoms* made earlier the same year, *Salt* was a double landscape made by mixing different media. In a letter to Vaughan Kaprow several months after *Salt* was disassembled, Lucier wrote that her purpose in making the piece was to bring together

> two different images/ideas that would normally be separated either by time or geography. I was interested in combining the open spaces and far-reaching vistas of Wyoming and Utah with the private and discreet sense of space in the Connecticut Valley. I chose to use certain prosaic materials to alter a preexisting landscape diagrammatically in order to make the piece abstract and at the same time real. It became a horizontal environment that could be looked at from a distance, walked through and seen from an aerial view.[19]

In the review of *Salt* that appeared in the *Middletown Press,* Lucier also remarked upon the significance of her chosen materials. Instead of the marble used for classical sculpture, she preferred to work with "everyday" materials able to evoke the specific qualities of the site.[20] To construct *Salt* these materials were required in quantity: 2,000 feet of snow fencing, 10,000 square feet of tobacco cloth, and 150 pounds of marble chips. The snow fencing was arranged in parallel rows placed at 50–70-foot intervals within a 550-×-400-foot field surrounded by foliage. The final row completely enclosed a sheet of tobacco cloth some 30–60 × 200 feet. Three cairns of marble chips resembling salt deposits

marked the route through a maze that created an optical illusion. The staggered rows of snow fence transformed the field into an imaginary vista: from one end they looked like slowly rolling waves in a shimmering, white sea, flanked by the woods, with the Connecticut River in the distance.

*Salt* is an important early work in Lucier's oeuvre for a number of reasons: in it, the double landscape appears in fully realized form for the first time. *Salt* is also the first work inspired by a journey, whose form comes from the act of remembering that journey, and that therefore expresses a uniquely personal relation to landscape. Installed for five hours on one day and never re-created, *Salt* is, in addition, one of Lucier's most short-lived and ephemeral works. Twenty-five years after disassembly, it belongs to the distant realm of memory. *Salt* is also the first work that Lucier shaped, on paper, in her notebooks, before, during, and after installation. As she recorded her impressions on the road, sketched the field at St. Clements, defined key ideas, and followed chains of associations, she discovered a way of working that remains to this day. It is through *Salt* that Lucier's notebooks became a conceptual studio.

Dating from summer 1970 to January 1972, the five notebooks used for *Salt* provide immediate context for the work and bring to life Lucier's creative process. The summer/fall 1971 notebook is the conceptual center of the group for *Salt* because it contains notes taken on the trip through the American West and also documents the genesis of the piece. Another notebook from the same group, however, reveals the impulse behind the trip itself in a form that bears striking resemblance to the scores for *Media Sculptures: Maps of Space.* Shot on the same trip, the *Media Sculptures* juxtapose photographs of landscape with written instructions asking viewers to concentrate on the geometric shapes found in two different vistas. An entry in the summer 1970–71 notebook expresses a similar idea: "Collect over a period of time, photographically, all the ○ □ △ in the environment. If this involves a trip, plot the trip in ○ □ △."[21] More than a passing thought, this score Lucier wrote for herself seems to predict the trip that led to *Salt* and *Media Sculptures.* Each entry in the notebook taken on the trip includes small drawings that reduce the terrain of ten different states to their essential geometries. The entries for Wyoming and Utah, for example, feature tiny sketches of nets, holes, fences, corrals, lakes, and tabernacles, along with references to salt flats, the Great Salt Lake, and the Salt Lake Monster.

The Great Salt Lake was an especially compelling sight: it set in motion Lucier's process of thought and seems to have allowed conceptualization to happen fast. Ten pages after her first notes the title "Salt: A Western Landscape" appears at the top of a page dated July 24, 1971.[22] Definitions of salt, expressions using salt, lists of materials, and the description of an unrealized companion piece all follow shortly. A working method that remains to this day is found here: key ideas for a piece are defined early on as meanings, associations, and cultural references are explored, and experience is transformed by the process of intellection. It is through this process that Lucier crafts her works conceptually: exploring, abandoning, retrieving, and reformulating her ideas for extended periods of time.

For *Salt*, this process lasted approximately three months. Because the work was assembled on-site and existed in fully realized form for only five hours on one day, it remained in process until it was installed, and the process of installation changed the working conception of the piece for a number of practical and aesthetic reasons. While Lucier chose materials like snow fencing, rock piles, and tobacco cloth early on and also used them on-site, other elements important during the creative process were either relinquished along the way or may not have remained in the work for the duration of the afternoon. These included wrapping trees and shrubs with fabric, placing a mannequin on the ground under a portion of that fabric, incorporating an aerial view of the piece, and including a journal documenting the construction of *Salt* on a stand in the field as a part of the piece.[23]

Trees were wrapped but then ultimately unwrapped on site. The mannequin was placed face down under a blanket of leaves near the perimeter of the field, but may have been removed during the course of the afternoon.[24] The tower on the grounds of St. Clements proved unsafe and was therefore inaccessible, so the aerial view, mentioned several times in the notebooks and in the letter to Vaughan Kaprow, remained a provocative impossibility. The journal, which was going to include photographs of Utah, sketches of *Salt*, shots of the work in situ, and pages from Lucier's notebooks, was given up before *Salt* was assembled on site. Sol Lewitt's twelfth "Sentence on Conceptual Art" seems especially appropriate here: "For each work of art that becomes physical there are many variations that do not."[25] Each unrealized idea expressed in the notebooks shaped a slightly different version of *Salt*. These ideas form a conceptual field around the work that illuminates

its range of concerns and also places it within Lucier's oeuvre and within contemporary art history.

Lucier has recently given two slightly different descriptions of *Salt*, calling it a " 'bridge' from performance sculpture to a more static kind of sculpture that was an environment"[26] and "a transition between ideas of object sculpture and ideas of environmental installation."[27] *Salt* in fact fits both descriptions. It leaves behind the object sculpture Lucier had been making in the mid-1960s, mostly clay heads and abstract shapes made from welded steel. More immediately, however, it follows a form of live sculpture constructed in performance such as *Hymn*, for which she created an amplified, human-scale web on stage. Twenty-five years ago Lucier described *Salt* in different ways in different places, calling it both a "large-scale environment sculpture" and a "realsculpture."[28] What to call this new hybrid form was obviously an issue, not only for Lucier but for the reviewer of *Salt* as well. To William Collins of the *Middletown Press,* Lucier said that *Salt* was suited to the place where it was built, "natural" in character, and changed in different weather and throughout the day.[29]

The review supplies context for *Salt* and provides a sense of what it was like to experience the piece. On the road to St. Clements, Collins enjoys the unseasonably warm weather, musing on the meaning of "Indian summer" while taking in the rich display of color along the Connecticut River. When he arrives at the estate, he is curious and inquisitive, if a bit unsure of what to do. Intrigued by the prospect of an aerial view, he asks if *Salt* is like the "mile-long colored lines criss-crossing in the desert"[30] seen in *Time* magazine, or if it is a "happening." Somewhat disturbed by the volume of the birdsong, he comments several times that it intrudes upon the "gentle afternoon." Appreciative, nonetheless, of other aspects of the experience, he gets a feel for the shape of his surroundings, glances at the refreshments on a nearby table, and, while he walks, contemplates other things: the bird calls remind him of a Tarzan soundtrack, the fencing of warnings to "keep off the grass" and then of cattle grazing in a field.

When Collins meets Mary Lucier, he asks why she has included recorded bird calls in a "natural" sculpture, wonders how she chose her materials, and remarks upon their sparse distribution in the field. Lucier responds that electronic sounds are "as natural as anything else," that *Salt* is not a happening but is intentionally "minimal," and that her interest in tobacco cloth stemmed from seeing how it made the

uniform landscape near the highway above Hartford seem surprisingly spacious and expansive.[31]

As a new kind of sculpture, both real and abstract, built on a large scale but with a minimal use of materials in a particular place, *Salt* was a site-specific installation made on the land, that used nature as a primary material, and that would now be described as an earthwork. As Lucier suggested in her letter to Vaughan Kaprow, *Salt* was less a fixed object than a temporary assembly of elements open to change: "All elements present were considered significant and a part of the sculpture; or insignificant and a part of the sculpture: the early morning fog, blazing afternoon sun, the shapes of trees, and the tire tracks that resulted from driving our bus through the area while setting up.[32]

*Salt* was made during the first wave of an ecological movement that inspired many artists to turn to the land, a time when art as environment began to merge with "environmental art." While artists like Robert Smithson built monumental earthworks in remote western sites, others, like Richard Long, made modest arrangements of branches or stones, and then disassembled them or left them to disintegrate.[33] Smithson perceived his relationship to the land as dialectical; Long's delicate sculptures are frequently described as natural. Like Allan Kaprow's three-dimensional environments, works by both men may be described as "organic."[34] The organization of a sculpture, says Long, "comes out of the type of material."[35] Organic art, echoes Allan Kaprow, "lets the form emerge from what the materials can do."[36]

In 1978, Lucier wrote an essay titled "Organic." It began, like many notebook entries for new works, with a definition: organic, as defined by Webster, means "inherent, inborn; constitutional; organized; systematically arranged; fundamental; in philosophy, having a complex but necessary interrelationship of parts, similar to that in living things."[37] Work that is organic is put together the same way: the nature of the material shapes the composition, and thus becomes an element of content. In organic art, writes Lucier, "subject and matter become interchangeable."[38]

Organic art also lives in its environment. Its relationship to that environment is therefore one of interdependence or reciprocity; while the art actively transforms its surroundings, those surroundings—altered by people, weather, motion, sound—in turn, transform the art, and become, in the process, integral to the experience. This makes organic art naturally antimonumental because it embraces change.

Lucier describes the *Polaroid Image Series* and the video installations

*Dawn Burn* (1975–76) and *Lasering* (1977) as organic works that embrace change. Both installations explore vidicon burn, a phenomenon that occurs when prolonged exposure to intense light alters and ultimately destroys photosensitive material on the camera's vidicon tube. In *Dawn Burn,* seven consecutive sunrises burned their paths onto the tube, carving a thick, dark scar; in *Lasering,* a helium neon laser etched more delicate white markings onto the tube in live installation. In both works, a technical limitation yielded a compelling imagery manifesting aspects of its own generation and decay. Scars were born as the camera "died," documenting its, own "organic" demise. Watching the slow unfolding of entropy, witnessing memento mori inscribed over time, viewers witnessed the decay of video technology, a poignant reminder of the end of a life cycle.

The video installations from the mid-'70s took ideas expressed in *Salt* in new directions by exploring them in a new medium. The complex interaction between art and environment, the importance of feedback, the embracing of change—these were important aspects of both *Dawn Burn* and *Lasering.* They were also key features of *Salt,* as Lucier had suggested in her letter to Vaughan Kaprow four years earlier. Like *Lasering,* an open system affected by wind, architecture, humidity, and passers-by, *Salt* also lived in its landscape, transformed that landscape, and was open to change—by fog, sun, the shapes of trees and tire tracks, people, weather, motion, and sound. In 1978, after several burn pieces, Lucier expressed her ideas about the relationship of organic art to its surroundings like this: "Work that is organic has a (more or less) dynamic relationship to its environment. It does not simply exist in a space, it *inhabits* it" (emphasis mine).[39]

Lucier's choice of words in this formulation is significant. It reflects her concern, in the years between *Salt* and *Lasering,* with the process of habitation, and her interest, more specifically, in the "concept-word 'INHABIT.'"[40] Dominating her thoughts in the early 1970s, this concept provided a title for a series of black-and-white photographs, often of landscape, two of which were used in the video sculpture *Antique with Video Ants and Generations of Dinosaurs* (1973). A small notebook dating from July of that year served as the studio where Lucier crafted the idea of inhabiting, on paper, and slowly began to develop her installation. A late November entry offers this definition: "inhabit: occupy physical space and time. physical space changes with passing of time and the nature of inhabiting."[41] Inhabiting is the activity of living in something; it takes place over time and alters the environment in which

it occurs. As a concept, inhabiting implies both location and duration; it suggests the possibility, and the process, of experience.

Begun in June 1972 and continuing on and off through April 1975, the *Inhabit* series was also called *Media Sculptures: Maps of Time*.[42] In each of the photographs in the series, Lucier's hand draws our attention to a feature in the landscape. In one photograph her hand encircles a tombstone, located beneath a group of trees at the far end of an expanse of grass. As the angle of her forearm guides our eyes across the space, directing our line of vision to the center of the image, her gesture creates a vista we are invited to "INHABIT." The fingers of her hand tell us to focus; they serve as a narrowed lens; they represent a specific point of view. They concentrate the act of looking on a specific feature, a tombstone, and force us to consider its place within the landscape.

Miniaturized within the circle of Lucier's fingers, the tombstone is something we must squint to see. Much larger are her arm, the field of grass, the trees, not to mention the stretch of sky, in which is stamped the word INHABIT. A compelling invitation as well as a command, this word, like her hand, directs our attention and provides a focus for concentration. It inspires a series of questions and associations: what does it mean to inhabit this landscape, to envision or imagine ourselves in this place? The place is a cemetery, where people are buried, and where tombstones mark the passing of time. A tombstone commemorates a life that is over; beneath it is a body that has returned to the land. In the act of living we inhabit different landscapes; in death we actually inhabit the land. By pondering the idea imprinted in this image, we live, if only for a moment, with the possibility of death.

In another photograph from the same series, Lucier's hand holds a magnifying glass close to the ground, asking us to "INHABIT" the intricate landscape beneath a cluster of lush leaves of grass. Here, too, Lucier directs our attention, provides a focus for concentration. Enlarged by the glass is a mysterious fragment, a scrap of paper imprinted with two groups of letters partially obscured by tips of grass. The letters read "CULES" and perhaps "BRO," and seem like part of a strange, coded message. By flipping letters in the first group, we get the word "clues," but where are the clues for deciphering this bit of text? And what does it mean to INHABIT this landscape?

To a photograph full of texture, Lucier adds a personal gesture: she holds the magnifying glass close to a blade of grass. By looking at the grass closely, we can imagine living there, or remember when we once lingered there. It is lingering in the grass which inspires Walt Whit-

man's poem, that song of self and soul in harmony with the land. A leaf of grass, Whitman writes, is "the journeywork of the stars," and many leaves of grass suggest "the beautiful uncut hair of graves." While loafing in the grass, Whitman's mind wanders; in his imagination he travels elsewhere: "My ties and ballasts leave me . . . I travel . . . I skirt the sierras . . . my palms cover continents." When returns to where he *is* and begins to end his poem, he "bequeaths himself to the dirt to grow from the grass [he] loves," returning the body of his language to the land. The grass is for Whitman the "flag of [his] disposition": in it, through it, he celebrates himself.[43]

By lingering in the grass in Mary Lucier's photograph, our ties and ballasts leave us, we travel elsewhere. When we return to where we *are,* we see where we have been, and that we have been moving through the landscape of imagination. Through the act of projecting ourselves into photographs of landscape, we skirt the sierras. We inhabit whole worlds.

In the same year that she began the *Inhabit* series, Lucier also created *Media Sculptures: Maps of Space* for Pauline Oliveros, Lin Barron, and the ♀ Ensemble. Conceptual performance photographs to be realized by the recipient, the *Media Sculptures* consisted of images of landscape accompanied by instructions asking performers to concentrate on the geometric shapes in a given environment or vista. First published in a book of scores entitled *Women's Work* (1975), which also featured compositions by Oliveros, Alison Knowles, and Mieko Shiomi, among others, the format of the *Media Sculptures,* while unique, was inspired by particular techniques from the world of new music.[44]

When describing the conceptual orientation of much of her early work, especially the tendency to write a prose score, Lucier has on a number of occasions mentioned the influence of composer La Monte Young.[45] Influenced by John Cage's theories and serving as a link between Cage and Fluxus, Young was interested in investigating sounds that were not only inaudible, as in Cage's 4′33″ (1952), but also merely conceivable. In *Composition 1960 #5* (1960), for example, Young released a group of butterflies into an auditorium; the piece was over when the butterflies flew away. The possibility of delicate sounds that had to be imagined was what interested him in this piece.

Like most Fluxus artists, Young's scores used clear, economical language to describe simple, open-ended actions meant to be interpreted freely by a performer. Such freedom might mean that the performer

was using his or her body in a theatrical activity, or performing the work in his or her mind as a thought. It might mean public or private realization, or individual or collective performance. Conceptual in format, the prose score as developed by Young and others was the agent that engaged the "reader-performer in the theater of the act."[46]

Mentioned more than once by Mary Lucier to illustrate the kind of instructions characteristic of Young's early work, *Composition 1960 #10 to Bob Morris* (1960) provides a good example of just such economy of language and of an open-ended format designed for unlimited interpretation. Consisting of the simple phrase "Draw a straight line and follow it," the piece was performed as part of the Fluxus International Festival of Very New Music in Wiesbaden in 1962 by Nam June Paik. In this interpretation, Paik dipped his head, hands, and tie into a bowl of ink and tomato juice, and then dragged them along a length of paper. The result was a composition that became a performance Paik called *Zen for Head.*[47]

Other new musical scoring methods are both similar to and different from those developed by Young. Alvin Lucier's prose scores are relatively long and somewhat poetic. They offer precise descriptions of procedures to be followed "cold-bloodedly," without the interference of personality, in order to permit, for example, the acoustic signatures of given environments to reveal themselves.[48] Oliveros, while interested in many of the same acoustical phenomena as Lucier, like Young, tends to use a shorter form, and since approximately 1970 much of her work has been devoted to the process of meditation.[49]

In that year, she formed the ♀ Ensemble, an improvisation group, both vocal and instrumental, devoted to the exploration of sustained tones, or, in Oliveros's words, of "unchanging tonal centers with an emphasis on changing partials."[50] For that group, Oliveros composed twenty-five *Sonic Meditations* to enhance and develop aural sensation. As performed by the group, usually sitting in a circle in a space with low illumination, the *Meditations* asked participants to make, actively imagine, listen to, or remember different sounds. Examples include allowing the vocal cords to vibrate naturally, forming a mental sound image and attempting to transmit it telepathically, listening to a sound until it is no longer recognizable, and remembering the sound of your own voice before you learned to sound the way you sound now.[51] The compositions are called meditations, writes Oliveros, because they involve "dwelling upon an idea, an object, or lack of object without distraction, or divided attention."[52]

Designed for Oliveros, Barron, and the ♀ Ensemble, the *Media Sculptures: Maps of Space* ask performers to dwell upon—or inhabit—both an idea and an object, in this case a single-sentence instruction and a photograph of landscape. In *Media Sculptures: Maps of Space #1,* the score instructs us to concentrate on certain geometric shapes within a given environment "until either the original scene is obliterated or an entirely new landscape emerges," or until our minds can no longer hold all the information. Through the act of concentration, the score asks us to transform a landscape, to let it become something else. Like the copying process used in the *Polaroid Image Series,* the mind, too, can disassemble and reassemble an image by reducing it to its essential geometries and thus changing a representation of landscape into something much more abstract.

The second *Map of Space* tells us to concentrate on the geometric shapes in a long vista and, by extending them, to "build a bridge" between ourselves and the farthest point in the picture. Here, a score configured into a geometric shape tells us to change something two-dimensional into something three-dimensional by creating an imaginary architectural structure from a geometric shape present in the landscape, and in this way to enter into or inhabit that landscape. The score activates the space beyond the edges of the frame; it is a map not only of space, but for performance. The score is the vehicle through which the reader-performer transforms photography into imaginary sculpture.

In the second pair of photographs in *Maps of Time,* a hand covers part of a body in one image that in the adjacent image is fully exposed. In this double landscape there is very little mystery; we know immediately what these images are. The line of an arm, the curve of an armpit, and the slight suggestion of a breast all tell us that this is a woman's body, concealing and revealing the scar from a mastectomy. Titled *Maps of Time: Nancy,* this pair of photographs, like *Maps of Time: Mother,* is drawn from the end of the tapes for *Noah's Raven.* There, the woman's warm skin comes out of the cracked red earth of a cassiterite mine, and is allied with the scarring of the land in the Amazon Basin. The woman is sculptor Nancy Fried, and bravely, in slow motion, she shows us her scar.

Frozen here in black and white, the effect is much starker: it is hard not to flinch, or want to look away. Rather than triggering imagination, these photographs force a confrontation—with fear, self-image, and the aging female form. Here, that form is completely transformed:

where there once was a breast there is now a puckered scar. That scar suggests a history, and preserves the memory, of a traumatic surgery, and a battle with disease. The scar on Fried's body maps her movement through time.

*Maps of Time: Mother* and *Maps of Time: Nancy* form yet another compelling double landscape which reveals the dialectic at the heart of Lucier's work. In *Maps of Time: Mother* we see the interest in abstraction; in *Maps of Time: Nancy,* the unflinching pull toward the real. In Mary Lucier's work these twin interests always work in tandem because their interrelationship is above all *organic:* complex and necessary, like parts in living things.

### Notes

1. *Felix: A Journal of Media Arts and Communication* 2, no. 1 (1995): 134–37. Lucier has called other recent configurations of photographs *Maps of Time* as well. In one vertical triptych dating from 1993, the top image is of an Alaskan glacier, the second image is of the marked (mapped) torso of a woman on a gurney prepared for breast reconstruction surgery, and the third image is of the cracked red earth in the Amazon. All three are drawn from *Noah's Raven.*

2. There is a parallel, compelling double portrait of Lucier's mother, Margaret Glosser, included in *Last Rites (Positano)* (1995). One image shows Glosser as a troubled young woman in her twenties, the other as a self-assured woman in her seventies, who, despite illness, knows who she is.

3. Mary Lucier, *"Noah's Raven:* A Photo Essay," in Sandra E. Knudsen, ed., *Noah's Raven: A Video Installation by Mary Lucier* (Toledo: Toledo Museum of Art, 1993), 26.

4. Inversion is a key technique in many of Lucier's works, but especially in *Denman's Col (Geometry)* (1981). In her statement for *Denman's Col,* Lucier writes, "Ambiguity results from the rotation and inversion of images and shift back and forth between positive and negative form. The subsequent disorientation of viewpoint and multiplicity of presentation—conventions literally turned upside down and sideways—liberate the viewer from horizontal/vertical logic as we normally experience it." Mary Lucier, artist's statement, November 3, 1981.

5. Mary Lucier, artist's statement, February 14, 1983.

6. *FLOW* is a work which emerged from *Last Rites (Positano).* Lucier's description of it is as follows: "A video projection installation for from two to eight projects and laserdiscs. Water images are projected on walls and/or in corners, overlapping in such a way as to create a single elongated video 'mural' which appears to flow in continuous fashion across the wall or around a room. Barely audible underneath the soundtrack of bubbling water is the intermittent autobiographical narrative as spoken by an elderly woman recalling formative

events in her past life." Mary Lucier, résumé, 1996. *FLOW* was included in the exhibition *Reinterpreting Landscape* at the Maier Museum of Art, Randolph-Macon Woman's College, Lynchburg, Virginia, January 20–March 17, 1996.

Another, early double landscape was a cover Lucier designed for *Source: A Magazine of the Musical Avant-Garde* 5, no. 2 (1972). On the cover Lucier superimposed a map of the Connecticut River Valley onto an image of the Mojave Desert. *Polaroid Image Series #3: Croquet* appears throughout the magazine.

7. This definition appears in a notebook dated October 1971. The notebook is in the artist's possession.

8. I am speaking here of *The Caverned Man, Color Phantoms,* and *Salt,* respectively. In *The Caverned Man,* an old man sat in an antique chair in a small pool of light, assembling and dissassembling a unique three-dimensional puzzle made from photographs of landscape adhered to toy building blocks. Projected in the folds of the curtains surrounding him were miniaturized images, perhaps representing his desires. In the room adjacent to the performance was another puzzle made from images of landscape adhered to geometric shapes. People were invited to try to assemble the puzzle, called *Impossible Puzzle,* on their way into and out of the performance. The work was inspired, in part, by the *Didactic and Symbolical Works* of William Blake, especially "Europe/A Prophecy/Etched 1794," which begins, "Five windows light the cavern'd Man." Lucier described her trip in this way during an interview with the author, New York, July 29, 1992.

9. Mary Lucier, artist's statement for the *Polaroid Image Series* (1969–74), January 1997. Three of these image series, *Croquet, Three Points,* and *Anne Opie Wehrer,* were exhibited in a show entitled *Mary Lucier: Early Video and Photo Works, 1969–1974,* at the Lennon, Weinberg Gallery in New York, January 7–February 8, 1997.

10. The first *Polaroid Image Series* was *Room* (1969), designed for accompaniment with *I Am Sitting in a Room,* by Alvin Lucier. *Polaroid Image Series #2–6* were *Shigeko, Croquet, City of Boston, David Behrman,* and *Three Points* (all 1970).

11. John Cage and David Charles, *For the Birds* (Boston: Marion Boyars, 1981), 80.

12. "Composition as Process" is included in John Cage, *Silence: Lectures and Writings by John Cage* (Middletown, Conn.: Wesleyan University Press, 1974).

13. The term *intermedia* was used by Dick Higgins to describe works which are between media in his "Statement on Intermedia," dated August 3, 1966, in Higgins, *The Something Else Manifesto* (New York: Something Else Press, 1966), included in Elizabeth Armstrong and Joan Rothfuss, eds., *In the Spirit of Fluxus* (Minneapolis: Walker Art Center, 1993), 172–73. The term is to be distinguished from the terms *multi-* or *mixed-media,* in that the latter add or combine art forms, whereas *intermedia* describes works that are between the arts.

14. George Maciunas, "Neo-Dada in Music, Theater, Poetry, Art," in Armstrong and Rothfuss, *In the Spirit of Fluxus,* 156–57.

15. There is a photograph of one of these early manifestoes in Owen Smith's essay "Fluxus: A Brief History and Other Fictions," in Armstrong and Rothfuss, *In the Spirit of Fluxus,* 24. The manifesto dates from 1963 and is a part of the Gilbert and Lila Silverman Fluxus Collection, Detroit.

16. These compositions were *The Duke of York,* by Alvin Lucier, and *Purposeful Lady, Slow Afternoon*, by Robert Ashley. They took place in 1969 and 1966, respectively.

The Sonic Arts Union consisted of Robert Ashley, David Behrman, Alvin Lucier, and Gordon Mumma. Mary Lucier performed as part of the group on their first European tour in 1967, and again on their second European tour in 1969. Mary Ashley, Shigeko Kubota, and Barbara Lloyd (Dilley) were also performers on the first tour.

17. "The Poetics of Environmental Sound" is a listening exercise. It is included in Pauline Oliveros, *Software for People: Collected Writings, 1963–1980* (Baltimore: Smith Publications, 1984), 28–35. Theory students of Alvin Lucier at Brandeis University participated in the exercise when it was first assigned to students at the University of California at San Diego in the late 1960s.

18. In "The Dematerialization of Art," Lucy Lippard described the effect of Conceptualism on the act of making art. She wrote: "As more and more work is designed in the studio but executed elsewhere by professional craftsmen, as the object becomes merely the end product, a number of artists are losing interest in the physical evolution of the work of art. The studio is again becoming a study." See Lippard, *Changing: Essays in Art Criticism* (New York: E. P. Dutton and Co., 1971), 255–76. I use the phrase "conceptual studio" here in a related, but slightly different way to suggest a shift from a studio in which objects are crafted by hand to a paper studio in which ideas are crafted in notebooks. Lucier crafts works conceptually in her notebooks before she realizes them in physical form.

19. Mary Lucier, letter to Vaughan Kaprow, copy in the artist's possession, January 31, 1972. Vaughan Kaprow was married to Allan Kaprow when he was helping to found CalArts. Vaughan Kaprow was in charge of an archive or a library at the school. She either received an invitation to *Salt,* or heard about it, and requested information about the work from Mary Lucier. Conversation with the author, July 29, 1992.

20. Mary Lucier, in William E. Collins, "'Realsculpture' at St. Clements," *Middletown Press,* November 5, 1971, 6.

21. Mary Lucier, notebook in the artist's possession, summer 1970–71.

22. Ibid.

23. Ibid.

24. Photographs in Lucier's possession show a mannequin in her Middletown studio, but none of the photos documenting the assembly of the piece at

St. Clements include the mannequin. Mablen Jones, however, mentions seeing the mannequin in the field in "Landscape versus Technology: Myth and Metaphor in the Work of Mary Lucier," *Center Quarterly* (fall 1987): 18. Perhaps Mablen Jones was on site while Lucier was trying out possibilities, or perhaps the mannequin was included for part of the afternoon. Mary Lucier says she also thought of lying in the field herself, as a kind of performance. Conversation with the author, July 15, 1993.

25. Sol Lewitt, "Sentences on Conceptual Art," in Claude Gintz, ed., *L'art conceptual: Une perspective* (Paris: Musée d'Art Morder de la ville de Paris, 2d ed., 1989), 201.

26. Mary Lucier, interview with Cynthia Nadelman, typescript, Archives of American Art, Smithsonian Institution, New York, N.Y., April 18, 1990, 125.

27. Mary Lucier, interview with the author, April 29, 1992.

28. Mary Lucier, announcement for *Salt* in the *Middletown Press,* 1971; and Mary Lucier, invitation to *Salt.*

29. Mary Lucier to William E. Collins, in Collins, "'Realsculpture' at St. Clements," 6.

30. Despite inconsistencies in Collins's description, this may be a reference to Walter De Maria's *Cross* (1968), which consisted of two lines in white chalk three inches thick, forming a cross five hundred feet wide and a thousand feet long at El Mirage Dry Lake in Nevada.

A similar work was De Maria's *Mile Long Drawing* (1968), created with the help of Michael Heizer in the Mojave Desert in California. This work consisted of two parallel lines four inches wide and one mile long, which were twelve feet apart from one another.

31. Mary Lucier to William E. Collins, in Collins, "'Realsculpture' at St. Clements," 6. Today this site is still a vivid memory: when Lucier was asked about *Salt* in several recent interviews, the sea of white tobacco cloth that once flowed along the road from Boston to Hartford is one thing Lucier usually describes. See Mary Lucier, Nadelman interview, Archives of American Art, 127–28; and Mary Lucier, interview with the author, July 29, 1992.

32. Mary Lucier, letter to Vaughan Kaprow.

33. Lucier's relationship to Robert Smithson is complex, and therefore reserved for an essay currently in progress. Lucier did not see Smithson's *Spiral Jetty* (1970) when she went to Utah, but because of the closeness in time of the works, and their shared concern with the Great Salt Lake, Smithson's name often comes up in articles about and interviews with Lucier. See, for example, the interview with Cynthia Nadelman at the Archives of American Art, 129, 161, 467; the interview with Peter Doroshenko, *Journal of Contemporary Art* 3, no. 2 (1990): 81–89, and the article by Mablen Jones, "Landscape versus Technology," 18.

34. Kaprow uses this word in *Assemblages, Environments, and Happenings* (New York: Harry N. Abrams, 1966), 202.

35. Richard Long, *Walking in Circles* (New York: George Braziller, 1991), 77.

36. Kaprow, *Assemblages, Environments and Happenings*, 202.

37. Mary Lucier, "Organic," *Art and Cinema* 3, nos. 1 and 2 (1978): 23.

38. Ibid.

39. Ibid., 27.

40. The phrase is Lucier's. It appears on a résumé from 1974 as part of her description of *Antique with Video Ants and Generations of Dinosaurs*. The résumé is in her possession.

41. Mary Lucier, notebook in the artist's possession, July 1973.

42. This title appears on the résumé from 1974 cited above.

43. All quotations are from Walt Whitman, *Leaves of Grass* (New York: Viking Penguin, 1959).

44. Alison Knowles and Anna Lockwood, eds., *Women's Work* (Brooklyn: Print Center, 1975). The photos were also reproduced in a collection of scripts edited by Richard Kostelanetz and titled *Scenarios: Scripts to Perform* (New York: Assembling Press, 1980), 88–89. The photographs used in these versions are identical, but differ from the ones used in the present essay. The geometric shaping of text beneath *Media Sculptures: Maps of Space #2* has a precedent in a typewritten version of the work that is in the artist's possession. Neither previously published version of the photographs contains this geometric shaping of text. On the subject of these variations, Lucier says this: In the case of either *Maps of Space #1* or *#2*, the work *is* the prose score. Different photographs may be used as part of the work without any alteration of the score itself. Conversation with the author, July 1997.

Another variation on the work is described by Mablen Jones in "Landscape versus Technology," 18. Jones says that in 1972 Lucier sent friends a series of three landscape prints, each approximately 4 × 5″, with the *Maps of Space* scores on their reverse sides. Jones likens these small prints with instructions to the various documents included in Marcel Duchamp's *The Green Box* (1934).

45. Mary Lucier, Nadelman interview, Archives of American Art, 161; and Mary Lucier, interview with the author, June 22, 1992.

46. Kristine Stiles, "Between Water and Stone, Fluxus Performance: A Metaphysics of Acts," in Armstrong and Rothfuss, *In the Spirit of Fluxus*, 66.

47. I am indebted to Elizabeth Armstrong, "Fluxus and the Museum," in Armstrong and Rothfuss, *In the Spirit of Fluxus*, 14–15, for this insight.

48. The phrase is Alvin Lucier's. It is used in Alvin Lucier and Douglas Simon, *Chambers* (Middletown, Conn.: Wesleyan University Press, 1980), 61, in their discussion of the score for *Quasimodo the Great Lover* (1970). Pieces included in *Chambers* which explore the acoustic signatures of given environments include *Chambers* (1968), *Vespers* (1969), and *I Am Sitting in a Room* (1969).

49. Oliveros was exposed to Lucier's music for the first time in 1964. The two composers met at the Case Institute, in Cleveland, Ohio, in 1966, where

Lucier performed his meditative performance for brain waves, *Music for Solo Performer* (1965). In 1967 Oliveros invited Lucier to the University of California at San Diego, where he began his work for *Chambers*. Oliveros describes her perceptions of Lucier's work in "Alvin Lucier," included in *Software for People,* 191–93. This essay was originally intended for publication as an introduction to *Chambers*.

50. Pauline Oliveros, "On Sonic Meditation," in *Software for People,* 148.

51. These are *Sonic Meditations I, III (Pacific Tell), XVIII (Re Cognition),* and *XX,* respectively. They all were published under the title *Sonic Meditations* in 1974 by Smith Publications in Baltimore.

52. Pauline Oliveros, "Introduction II," in *Sonic Meditations*.

**Mary Lucier**

*Journal of Private Lives* **(1972)**

Live writing. A story.

Document examination. Indication procedure for gathering hidden or obscure information.

Images that supply and reinforce the main body of information. Also place the viewer as voyeur.

Enactment. Performance of private ritual.

Device. Some interaction among the technology, performance, and images that reinforces the content of the images through the very means of perceiving them.

March 1, 1972

**Tom Johnson**

## Concerts in Slow Motion

A prerecorded voice is heard: "At the time of the next statement, this cassette will be closer to microphone one than Alvin's cassette, and further from microphone two than Mary's cassette." Then a different voice: "At the time of the next statement, this cassette will be further from microphone one than Stuart's cassette, and further from microphone one than Mary's cassette." There are four voices in all, and they continue to describe their positions in this manner, the recording quality varying accordingly with each statement. It is very difficult to visualize the movements of the voices, and I didn't bother to try for the first five or ten minutes. But there was nothing else to do, and gradually I became involved and began trying to visualize the movements being described. It was a totally unemotional experience, and yet a fascinating one.

This is a description of Alvin Lucier's *The Queen of the South,* presented on the March 19 program, which opened the Spencer Concerts series. And judging from this concert, it will be an extremely adventurous and thought-provoking series. Some of the seven programs will be presented at Village Presbyterian Church, and others will be at Spencer Memorial Church, near Boro Hall in Brooklyn.

The second piece on the program was Mary Lucier's *Journal of Private Lives.* It begins with a sort of prelude, consisting of black-and-white slides, depicting different forms of currency, along with newspaper clippings which are reversed and almost impossible to read. The body of the work consists of three simultaneous events. On a screen at the left, one sees a hand slowly writing a message: "In the dream I am writing you a letter. I don't know what I am saying in the letter, but

Originally published in the *Village Voice,* March 30, 1972, 39.

**49**

you must mail me a letter arranging to meet me on such and such a day
. . . etc." On a screen at the right is a series of color slides showing
slightly different views through a window. All are rather hazy, and a
good deal of concentration is required in order to pick out the differ-
ences between them. The third event takes place on a central screen.
For a while there are slides of solid colors, only slightly different in
shade. Then there are two simultaneous projections on the screen, and
a couple begins slow-motion ballroom dancing, casting mysterious
double shadows on the screen. The whole piece is in dead silence.

The program ended with Stuart Marshall's *A Sagging and Reading
Room.* Here, four singers sit around a square metal plate, about three
feet across, with sand sprinkled on it. As they sing into their micro-
phones, the metal plate vibrates, causing the sand to shift into many
different patterns. It had a very religious feeling that night, with every-
one staring at the sand as it moved into one intricate design after an-
other. Most of the singing was not very pleasant to listen to, but it
didn't matter because the movements of the sand had some of the same
magic for us that Navajo sand paintings must have for the Navajos.

The most striking thing about the concert as a whole was its cool-
ness. Very little actually happens in any of the pieces, and they all work
on a static dynamic plane. And yet I was never bored. The minimal,
slow-motion approach gives one time to become involved in image in
a very personal way. And if you can flow with it, and stop wanting
something dramatic to happen, it can be extremely rich. The slam-
bang-fast-pace-keep-the-show-moving approach we have all grown up
with is not the only way to put on a concert, by any means.

**Mary Lucier**

*Red Herring Journal (The Boston Strangler Was a*

*Woman)* (1972)

Physiognomy of Female Offenders

Spoken descriptions

Live writing

Three slide projections in vertical format are shown side-by-side continuously throughout the performance. Three slide trays contain eighty images each of various female or impersonated-female physiognomies. Most are criminals. There are white and black, yellow and black, and red and black image groupings in each tray.

A prepared text consisting of several hundred statements culled from the literature on female offenders is recited into a microphone by a female speaker throughout the performance. This is delivered slowly, deliberately, with long pauses.

A woman sits at an overhead projector and writes, as slowly as possible, a prepared text describing, in first-person terms, a strangling. After she has completed this text, which should take an hour, she writes a fantasy or true story also in the first person, dealing with a sexual or criminal act.

December 16, 1972

**Mary Lucier**

**Spoken Text from *Red Herring Journal (The Boston Strangler Was a Woman)* (1972)**

She was born about 1755.

She was known to the general public as "Margaret the mother of criminals."

She had one bastard child, Alexander.

She had four bastard children before marriage, three of them mulattoes.

She was unindustrious and a pauper.

She had no property, received relief, and was temperate.

She was reputed chaste.

She married Lawrence who was licentious and had shot a man.

She had two bastard and five legitimate children.

She was a prostitute.

She married Harvey who was probably a thief.

She was born between 1755 and 1760.

She was a harlot before marriage.

She was not industrious.

She was not healthy.

She had no property.

She was not criminal.

She received relief in her old age.

She had one illegitimate child.

She became a prostitute at the age of thirty-five while her husband was in State Prison.

She was a harlot and a pauper and nearly blind.

She was a harlot who had been placed in the poorhouse for debauchery at the age of twenty-two.

She was a harlot.

She had been in the poorhouse and received relief.

She cohabited with her second cousin.

She was sent to the penitentiary for beating her husband.

She became homicidal and delusional after her release from imprisonment and was sent to a hospital for the insane.

She was unable to learn in school.

She married a cousin.

She ran a brothel.

She served time in the penitentiary for disorderly conduct.

She became pregnant in 1911, was arrested for disorderly conduct, and then married a mentally defective cousin.

She was sent to the House of Refuge for disorderly conduct at the age of fourteen, where she remained three years, acquired a little schooling and the ability to read and write.

She became a harlot.

She married a licentious, semi-industrious man who did little to support her or her children.

She had a subnormal mentality.

She has a disagreeable temper.

She became a harlot, later married, had one child, continued her harlotry, and was finally divorced by her husband.

She was divorced by her husband for infidelity.

She became a prostitute at the age of fourteen and was sent to the State Training School for Girls. She made a good record for a short time after leaving the institution, married, and has one child. At eighteen she was again arrested for disorderly conduct and at twenty-two she was found in a house of prostitution.

She was dull in school.

She married a steady and rather industrious though ignorant man. They had five children. She has cohabited since his death with a worthless individual who has not given her any support.

She married a distant cousin and has two small children.

She dresses flashily and gaudily and works in a factory.

Her brother has been in the penitentiary.

Her mother was a pauper in the poorhouse.

She tried to kill one of her children.

She was addicted to the use of opium.

She was in the Almshouse as a young girl and later was placed in a Children's Home.

She was attractive, neat, and quiet.

She was promiscuous.

At forty she was arrested for intoxication and was sent to jail for ten days.

She associated with a woman much like herself in appearance.

She could neither read nor write.

She was lazy.

She does housework to support her nephew.

She became a harlot and acquired syphilis.

She was five years old when her parents died.

Her younger brother was a laborer in the cement mines and died at the age of twenty-five.

She has married twice.

She was married and had three children, two of whom died in infancy.

She never attended school.

She married a laborer.

At twenty-one she became pregnant and forced the man to marry her.

She is a thief and will steal anything she can lay her hands on.

At nineteen she was arrested for petit larceny.

She can read and write, is now employed at housework, and is immoral.

After some years of teaching she had a nervous breakdown.

She could read but not write.

At thirty-two she was sent to the county jail for ten days for vagrancy.

She became an alcoholic.

She has recently married but has no children.

At one time she was an actress in a traveling show.

She had epilepsy.

At one time she joined a traveling circus.

She is very neurotic and has migraine.

She shows an ugly disposition and continually quarrels with her neighbors.

She has committed incest with her brother and also her father.

She became addicted to the use of drugs.

She has had little education but is considered intelligent.

Her second child died in infancy.

She "had brains enough but used them in the wrong way."

She has a quiet disposition.

She spent what she earned in drink and was always poor.

Her husband was sent to Sing Sing for larceny.

She was considered suicidal and homicidal.

She is of fair mentality and worked in a cigar factory until her marriage.

She married a steady, industrious fellow and has three small children.

She is slovenly in her personal appearance.

She married a man sixteen years older than herself.

She committed incest with her father after the death of her mother.

She was raped by the man with whom her mother was living while her father was in prison.

She is a great talker.

She married a cousin who was impotent.

She is ignorant and dirty.

She was incapable of learning in school and was a harlot before marriage.

She has always worked hard and earned money by taking in washing.

She is remembered by her teachers as being very slow and incapable in school.

She has a speech defect.

Her husband was killed while robbing a bank.

She was illegitimate.

She is quiet-spoken, neat, and refined.

She was a prostitute in her mother's brothel when young.

She is a descendant of a family known for its thieves and prostitutes.

She was a farm laborer.

She served a term in State Prison for burglary.

She never owned any property and has always been poor.

She was brought up in a very respectable family.

She was never married.

She married a fisherman by whom she had one child.

She ran a restaurant in a large city, then moved to a small town.

When she was very young she married an expert glass-blower.

She has a good sense of humor.

She was married and had no children.

She attended church regularly.

She suffered from heart disease.

She attempted to commit suicide by taking poison.

She was born in Wisconsin.

She had infantile paralysis at the age of two.

She was white.

She married a German.

She had gonorrhea and signs of primary syphilis.

At the time of her arraignment she was wearing a two-hundred-dollar dress and the price tags had not yet been removed from her hand-made underclothing.

She was often seen in the company of homosexual men.

One day she was found on the street in a dazed condition and taken to a hospital where she was held for a day and found to be suffering from acute alcoholism.

She was believed to be a Lesbian.

Her physical condition was found to be excellent and she had no venereal disease.

She keeps in touch with her brother and sister but seldom sees her parents.

On several occasions she threatened to kill herself.

She denies ever having had intercourse with any man.

She is extremely hostile.

She shot her fiancé.

She lived alone.

She abandoned her children.

She tried to poison her daughter.

She had thick hair and a heavy jaw.

She had sunken eyes and a receding chin.

She was always drunk.

She had a crooked nose.

She had fits of violent anger.

She looks like a man.

She was beautiful.

She had prominent cheekbones.

She was proud.

She was a good wife and mother.

She lived in poverty.

She tried to poison her husband.

She was subject to convulsions.

She formed a violent attachment with a woman named Lodi.

She had no tattoos.

She was a born criminal.

She was impulsive.

She wrote love letters.

She once said, "I do not like girls."

She starved her daughter.

She had a deep voice.

She was beautiful.

She was a prostitute.

She lived with another woman in extreme poverty.

She was often depressed.

**Mary Lucier**

*A Portrait of Rosa Mendez in 1975* (1971–1974)

A search for the identity and whereabouts of certain fugitives and phantoms as they manifest themselves in the audio, infrared, and light spectra.

Introduction:
Rosa Mendez is a made-up person, invented by a company I used to work for, the ideal endorser for certain products in their mail-order catalogue. She existed as a name, a signature, and a face in a color photograph. She came to signify the particular group of people who worked on that promotional campaign, and I would often hear her being paged over the P.A. system. Undoubtedly, she also represented the attitudes, ethnic background, and tastes of the majority of subscribers, as well as the psychological acumen and tendency to manipulation of her inventors (or discoverers). She struck me as very substantial and significant phantom.

Real people who become fugitives—Angela Davis at the time, Patty Hearst now—become more phantom-like the less they can be physically observed. Their existence becomes a matter of documentation through the media's manipulation of clues, rumor, and previously known facts. Sophisticated technologies which are designed to make these persons corporeal again, usually for the purpose of apprehension, often produce very strange, beautiful imagery: Patty Hearst in the bank robbery, recorded by surveillance cameras, the SLA as photographed by a Polaroid camera, the picture appearing in *Time* magazine, distorted by heat and flames during the shoot-out in L.A.

From my experience with visual and audio technologies I knew that these recording systems also produce their own phantoms. One aspect

of this phenomenon was explored by the composer Alvin Lucier and me in 1969. His composition, *I Am Sitting in a Room*, evokes the resonant frequencies of a space by successive copying through microphones in that space, a portion of recorded speech; I made seven visual counterparts, carrying a photographic image through as many as 132 generations of gradual decay to the emergence of a new configuration of shapes.

I decided to make a visual theater piece about these technologies in which there is an elaborate search but no target. Procedures will be based on methods of surveillance, crime detection, and principles of the composite police sketch. Any information or artifacts resulting from this search might be seen to illuminate such popular phantoms as Howard Hughes, activities of the CIA, the Holy Trinity, the Abominable Snowman, Unidentified Flying Objects.

*Proposal*:
The search will take place over a period of several months and will be in two parts: 1. The gathering of information from geographical locations throughout the city using existing surveillance systems, e.g., closed-circuit TV monitors in apartment lobbies, banks, and stores, a camera with telephoto lens out the window of a moving vehicle, video-monitored metal detectors in bus terminals and airports, night-viewing devices on the street and atop buildings. (One assumes Rosa Mendez to be present in all pictures. Thus, each day's or week's collection of images might be thought of as a miniature topographical composite: A Portrait of Rosa Mendez in Battery Park, A Portrait of Rosa Mendez in Times Square, a Portrait of Rosa Mendez at 125th St. and Broadway.) The resulting data will be divided according to a nine-part grid, rephotographed in sections, and stored on 35 mm slides for use in performance. 2. In the performance itself, three composite "portraits" will be continuously derived from the vast quantity of stored material, on-the-spot descriptions, and the real-time flow of information from members of the audience.

Composite *A,* the topographical portrait, will change continually and at varying speeds—somewhat in the fashion of a slot machine—as bits of images are rear-projected from nine slide projectors. A succession of arbiters will attempt to influence the portrait. She/he can hold some

bits while others keep changing, blank some out, or freeze all at once, or use any other method to reveal or obscure evidence.

Composite *B* is a live sketch, drawn by a police artist according to audience descriptions and enlarged by means of an overhead projector. The artist's and witnesses' dialogue will be amplified through four loudspeakers placed at the periphery of the performance area.

Composite *C* will be a display of video projection and monitors from three live camera stations set up to monitor aspects of individuals from the audience—their fingerprints, voiceprints, or other distinguishing physical characteristics; at times these cameras may also monitor Composites *A, B,* and *C.* Any interference due to movement in front of the projector lens or other attempts to affect the projected image will be considered part of the composite.

Polaroid cameras and portable video systems may be used to record and recirculate evidence.

People may assume masks or escape to Algeria.

The installation should run for three days' continuous showing in a spacious gallery with low peripheral lighting.

September 26, 1974

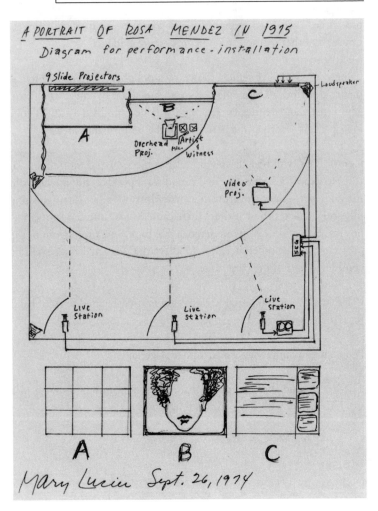

From the proposal for *A Portrait of Rosa Mendez in 1975* (1971–74).
Photo by Mary Lucier

**Mary Lucier**

*Fire Writing* **(1975–1976)**

Continuous tube burn in live performance

The performer writes in air with a portable video camera, allowing an intense light source such as the sun or laser beam to cross the vidicon tube. As she writes, the camera repeatedly sweeping a given area, the light will cause bits of the text to be cumulatively recorded until, in time, the surface of the tube is entirely inscribed with the burn calligraphy. The audible text, heard through loudspeakers around the room, will be a mix of prerecorded recitation and the performer's attempt to follow, vocally as well as visually. The performer will be situated on an elevated platform with the lasers placed in an arc around the periphery of the space and aimed directly at the camera. The live video will be viewed on monitors placed near the performer and facing the audience.

October 25, 1975–July 10, 1976

3.

                              with a handkerchief about his neck

--and warehouses of oil and wines and brandy and other things--

choked his ears and sent him blind for a time.

                         swiftly and fiercely

could perceive the motion with their eye, but ~~even~~ then they heard
     it; ~~it made a rushing, mighty noise, though at a distance
     and but just perceivable.~~

Then we would "theorize":
I saw                          to blow out the flames too late
                               to put them out too soon

The bear
my guests, Mr. Wood and his wife Barbara, and also Mr. Moone
One of the watchers

made to retreat but unused to the woods he stumbled often
had an extraordinary good dinner
would tell

                         when the barrels of rum exploded like
                              barrels of gunpowder

his body
both of these stars
the brulot

                         surrounded by the fire
                         hot, sticky and truly an essence,

became Black and was Finally consumed
in my glass
     calculated so that they cannot be ~~so perfectly~~ called the
        forerunners or foretellers, much less the procurers of such
        events as pestilence, war, fire, and the like,

His spirit
his warning
my thoughts and the thoughts of the philosophers
the true mobile fire

From the spoken text used in *Fire Writing* (1975). Photo by
Mary Lucier

# II  Collaborations

## Alvin Lucier

### *I Am Sitting in a Room* (1969) [score]

For voice and electromagnetic tape

Necessary Equipment:

  1 microphone

  2 tape recorders

  amplifier

  1 loudspeaker

Choose a room the musical qualities of which you would like to evoke. Attach the microphone to the input of tape recorder #1. To the output of tape recorder #2 attach the amplifier and loudspeaker. Use the following text or any other text of any length:

> I am sitting in a room different from the one you are in now. I am recording the sound of my speaking voice and I am going to play it back into the room again and again until the resonant frequencies of the room reinforce themselves so that any semblance of my speech, with perhaps the exception of rhythm, is destroyed.

> What you will hear, then, are the natural resonant frequencies of the room articulated by speech.

> I regard this activity not so much as a demonstration of a physical fact, but more as a way to smooth out any irregularities my speech might have.

Record your voice on tape through the microphone attached to tape recorder #1.

Rewind the tape to its beginning, transfer it to tape recorder #2, play it back into the room through the loudspeaker, and record a second gen-

eration of the original recorded statement through the microphone attached to tape recorder #1.

Rewind the second generation to its beginning and splice it onto the end of the original recorded statement on tape recorder #2.

Play the second generation only back into the room through the loudspeaker and record a third generation of the original recorded statement through the microphone attached to tape recorder #1.

Continue this process through many generations.

All the generations spliced together in chronological order make a tape composition the length of which is determined by the length of the original statement and the number of generations recorded.

Make versions in which one recorded statement is recycled through many rooms.

Make versions using one or more speakers of different languages in different rooms.

Make versions in which, for each generation, the microphone is moved to different parts of the room or rooms.

Make versions that can be performed in real-time.

## Alvin Lucier and Mary Lucier

### *Hymn* (1970)

For female dancer and amplification system

Study carefully the webs of common spiders.

Using them as models, weave snares, orbs, meshes, sheets, hammocks, networks, labyrinths, and retreats in such places as bushes, trees, boxes, rooms, and across the tops of cities.

Use several sizes and weights of thread, silk, string, fishline, cable, or any other web-building material.

Amplify the building of the web—including all sounds that result as bridge-lines are fastened, radii tightened, and other tensions ascertained—by placing vibration microphones at the points and on the surfaces to which first-order foundation lines are attached or by deploying air microphones in such a way as to sense the whole environmental situation.

Test relationships by stretching, pulling, scraping, and plucking.

All proportions, including those of body movement, are determined by the conventions of the particular web-style, the physical characteristics of the space, and the real-time decision-making processes of the web-builder. The lengths and weights of the strands plus the density of the total construction determines the pitch and timbral structure of what could be thought of as a human-scale, harp-like stringed instrument.

Middletown, Connecticut

## Mary Lucier and Cecilia Sandoval

## *The Occasion of Her First Dance and How She*

## *Looked* (1973)

| Set | |
| --- | --- |
| Slide images | Live performance |
| Videotape of Thunderbird Dancers | Source text in part |
| by Mary Lucier | by Cecilia Sandoval |

The set consists of a dance floor marked off from the audience by red plush theater ropes, a red-spotlit sitting area with the dancer's clothing displayed, and a back "wall" of visual images. In the center of this wall is a sixteen-foot vertically hanging sheet of frosted acetate for rear projection. Three slides, each projected to at least five-foot height, one atop the other in totem pole fashion, provide unchanging imagery throughout the performance. Other hung or draped material, such as velvet, completes the curtain on either side of the screen. As few as six, as many as twenty television monitors are placed in two groups to the right and left of the screen or massed in a single area.

There are two separate sets of slides which may be used. One set consists of three pictures, two in Polaroid color, the other in black and white, of American Indian women holding fruit. The black-and-white slide can be colorized by adding a gel in front of the projector lens. The second set is a series of three snapshots of young Black and Indian men dressed up as women. The slides are black and white but one should be colorized mauve for projection.

The videotape is a half-hour silent black-and-white half-inch tape of stills, the image quality of which has been degraded through three generations of copying from an original source tape of a fashion show and

Pow-Wow by the Thunderbird Dancers. It begins with a very slow six-minute zoom into the miniaturized TV-within-a-TV image of a seated figure, during which there is no other activity on stage and no sound.

Most of the text was derived from taped interviews in which Cecilia Sandoval relates certain episodes in her life, both real and fantasy. The stories were transposed to the third person feminine and arranged in four series of simple descriptive statements which are read slowly and deliberately over the microphone. The rest was excerpted from a newspaper interview with two women who discuss their marriage to each other; it is recited very rapidly with few pauses.

The live performance is the core of the piece. Cecilia asks members of the audience, both men and women, to dance with her or to sit with her. She talks and sings softly throughout, telling stories and playing games in Navajo. She changes clothing on stage at least twice during the performance. Her costumes are:

Black body suit with black stockings and red high heels

Blue and yellow warm-up suit

Black evening dress

Any combination of the above

She must become a bridge between the ghostly images and life, between the past and the present, between male and female, white and nonwhite.

Additional props might include photographs of Cecilia or other feminine artifacts that may be shown or presented to the audience.

Sequence:

1. Spotlight on. Two empty chairs on stage.
2. Slides on.
3. Cecilia takes seat on stage.
4. Videotape begins. Six minutes of slow zoom.
5. Cecilia asks members of the audience to dance with her or to sit with her.
6. Mary begins to read text. Amplified speaking continues interspersed with dancing until the audio tape begins.

7. Audio tape is started three minutes before the end of the videotape. Approximately two and one-half minutes of "Lead Me On," by Conway Twitty and Loretta Lynn.

8. At audio cue, Cecilia abandons the audience. She turns off monitors one by one, leaves stage, turns off slides backstage. Spotlight remains on until music is finished. Members of the audience still on stage are left to their own devices.

April 1973–September 1973

## Mary Lucier and Elizabeth Streb

*In the blink of an eye . . .*

*(amphibian dreams)*

*"If I could fly I would fly"* (1987)

A videotape created in association with the choreographer Elizabeth Streb and her company. This work consists of a suite of dances, abstracted from their contexts and structured so as to suggest the evolution of a mythical figure from black void to the natural landscape to an aerial world. Focusing on the physical body isolated in space, or in relation to simple elements of landscape, the tape examines themes of confinement, struggle against gravity, and the persistent human desire to achieve a higher state.

April 7, 1987

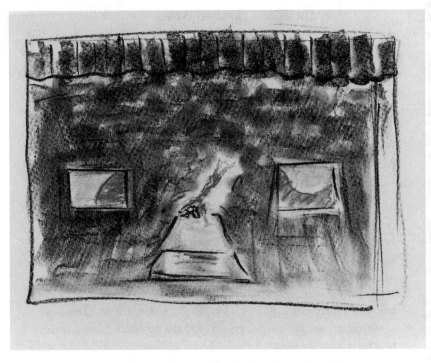

Drawing for performance of *Amphibian* (1985). Photo by
Mary Lucier

**Christine Temin**

## Daring Mix of Water, Dance, Video

*DANCE FOR TELEVISION—A three-hour, fifty-minute program of nine video dances. At the Institute of Contemporary Art, through October 29. Part of a seven-week series,* The Arts for Television, *organized by the Museum of Contemporary Arts, Los Angeles.*

Video can liberate dancers from gravity, distort their shapes and sizes, let them dance upside down. So can water. It's not surprising, then, that the freest and freshest of the nine dance and camera collaborations in the ICA's nearly four-hour marathon, *Dance for Television,* take place in water.

We are not talking Esther Williams here. We are talking about a few of the most adventurous choreographers around, who have discovered water as dance's New Frontier, who have done for water what John Curry did for ice. This, folks, is a genuine trend, which will crop up again: The Japanese butoh group Sankai Juku, for instance, does an ankle-deep water dance that Dance Umbrella wants to bring to Boston next year.

The ICA water dances are *Lament,* by the Japanese choreographers Eiko and Koma, made with video artist James Byrne; *If I Could Fly I Would Fly,* by two Americans, choreographer Elizabeth Streb and video artist Mary Lucier; and *Waterproof,* by a French team, choreographer Daniel Larrieu and video artist Jean-Louis Le Tacon. *Lament,* shot in tranquil black and white, begins with a nude body huddled on its side and reflected in still water nearby. The space is ambiguous, the patterns made by the slowly unfolding body are kaleidoscopic. A second body slices across the front of the screen, glistening with water drops. One

Originally published in the *Boston Globe,* October 23, 1987.

set of images dissolves into another; the two figures are isolated from each other and from the rest of the world, working with total concentration to arch upward, over the water. Both as sculpture and as a statement of effortful emotion, *Lament* is gripping.

In *If I Could Fly I Would Fly,* Lucier focuses on one section of Streb's reaching figures at a time, confining the figure to the suffocating black box of the television. Restless yearning characterizes the choreography. The images suggest a body bouncing off an unseen trampoline or crouching like a seagull on an ocean rock. The dancer is also reflected in rippling water which breaks the human figure into shimmering horizontal striations. Lucier and Streb focus, with brilliant success, on the most suspenseful and suspension-filled moments of dance, when the dancer does indeed seem, for a split second, almost able to fly.

*Waterproof* features a whole slew of dancers in and around a swimming pool, looking somewhat inhuman in their little black goggles. Larrieu's delectable choreography has them float through backward rolls and do splits while standing on their heads. *Waterproof* is no mere diversion, though. Some of the splashing hints at baptism, and some of the solemn floating suggests corpses on a sacred river. Larrieu capitalizes, with great imagination, on the way water slows and softens human movement.

Nearly three hours of other video dances—by Merce Cunningham and Nam June Paik, Hans van Manen and Henk van Dijk, Anne Teresa de Keersmaeker and Marie Andre, Trisha Brown and Peter Campus, Karole Armitage and Charles Atlas, and Charles Moulton and John Sanborn—come before the water dances in this mega-program.

## Mary Lucier and Elizabeth Streb

## *MASS* (1990)

Video, Mary Lucier

Choreography, Elizabeth Streb

*MASS* is an installation featuring three synchronized video images projected vertically onto the rectangular faces of three freestanding, slanted screens arranged at angles to one another in the exhibition space, with accompanying three-channel sound. Each screen measures approximately six feet across by nine feet high, rising off the floor at about a seventy-degree angle, with loudspeakers embedded behind the projection surface. The video images—most of which have been shot from overhead with the camera on its side—are beamed from projectors mounted on the ceiling and aimed downward in a vertical orientation.

The videodiscs depict the interaction of individual and aggregate entities engaged in a struggle of force and resistance. Objects and bodies track vigorously up and down and across the three ramps with the dynamic of a group acting as one organism. They collide, explode, push, leap, fall, and rebound in anonymous space and engage in confrontation with the urban environment. As energy shifts back and forth between representations of the individual and the social, the choreographed and the random, the figure of a lone dancer crouched on a rock against the city skyline gathers recognition as an emblem of endurance. This figure, like the artist in society, bridges inhospitable worlds and forges her survival "between a rock and a hard place."

September 25, 1990

## MASS
### between a rock and a hard place (1990)

A single-channel videotape derived from the installation. It was produced by *Alive from Off Center* and first aired on PBS, August 30, 1990.

**Tom Whiteside**

## Momentum, Balance, and the Violence of Gravity:

## *MASS,* by Mary Lucier and Elizabeth Streb

The first image in *MASS* is a lone figure, a dancer, up on her feet but otherwise round, knees drawn toward chin, arms wrapped completely around legs, atop a large graffiti-scarred rock. The New York skyline is in the background, vague city sounds quietly present. This figure is protecting herself, balancing on something solid. She seems to have the shape and structural strength of an egg, contained and protected from the world outside. A slow zoom in focuses attention on this individual.

The image is as we expect it, a squarish rectangle resting on its long side. For a century the motion picture frame has been the primary home of movement in visual art. Activity in this frame, camera movement through this frame, and the implied completion of action outside of this frame (offscreen) is familiar. It is, by and large, the way we experience our world. We understand that frame, we are comfortable with the world it depicts.

Forget comfort. Don't trust your protective pose, nor consider your balance to be infallible. That egg is not the boulder, even though they look alike. A boulder's protection is molecular toughness and density, challenged only by the rains and winds of eons. The temporal scale of such deterioration is impossible for us to fully comprehend. We are more like the egg—organic, liquid, messy, susceptible to disease, contamination, and rapid decay. Humans can take the self-protective pose, balancing on our limbs and living by our wits, but we have no shell. Until the solitude of that final mortal act we must each live as part of the larger mass of life. It is not easy. There are reports, some centuries

Originally published in Tom Whiteside, ed., *MASS.* Catalogue (Raleigh, N.C.: City Gallery of Contemporary Art, 1991).

old, which inform us that it was no easier in earlier times. These reports—call them works of art—are in widely varied forms, but all were made by those who have been human enough to examine and explore this fragile position on earth and in society.

*MASS* is a three-channel video and sound installation by Mary Lucier and Elizabeth Streb. Three synchronized images, from laserdiscs, are projected onto freestanding six-by-eight-foot screens arranged in a slight arc within a large dark space. The images are vertical, projected from overhead. The camera was turned on its side while shooting, as are the projectors in exhibition. Each screen has a separate soundtrack, and that sound emerges from the screen itself; the source of each sound, in space, is specific. The space around the screens is dark and undefined. Each one hovers a few inches off the floor. As the two outside screens face slightly inward and all three screens are tilted backwards at a seventy-degree angle, there is no single picture plane. The screens float, their projected light reflecting off in invisible intersecting lines which create numerous vertices in the viewing space. Combined with the directional sound, it creates a moving image that energizes the entire room. There is a visceral sensation of being inside the space of the image. You cannot place yourself at any one point that is absolutely perpendicular to the image; you cannot precisely position yourself outside of the picture.

The external structure of *MASS* is the sculptural placement of screens, speakers, projectors, and connecting cables. It is an installation and the entire room is the work. The internal structure, which is the part of *MASS* that will always remain the same no matter where it is installed, is the synchronized temporal relationship of the three images and their attendant sound. The external structure is the skeletal system, the hard fixtures to which the muscle and sinew attach. It has been manufactured; it can be shipped; it has weight, bulk, and surface. The internal structure is ephemeral; it cannot be touched. It exists only in the presentation of projected light. There are no real physical attributes, only the precise but dimensionless measure and meter of time, the ever-changing frame of time through which we live and move.

*MASS* is eleven minutes long. The first shot, described above, lasts just less than one minute. It is framed in the optical center of the middle screen, a small insert rectangle that behaves as a motion picture should. It rests.

After that shot quietly fades out, sonic and pictorial action and texture break out and break up over the three vertical frames. First left,

then right, then center, dancers' bodies slam into clumps and clusters, and the quiet comfortable existence of the individual at home in the familiar world is gone. (As with the first figure, clothes identify these people as dancers, performing artists at work.) Repose and balance are replaced by violence and crowding, and the camera placement is unconventional for dance, a closeup. Any comfort of seeing this action from afar has been denied.

From above, the camera has tightly framed a central meeting point of the dancers, and they rush in from all directions. Each comes to this point with considerable momentum. When these momenta meet there is the sound of bodies thudding, and the figures bounce and rebalance in reaction to the collision. They are not billiard balls, clicking and veering off on courses of geometric precision, but instead are human bodies, able to absorb some shock but still showing signs of impact and recoil. The performers respond with guttural noises. Their nonverbal sounds, made into music, articulate and punctuate their actions.

These clusters of dancers are replaced by heavy static images from the urban landscape. These images push down from the top in hard-edged full frames, shoving the dancers off the bottoms of the screens. The right screen changes first. A modern high-rise building shot from a low angle, it arrives with the metallic screeching sound of city traffic. The left screen follows with an image of St. Patrick's Cathedral, also shot from a low angle. The center screen then comes in with an image which is at first difficult to decipher. It is a large cross, or a plus sign, industrial in appearance but tightly cropped and devoid of context. For a moment the installation reads like a rebus of some socio-mathematical formula: Church plus Business equals . . . The moment soon passes as people appear in the foregrounds of the left and right screens, walking in front of the buildings. We are in the city. The central image zooms out to reveal that the cross is actually formed by the center pole and two extending arms of a light stanchion in the median of a busy city highway. Cars are in motion on either side of the stanchion, and what was at first glance a static symbol becomes merely one small detail in a scene of constant kinetic energy.

These shots, and the very first image, are the only ones in *MASS* that have conventional photographic context. The backgrounds can be read. The images provide enough information for the viewer to construct a mental picture of the scene before the camera. This is in sharp contrast to the dance scenes, which take place in performance space, enough space to frame the figure but with no clues as to any other qual-

ities of that space. The background is often simply light or dark in turn, and this figure-to-frame relationship is an interesting aspect of this piece. Usually we can determine the relationship of camera to ground. Is it a high-angle or a low-angle shot? Where is the horizon? The camera can be tilted up or tilted down but we expect the subsequent presentation to be perpendicular to the floor. We expect pictorial space, although it is understood to be a weightless abstraction, to follow the laws of gravity. But with the screens tilted back at seventy degrees, gravity cuts through the pictorial space in a disorienting fashion. Camera placement is often above, like that of the projectors, and the dancers are seen from an angle that highlights the group, not the individual.

The urban scenes are pushed off the screens from right to left by dancers bouncing and bumping large brightly colored rubber balls. Torsos and hips are used, not limbs, and the candy-colored balls and their funny boinging sounds provide the instance of greatest levity of the entire eleven-minute cycle. It is not a game, but it is playful. One unattended ball even rolls back into the right frame as the right-to-left sweep continues, as if to say, "I'm playing by my own rules, I can go wherever I want."

After more leaps and kinetic body clusters reminiscent of slam dancing, the balls are seen again without their human companions in a simple sequence that greatly advances the scope and meaning of *MASS*. They appear suspended in black space, stationary but quivering slightly. The frames do not completely contain every sphere, and attention is drawn to the edges of the frames. Given such elemental shapes—curved lines of spheres, straight lines of frames—it becomes necessary to mentally complete the spherical forms in the space between the screens. If read as flat, there is not enough space between the screens, but the space between these frames is not flat—there is undefined space, and undefined time, resting in each dark gap between the frames, and indeed in the vast space of the universe. In some fashion, this moment of quivering repose makes one aware of the static/kinetic tension not only of the moving image but of one's own life. The planet beneath our feet feels solid and static, but we are all spinning around an axis and hurtling through space along the line of an orbit. These speeds are not on human scale. We can perhaps imagine them in our brain, but not with any other muscle in our body.

With these balls hovering, it seems that we are inside a static model of molecular structure, and although it is certain that these balls are

large (scale has already been established) and that they occupy real space, the shot looks as if it might be a miniature, perhaps computer generated. There isn't much time to study this, however, as suddenly the balls are flying through space at the camera. It is bombardment, and the immediate reaction is to take a defensive position.

Suddenly, against solid red fields dancers jump in the frame from above. They land on an indistinct surface, then spring forward towards the camera, falling out of the frame into that most unusual offscreen space, the space in front of the screen. These leaps are certainly not balletic, they are more like long jumps or triple jumps. Counterpoint develops between the three screens as pace and order change. The camera placement creates a curious foreshortening of the image, and the figures appear to be both hovering and falling. The framing is very tight and the emphasis is on torsos, limbs, and feet. Muscles of the feet power this movement.

The leaping is done individually, but much of the dance is collective. A circle is seen from outside, the dancers interlocking arms over shoulders and circling clockwise on the screen. Again the movement is athletic; the configuration of bodies evokes wrestling and rugby as well as circle dancing. Each camera is static, and the movement across the three screens is an eggbeater of synchronous overlapping. Counterpoint is introduced to this temporal triptych when horizontal inset screens appear. These images were shot from inside the ring of figures at eye level. Movement in these insets is left-to-right, more linear than the interlocking circular flow of movement in the surrounding vertical images. The kinetic energy on the screens at this time is highly complex, and for the first time faces are important. No longer seen merely as bodies in unitards, the dancers can be identified as individuals. Eyes, hair, and mouths are windows to the soul; faces are the portals of personality. As the background images fade to black, the inset faces continue their slow-motion circling, followed soon by a sequential fade to white of the entire left, center, and right screens.

Three white screens are accompanied by an eerie, breathy sound. The sound is musical and has pitch, and as it works its way up in a progression blurred bodies fly through the space. The edges of the silhouettes are burned by the hot white background. There is no floor, no horizon, only the direction of velocity of the freely falling (rising?) figures. Like the previous sequence of insets shot from within the ring dance, this free-fall sequence has lovely patterning. Figures fly from left to right, moving across each screen individually and through the space

between screens as well. With accompaniment from a subtle downward turn in the musical progression, the bodies also begin to fall down, with more emphasis on down (remember gravity?), but there is no sense of landing, only continuous movement through space.

The final image of the piece is of weightlessness. Returning again to the exact form and location of the opening image—the single horizontal rectangle in the center of the middle screen—silvery bodies, well modulated in blue light, swim and float in an indistinct medium. The inset screen is small and very crowded but the space is indefinite. We might be looking through a tiny window at astronauts in a space capsule, for where else have we seen such movement of bodies? What do we know, on a muscular level, other than the gravity present on Earth's surface?

The solitary figure perched on a rock in the opening shot of *MASS* is Elizabeth Streb. It is the only time she appears on screen. Streb choreographed the movements that are at the core of *MASS* in an earlier performance called *Mass Dance*. Together, Streb and Mary Lucier created *MASS* not as documentation of that performance but as an entirely new work utilizing elements of the performance as raw material.

In two previous video installations—*Ohio at Giverny* and *Wilderness* —Lucier's use of images only implies human presence, and the figure is mostly absent. Those works with their reference to painting (Monet and the Hudson River School, respectively) were designed for exhibition on banks of video monitors. In *MASS* the size of the projected images allows the human figure to be presented in human body scale, or something larger than human scale.

Lucier is always in the narrative mode but her work is not storytelling, as formal concerns are foremost. She uses metaphorically weighted images boldly—the buildings which screech in from the top of the frame in *MASS,* the earthmoving truck that cuts into the placid mountain terrain in *Wilderness.* (Like a square-nosed heavy metal pit bull, it wipes out from the center to completely fill the frame.) There is no irony to these shots and their meanings are clear: cities can be oppressive to people; industry obliterates the pristine landscape. But rather than use these points to build an argument in journalistic style, Lucier uses them as hooks, places to hang your meaning. Her streamlined narratives allow room for different interpretations.

Sounds made by the performers, such as breathing, running, and jumping, were recorded during performance and later processed by

Lucier and her longtime collaborator Earl Howard. It is a unique method of production. Lucier brings in raw sound recorded in the field and explains to Howard, who is blind, what textures and qualities of sound she is seeking. She describes the images and he responds by re-working the sound to create mood and atmosphere. Lucier then takes this second generation of sound material to the edit room and creates the final audio track in sync with the images during post production. No score is written. The sound is recorded, enhanced, and created anew, then edited into the video master.

In their respective fields, Lucier and Streb are formalists both precise and poetic. The form of *MASS* has a cool aura of refinement. There is no soft spot and no rough corner. All is sleek and elegant, serving up muscle grunts and body slams with a fine polish. The video hardware is unobtrusive, practically unnoticeable. The screens have a thin profile that includes the speakers. There is no bulk or box behind the images. A video monitor has the weight and even the heat of the tube behind the image, but a projected image is as cool as starlight. An eleven-minute piece exhibited as a continuous installation, the interval between cycles is only a few seconds. Very cleanly, with no noise or glitch, *MASS* starts again. I remember waiting for the tapes to rewind "in between" screenings of *Ohio at Giverny,* and the countdowns and pauses as the two channels synchronized. It was a considerable distraction in an otherwise elegant and beautiful work, a rough edge that caused me to question my own persnickety desire for unsullied effi-ciency. Such perfection has been achieved here, in the switch from ana-log (videotape) to digital (laserdisc) technology. Just as the painter's touch is the eye's direct connection to the creative force behind the pig-ment, so it is with the control of temporal and electronic elements in an installation of moving images.

When motion picture technology was first developed a century ago it allowed for a major change in visual art and human sensibility: the visible record of the manipulation of time. In 1895 a Lumière cine-matographe operator in Lyons reversed his cranking motion of the pro-jector and the one-shot film *Demolition of a Wall* ran backwards. A tumbled wall of heavy masonry rose from the ground as workers looked on. Bricks and stones came up from chaos on the ground and neatly reassembled in the orderly configuration of a wall. These objects defied gravity. As the wall came together it gathered an impressive cloud of dust, causing it to disappear in a split second. Time became a malleable element in the visual arts, and we began to see the world diff-

erently. As the cinematographe (and numerous other machines) traveled the globe, taking and giving pictures, the projected motion picture frame became a window unlike any which had ever been seen, or even imagined. The horizontal and vertical boundaries were familiar, of course, right angles chopping into space. (It was the canvas stretcher that originally put corners on our pictures; photography followed suit despite the fact that lenses create circular images.) The revolutionary development was the unprecedented ability to re-create a record of movement and action—in time, within the temporal boundaries. This has caused cinema to become our main frame of reference. The mid-century introduction of television served only to strengthen the dominance of this rectangular shape, this form that "plays back" time by making it part of everyday life in the industrialized world.

We are now at the end of the century and we face a constantly accelerating pace of change in motion picture technology, but the basic single rectangular frame has remained the same. *MASS* breaks the mold and carves abstract ideas of space, weight, rhythm, and balance out of the background of modern life, performance, and technology. Using familiar elements in this singularly unfamiliar frame of the gapped vertical triptych, *MASS* challenges all preconceptions based on viewing cinema and television. It casts us forward into the future, but it is hard to tell if we are falling or rising. Can we really live anywhere in space other than on this Earth? If we do, how will we move? Will we bounce when we run into others? From the microscopic to the astronomical, all scales other than the human scale are difficult to imagine. Even as we spin and hurl through space, *MASS* helps us to more accurately map our position on Earth and in society.

# III Installations, Sculptures, and Environments

**Mary Lucier**

*Salt* **(1971)**

Middletown, Conn.

January 31, 1972

Dear Vaughan Kaprow,
The following brief statement should answer your questions about *Salt* and help elucidate the slides. Enclosed is another picture taken by Stuart Marshall while setting up the day before the show to give a better idea of the nature of the cloth and of scale.

*Salt* is a landscape that resulted from superimposing two different images/ideas that would normally be separated by either time or geography. I was interested in combining the open spaces and far-reaching vistas of Wyoming and Utah with the private and discrete sense of space in the Connecticut Valley. I chose to use certain prosaic materials to alter a preexisting landscape diagrammatically in order to make the piece abstract and at the same time real. It became a horizontal environment that could be looked at from a distance, walked through, and seen from an aerial view. The materials used were 2,000 feet of snow fencing, 10,000 square feet of tobacco cloth, 150 pounds of marble chips, and a gently rolling field bounded by foliage. The fences were placed across the field in seven rambling but roughly parallel (to one another) rows in such a way that to get from one end to another people had to traverse the field right to left and left to right six times. The final row completely enclosed a sea of tobacco cloth some 30–60 by 200 feet which was inaccessible to people. Three pyramids of white marble chips served as cairns to mark the walking route and, in some cases, to invoke the farthest boundaries of the field where a fence did

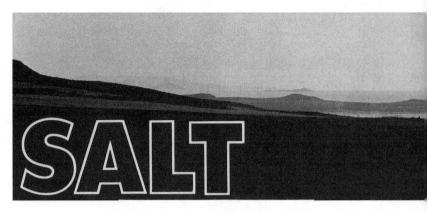

Invitation for *Salt* (1971). Photo by Mary Lucier

not reach. Many people attempted to taste the marble chips. On two sides of the field were loudspeakers through which Alvin Lucier repetitively played Western American bird songs. All elements present were considered significant and a part of the sculpture; or insignificant and a part of the sculpture: the early morning fog, blazing afternoon sun, the shapes of trees, and the tire tracks that resulted from driving our bus through the area while setting up. This was an attempt to collaborate with, rather than impose upon, the natural environment. Care was taken not to cause lasting damage in or around the field, and all man-made materials were eventually removed.

Mary Lucier

**William E. Collins**

## "Realsculpture" at St. Clements

"Indian summer," we are told, is the revival of mild weather following a frost, an unseasonable respite of warmth when we thought that all was lost.

But we cannot rightly use the term this fall or revel in its moods, according to the *Times,* because we have yet to experience a frost. Without a prior vision of last things, how can we be thankful for a final flicker of life?

These thoughts occupied us as we traveled along Route 66 in Portland to the St. Clements Estate. Our sleeves were rolled up and the windows were rolled down. It was hot, and the unmistakenly fall-like display of color along the river could not persuade us that we soon would be shoveling snow.

We were going to St. Clements to view a "realsculpture" by Mary Lucier, a sculptor who lives in Middletown.

A "realsculpture," she told us, is "a large-scale environment sculpture suited to the place where it is built." We had asked whether it was like the pictures we had seen in *Time* magazine, of mile-long colored lines criss-crossing in the desert.

"Something like that," she had said.

Her sculpture was "a landscape especially designed for a large, gently rolling field bounded by foliage. It is intended to be looked at from a distance, walked through and seen from an aerial view."

Wondering how we could get an aerial view, we turned into the driveway of the Estate. To the right in what was clearly a "gently rolling

Originally published in the *Middletown (Conn.) Press,* November 5, 1971; slightly abridged.

field" we saw meandering lines of picket fence—the kind that keeps walkers off the grass in spring—and heard amplified bird noises . . .

We heard a deep voice boom across the field: "Page 27 to page 29 . . . Prairie chicken . . . " We heard what we presumed was a prairie chicken, squawking with unseemly volume into the gentle afternoon.

The voice returned: "Trumpeter swan," it said. We approached the field and saw to our left a table on which were laid jugs of wine and cider, apples in a basket, and walnuts in a bowl . . .

The field was an open rectangular space surrounded by heavy woods on all sides. Unbroken lines of snow fence were stretched at regular intervals along the field. At the base of three large evergreen trees was a neat half-circle of white tobacco cloth. Small pyramid piles of white marble chips were placed at random spots in the field.

We saw Mary Lucier . . . We introduced ourselves (as the deep voice over the speaker was announcing the American bald eagle) and asked her what we were to do.

She said we were to walk through the field, to "become familiar" with the natural and man-made environment. As we started to experience, she told us that she had used two thousand feet of snow fence and ten thousand square feet of tobacco cloth.

How was the man-made aspect supposed to fit into the natural aspect? we asked. The snow fence and tobacco cloth, she said, were intended "to evoke the qualities of the field." She emphasized the natural character of her sculpture.

The sound of a western skua screeched from the speaker. Surely that wasn't "natural," we said. Mrs. Lucier disagreed: "I think that electronic sound is as natural as anything else," she said.

The choice of sound for the realsculpture was made by the artist's husband, Alvin Lucier, who is a professor of music at Wesleyan. He said that the recording was titled *Western Birds,* and had come from the Cornell Ornithological Library.

Mr. Lucier said that studies had been made of the effect of recorded animal sounds on real animals, and that for the most part they were indifferent to the noise. Mrs. Lucier said that from an artistic standpoint the recorded sound was an "addition" rather than an "imposition." . . .

How had she chosen the components? we asked.

She said that she had been so "shocked" by the sight of tobacco cloth as seen from the highway above Hartford that she decided to use it in her sculpture. She had been impressed by the sight of the cloth, she said, because it relieved the flow of dreary landscape along the highway.

We remarked that she certainly had used her materials sparingly—given the size of the field.

Mrs. Lucier said that she intended her sculpture to be "minimal" and that she liked to think of it as "prosaic" and "mundane."

"I don't like monuments but I do like sculpture," she said. Great hunks of marble did not appeal to her as much as the subtle use of everyday materials.

She pointed out that *Salt* changed in different weather and during different times of the day. In the morning, when she had set up *Salt,* a heavy fog remained on the field, she said. Now the sky was cloudless and the sun was etching sharp shadows.

As the day progressed, she added, the sun cast different shadows. The wind also twisted the line of fence from time to time. There was thus a certain amount of randomness in her sculpture, although she said that it was not her aim to celebrate randomness. . . .

We sat down on the grass. It was now very warm and the lines of fences somehow reminded us of cows grazing in a field. We got up and walked to the refreshment table, took an apple from its basket, and then walked to the car. We drove off munching our apple.

**Mary Lucier**

*Air Writing* **(1975)**

A three-channel continuous videotape installation

The camera inscribes upon the landscape like a pen; the land-scape in turn inscribes upon the vidicon tube, and the resulting tapes are the documents which contain the calligraphy. The writer writes in air with the portable camera using pauses, selective focus, and editing for punctuation. The writer may decide to enunciate certain spellings as she writes. The audio, as recorded by the camera's built-in micro-phone, is a mix of environmental sound, the amplified creaking of the camera grip and switch, and whatever utterances the performer makes. Theoretically the tapes are decipherable as script.

October 1975

. . . . .

From 1973 to early 1975 I experimented with a form of journal keeping entirely inspired by the video portapack. It was a period of great change in both my personal and aesthetic lives: my marriage was ending as I was turning thirty; my work as a sculptor and photographer no longer seemed to have the vocabulary or the gesture or the freshness that I de-sired, and I had begun to incorporate elements of video into perfor-mance pieces and installations. Taking my black-and-white Sony porta-pack on a trip to California, I recall spending a great deal of time alone, thinking, in unfamiliar rooms. The solitary impulse to write sur-faced but was subverted, I am sure, by the presence of the camera. I eventually arrived at the idea of writing with the camera itself as the pen, and so I began the peripatetic series of tapes that were to become the three-channel installation called *Air Writing*.

Each day I would travel by car to a different location—the Oakland Airport, the Berkeley Hills, bank and supermarket parking lots—where

I would perform my journal entries and letters to friends by "writing in air" with the camera across the given landscape. On other occasions rooms, corridors, and windows animated my writings. The subsequent tapes and their calligraphy—accumulated over several years in both California and New York—were edited into their final three-channel version for an exhibition at the Kitchen in October of 1975.

Unlike my recent multichannel work, these three tapes do not bear a precise temporal relationship to one another. They are loosely structured, chronological juxtapositions of place and mood, presented much as they were originally "written"—a short, descriptive journal entry next to a long, rambling letter, next to a ruminative chapter.

February 1985

**Mary Lucier**

*Dawn Burn* **(1975–1976)**

(A multichannel work for seven horizontally aligned video monitors with single 35 mm color projection.) This piece consists of seven days' cumulative taping during July 1975, of thirty minutes of the sun rising over the East River in New York City. Each sunrise is burned onto the vidicon tube according to the variations in the sun's actual path each morning; the camera remains in a stationary position throughout the seven days' taping, and at the same focal point, except for a search-and-register process during the first five minutes of each tape following day one. In playback, all days' dawns are viewed simultaneously but separately on each of the seven monitors, each day containing the accumulated burn of those before it. A wide-angle color image from the same location is projected large behind the line of monitors. There is no audio.

New York, July 1975

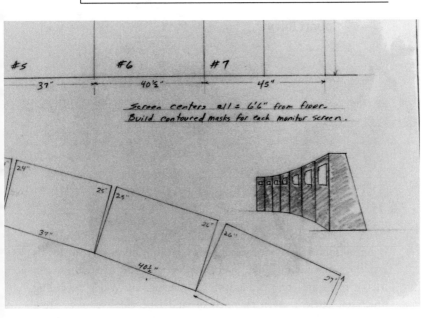

Detail from blueprint for reconstruction of *Dawn Burn* (1975–76),
November 2, 1993. Photo by Mary Lucier

**Robert Riley**

*"Dawn Burn"*

Taking its form as a dolmenlike structure, *Dawn Burn* (1975) is a groundbreaking video installation that introduced new materials into the sculptural medium: the size and shape of the television screen itself, "real-time" or unedited video imagery, and video recording processes. Lucier's seven channels of landscape video imagery are a record of a sequence of seven sunrises over New York's East River. While Lucier videotaped the sun's gradual elevation, aligning the actual horizon with the bottom edge of the television frame, the sun's luminosity burned a spot in the picture tube as it reached its level of tolerance. This left the picture tube, and the videotapes made with it, indelibly scarred, and Lucier embraced the flaw for its lyricism and documentary quality. As the sun rose, it etched its path in the tube: the burn became a line that measured time, extending the expressive gesture of drawing, painting, and sculpture into the technology of video, and distancing the creative act from the human hand.

*Dawn Burn* prefigures artists' projects in video and photography from the late 1970s and 1980s that look upon the natural environment with grave concern. Lucier's placement of seven monitors that increase in size from left to right—and each marked with an additional burn from the preceding day—echoes the efflorescence of sunrise light. Ephemeral and monumental, *Dawn Burn* employs the symbolic nature of video to simultaneously explore themes of illumination, time, decay, and renewal.

*Dawn Burn* is the first video installation in the San Francisco Museum of Modern Art's media arts collection to undergo conservation.

Originally published in *The Making of a Modern Museum* (San Francisco: San Francisco Museum of Modern Art, 1994), 110.

The artist's original video material and sculptural plan—seven one-half-inch, open-reel videotapes, plinths, and television monitors—are now obsolete. Twenty years old, the videotape was subject to decay and irreparable loss. New conservation practices made it possible to digitally restore the original video image and transfer the signal to new archival video material for its protection and long-term presentation.

## Mary Lucier

### *Paris Dawn Burn* (1977)

For seven channels of black-and-white video, with single color slide projection

This work was recorded on location for the Tenth Paris Bien-nale from the fifth-floor balcony of the Cité des Arts, Paris, between August 31 and September 10, 1977. It consists of seven thirty-minute videotape recordings of sunrise displayed on seven monitors of ascend-ing sizes arranged in an arc. Each tape (each day) begins with a shot of the Centre Pompidou in the distance to the northwest, followed by a slow pan to the east, where the sun is seen rising over the dome of St. Paul's (le Marais). The camera was placed in the same position each day; there is a gradual day-to-day telephoto zoom, prior to taping on days two through seven, from the original scene—a corner of the city—to the final closeup shot of the dome of the church. As the sun rises it burns a black mark on the surface of the camera's vidicon tube, so that by the last day there are seven burn tracks on the tube representing the cumulative positions of the sun during all of the days' tapings. (Burn paths from days two and three virtually overlap.) The spaces between the burn paths are a combination of the gradual telephoto increment and the natural motion of the earth in relation to the sun. A color slide, taken at the same hour from the same location, is projected in a "key-stone" fashion against the rear wall and somewhat above the curving line of monitors.

May 1978

**Richard Lorber**

## Mary Lucier, the Kitchen

Climatic changes in the artistic and economic environments have had notable impact on the development of video art. A number of galleries have abandoned what they found to be the unprofitable practice of trying to sell or distribute artists' videotapes (they never had the commodity appeal of unique art objects or even photographs). At the same time, nonprofit arts organizations have become aggressively involved in cablecasting artists' video, advancing collaborative approaches to the medium and a higher awareness among artists of its social functions. The few museum showcases for video, such as the Whitney and the Museum of Modern Art, have also begun exhibiting a greater number of issue-oriented video documentaries by artists or about the art world.

Much of the video medium's modernist "self-criticism from within" championed by early video art experimentalists has yielded to a more "outer" and literal social criticism—video critiques of the "media environment." Fewer artists today seem interested in perceptual explorations of the unique technical features of the medium, while more have taken to parodying the content of, or providing serious programming alternatives to, commercial TV. Economics and social consciousness notwithstanding, in the evolution of its adversary position artists' video has come much closer to becoming artistic television.

Against this backdrop the original visions of only a handful of the earliest video experimentalists have survived and matured. For these it seems that the "systems esthetic" of the video installation has become the most fertile ground for participation in the "tradition" of advanced

Originally published in *Artforum* (September 1978): 81.

painting, sculpture, and intermedia forms. A recent video installation by Mary Lucier at the Kitchen stands out as a paradigm of this genre.

*Paris Dawn Burn* was a marvel of concision, astutely exploiting the latent properties of the video medium to generate manifest imagery with powerful symbolic resonance. The work serially presented seven recordings of the sun rising over a church dome. Each black-and-white tape was played in overlapping sequence on one of seven monitors of increasing size, placed on platforms arranged in a wide arc. A color slide of the scene of the sunrise was projected behind the monitors; it did, like the audio track of morning sounds, heighten the real-time verisimilitude of the work. Lucier's signature as a video artist is the burning of the camera's vidicon tube—its light-sensitive "eye"—and the recording of it as an image on the tape. Here, when played back, that intense ball of sunlight seemed to scar the inner surface of the screen. Literally tracing the sun's ascent, each scar also marked its shift of position from the previous day, since the use of the same camera for each of the seven tapings allowed the previous day's burns to register accumulatively on each successive screen.

*Laserings,* Lucier's other installation at the Kitchen, involved the burning of the vidicon tube in real-time. A helium laser gun suspended from the ceiling aimed a beam directly at the eye of a suspended live camera. A live monitor displayed erratic burn spots and optical diffractions as the free-swinging laser and camera shifted positions owing to natural vibrations in the room.

*Laserings,* however, seemed rather more of a technical exercise or formal study, compared with the synergism of form and content in *Paris Dawn Burn.* The initial monitor image of a sedate predawn cityscape served as a picturesque foil for the calculated mutilation of the mechanism of this illusion. "Sacrifice" of the video camera (a damaged vidicon tube must be replaced at considerable cost) is the factual outcome of the artistic, ritualized witnessing of sunrise over church.

If this is "antivideo," it is far less polemical than, say, the work of Douglas Davis. Lucier stages her media martyrdoms as a mode of distancing the viewer from the illusionism of video, seeking to objectify its automatic mediation of perception. Her burning of the video "eye" (anthropomorphically identified in the viewing act) is a surrogate for the "masochism" of such artists as Chris Burden, Vito Acconci, and Herman Nitsch, who have contrived to depersonalize and objectify their own bodies through actual or simulated self-abuse. Shock attrac-

tion, however, is not Lucier's methodology. The uniqueness of her conception lies in its formally redeeming virtues. She considers the burn markings "a kind of calligraphy." Indeed, the video scars of *Paris Dawn Burn* were a most elegantly executed epitaph.

## Mary Lucier

### *Laser Burning Video* (1977)

### *Untitled Display System* (1977/1997)

### *Bird's Eye* (1978)

*[Note: Beginning in 1975–76 with the performance of* Fire Writing *and the video installation* Dawn Burn, *Mary Lucier began a sustained investigation of the phenomenon of vidicon burn, described below. Over the next six years she made eleven works which included burn imagery. This score is a composite Lucier created recently to describe the installations* Laser Burning Video *and* Untitled Display System, *both of which examined the process of burn. Because burn was also used to create the single-channel tape* Bird's Eye, *as Arthur Tsuchiya makes clear in his review of the work (reprinted on p. 109), the title of that work is also listed above.]*

#### Laser Burning Video

A display system for burned vidicon tubes, videotape, and live laser

#### Burn

To produce a video image, light is focused through a lens onto a photosensitive target, i.e., the surface of the camera's vidicon tube. That target surface consists of many tiny dots which change their resistance with the amount of light that strikes them. When an intense light such as that from the sun or a laser is focused directly on the tube, the surface of the vidicon is "shorted out" and the photosensitive material becomes permanently altered. The burn markings that result become a kind of calligraphy describing movement of a source of light, or of the camera in relation to the light, in time and space. The tube remains a displayable artifact of that process.

### The Live Laser

A helium neon laser and a video camera are suspended from the ceiling, free-swinging and facing each other at a distance of approximately fifteen feet. When at rest, the laser is aimed directly into the camera's lens, striking the vidicon tube inside the camera. As the suspended objects move due to natural vibration and air currents, the laser beam sweeps back and forth across the surface of the tube, creating constantly changing optical diffraction and interference patterns; at the same time the intensity of the laser light causes burn tracks to accumulate which describe the path of the laser's motion throughout the duration of the exhibition. These phenomena are visible live on a closed-circuit monitor.

### The Tube Artifacts

As many as four sculptural units display a collection of vidicon tubes which have been previously burned during performances of *Fire Writing* or during other laser/video installations. Each tube is reinserted into a camera, which is then viewed live on a monitor. The lens openings are blocked to prevent ambient light from affecting the image. Each tube bears its own distinctive calligraphy of luminous white markings with layers of gray and black lines. The images are permanent and static, although when seen on a large monitor screen there is an impression of fluid movement on the raster itself.

### The Videotape

A monitor displays the videotape of a tube being burned during a performance of *Fire Writing* at the Kitchen, October 1975.

November 1977

### *Untitled Display System*

A series of equipment clusters or sculptural units designed to hold cameras bearing burned tubes and monitors on which to display their markings. These video "drawings" were produced by the use of lasers during performances of *Fire Writing,* which was an attempt to reproduce spoken text as script—words and sentences written in air with the camera in response to a prerecorded audible text.

The burn images can be seen with the camera lens caps in place, showing just the pure laser markings which persist on the surface of the camera tube. Or, they can be viewed with the lens caps removed, thus allowing ambient conditions of light, shadow, and movement within the exhibition space to modify the otherwise unchanging, permanent patterns.

January 1997; both revised August 1998

**Victor Ancona**

## Mary Lucier's Art: Light as Visual Image

Light, process, and natural phenomena became more and
more important to Mary Lucier until, when she went into video, light
actually became the subject of her tapes. She is still preoccupied with
the exploration of "flaws" or "failures" in materials and equipment. She
is challenged by video's narrow bandwidth for optimum perfor-
mance—from the low-contrast, unacceptable "snow" image to the de-
facing "burn" which has become her trademark.

Mary Lucier is fascinated by imagery that goes beyond the accept-
able. Not unlike Nam June Paik, she investigates the limits of the tech-
nology, stretches it as far as it will go, and awaits the results with antici-
pation. She acts as a "facilitator of a process," a term she uses to describe
herself.

"I was always interested in technology," she said. "What I was doing
in slide imagery was very similar to what I am doing now. I would take
a process and go into it as deeply as I could. My images always resulted
from my either exploiting the aberrations of the technology or doing
something quirky with the technology itself."

For years, Lucier's involvements included sculpture, black-and-white
still photography, literary concerns, music, and performance art before
she evolved into working with video as a throwback to her interest in
sculpture. Her wish to present video spatially is an endeavor in which
she succeeds admirably. "Time and the internal luminescence of light
in video, plus my sculptural and architectural concerns, are my deepest
interest at this time," Lucier told me. She is also concerned with the
3-D tactile quality of the video image.

Mary Lucier's chance meeting with video burn occurred when she

Originally published in *Videography* 4 (July 1979); abridged.

first used a video camera to tape a dance company outdoors. Looking through the viewfinder, she noticed what looked like a hair. Drawing on her knowledge of still photography, she cleaned both front and rear elements, but the "hair" remained. She hadn't realized that the burn was caused by having pointed the camera at the sun. Certain weak burns tend to erase themselves in time, but Mary accelerated the process by aiming the camera, with aperture at its widest, at a brightly lit white wall for two weeks. After that experience, video burns were indelibly etched on her mind!

In *Lasering,* Lucier suspends a helium neon laser and a video camera from the ceiling, each freewheeling and facing each other, the laser aimed directly into the lens, thus striking the vidicon tube inside the camera. As either laser or the camera or both move due to human intervention, air currents, or natural vibrations, burn marks describe the laser's motion on the vidicon tube and are visible on the monitor, creating electronically generated calligraphy produced in time and space.

"Why use a laser?" I asked. Lucier replied that she needed a light source that wasn't the sun. She finds that developed laser imagery could become synthetic beyond a certain point. "I liked what I've done because it was very natural, but beyond that, the manipulation—I don't know—I'm not sure what I'm going to do with lasers. I'm not interested in effect, I'm interested in process. Maybe the only laser piece I would ever make is the one I made."

## Arthur Tsuchiya

## *"Bird's Eye"*

Lucier has succeeded in making a refreshing, beautifully mysterious work. It is these qualities that make *Bird's Eye* special.

*Bird's Eye* begins with a simple pattern of white shapes upon a black background. The forms grow in size and intensity very slowly as the soundtrack comes up; high-pitched tones and birdlike chirping combine with the gradually transforming image to give the sense of dawn. The visual patterns are constantly changing, and the sounds, barely short of being shrill, seem to go through repeating progressions of just a few tones. The sound creates rhythms, while the visual patterns shift at irregular rates.

The presence, or perhaps the evidence, of the artist's hand is felt most strongly through these irregular movements. Although the frame is always stable, there is a hand-held quality to the tape which offsets the severe soundtrack and the more predictable and mechanical visual effects of zooming and moving moiré patterns. The presence of sound is nearly constant; and the one brief silence serves to support John Cage's contention that silence, too, is a positive musical element. The image sometimes evokes natural sights such as sunlit cobwebs, reflections off the surface of snow, or perhaps sunlight through a frosted windowpane. About halfway through the tape the picture returns to its original configuration, and then quickly moves on to a different progression of changes, with the pace increasing during the last third of the tape. At the end the image returns to the original, but with a black smudge added, a "burn" etched into the video tube by the intense light captured by the lens. Lucier is well known for her *Dawn Burn* works

Originally published in *Afterimage* 7 (November 1979): 5.

and her performance and tape involving a laser which make use of the black afterimage left on the video camera's tube.

Cycles recur in Lucier's work. The repeated sunrises in her *Dawn Burn* and *Equinox* pieces and the suggestion of dawn in *Bird's Eye* combine in this tape with a repeating sound pattern (which sounds like the ringing of a microphone in an audio feedback loop), the bird call and other natural references, the visual presentation of concentric circles, and the return to the initial image. In *Bird's Eye*, Lucier has woven a complex work from simple elements; the sounds and images form a tape that is musical in its control of temporal flow. The successful pairing of abstract imagery with electronic audio has evaded most artists. Lucier, without apparent effort, has accomplished the task while enlarging the scope of her work.

# Mary Lucier

## *Equinox / A Color Dawn Burn* (1979)

A Video Sculpture

This work incorporates seven separate fifty-five-minute video-tape recordings of sunrise, displayed chronologically from left to right on television screens of increasing sizes housed in a specially designed, freestanding steel and wood structure.

The tapes were recorded on seven mornings between March 9 and March 21, 1979 (the vernal equinox) from the thirty-first floor of Independence Plaza in Lower Manhattan, with a view encompassing a more than 180 degree panorama of the New York City skyline—from the Empire State Building in the north to the Statue of Liberty in the southwest. Each tape (i.e., each day) opens with a thirty-second still shot of Midtown, followed by a three-and-a-half-minute pan from north to south, down the East Side and across Lower Manhattan, which ends with a twenty-five-second pause at the harbor. After approximately a two-and-a-half-minute reverse pan, the camera comes to rest facing east. The Williamsburg Bridge is visible in most of the tapes.

Following the first day, each tape incorporates a fourteen-degree increment of telephoto lens zoom: day one was shot at 17 mm, day two at 31 mm, day three at 45 mm, day four at 59 mm, day six at 87 mm, day seven at 102 mm.

At this time of year the apparent progress of the sun across the horizon is from south to north. To compensate for this movement, each day the camera frame center was shifted several degrees to the left (north).

As the sun rose each day it burned a mark on the camera's internal recording tube. These burns appear on the tape as a series of dark

**111**

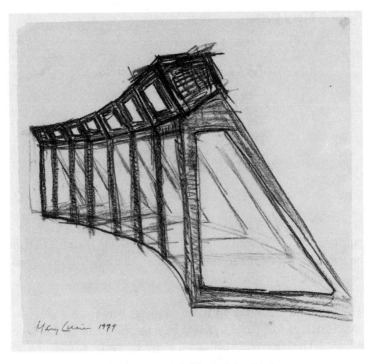

Sketch for *Equinox* (1979). Photo by Mary Lucier

greenish streaks or slashes in the sky trailing the exact path of the sun. Because of the day-by-day telephoto increment and the northward camera shift, the burn paths eventually begin to absorb one another. On the last day I abandoned the still camera frame technique in order to follow the sun, causing the burn signature to change and move in several stages across the frame and out of the upper right corner.

The complete cycle of the piece lasts about fifty-seven minutes, and is repeated every hour.

1979

**Grace Glueck**

## *"Equinox / A Color Dawn Burn"*

By way of celebrating spring's arrival, Mary Lucier, a former sculptor now involved with video, took her camera to the thirty-first floor of a downtown skyscraper early last month, and on each of seven days, ending on the vernal equinox, photographed for nearly an hour the sun rising over Manhattan. She began each session with a still of the Midtown area, then panned the Lower Manhattan skyline, finally bringing the camera to rest facing east. And each day she zoomed in closer to the sun, which cooperated by registering the exact track of its path on the videotape as a series of greenish streaks that grew progressively larger with each day's recording.

Now Miss Lucier has put all the tapes together in a multichannel video piece, accompanied by a soundtrack that captures the roar of wind mixed with the accelerating hum of the city. The tapes, shown simultaneously on seven overhead video monitors arranged in sequence and increasing in size from twelve to twenty-one inches, form a startlingly beautiful seven-day chronicle of—well, dawn over Manhattan. The colors, changing each day and from minute to minute, are simply marvelous, from the sullen grays and buffs of the dusk-wrapped buildings to the silver, peachy-orange hues with which the sun invades the nighttime sky. One thinks of Monet (as, in fact, Miss Lucier did) and his attempts to portray the effects of changing light on haystacks, bridges, Rouen Cathedral. All together, it's a lovely show and one that explores with imagination the potential of this tricky medium.

Originally published in the *New York Times,* April 13, 1979.

## Mary Lucier

### *Planet* (1980)

Planet is a video installation consisting of a single sixteen-minute color videotape displayed continuously on five television screens arranged in a sharp upward curve. Embedded in the center panel of a triptych wall, the monitors increase in sizes from twelve-inch to twenty-one-inch diagonals, each screen progressively rotated at a forty-five degree angle to the preceding one, from left to right along the arc.

The videotape was shot from the roof of the Hudson River Museum at varying times of day during the summer, fall, and winter, with the outer dome of the museum's planetarium as the central image. Changing light and atmosphere animate the surface and volume of this ambiguous sphere, which appears alternately as a distant, moonlike body, as domed architecture, and as gently curving horizon—always orienting the viewer in relation to the sun.

In short, rhythmic cuts, with light coming from the left, rear, or right of the camera, I have attempted to suggest the metaphoric "identity" of the object and to create a sense of motion in space. The longer passages shot directly into the sun over the dome are intended more to evoke the affective qualities of light and color. A kind of hieroglyphics connects these sections to one another through the calligraphy of white clouds in a blue sky, the "archaeological" markings on the dome surface, bare branches against winter clouds, hair blowing across the lens, and the burn marks that accumulate on the camera tube as it tracks the light, describing its inevitable encounter with the sun. The juxtaposition of "clean" and "scarred" views continues in counterpoint throughout.

Page from storyboard for *Planet* (1980). Photo by Mary Lucier

Light is used in this work not only to articulate shapes or colors, but also to irradiate them. In aiming the video camera at the sun, illumination becomes absorbed into the recorded image, almost as if the light were in the camera. By manipulation of camera and optics alone, I mean to explore visual reality as phenomena of charged color, lightness, and darkness.

September 25, 1980

## Martha Gever

## Mary Lucier's Elemental Investigations: *Planet*

Inside a video camera tube photons—light energy—are translated into electron movement—electrical energy. More precisely, this conversion takes place at the target, a microscopically thin layer of conductive material which allows electrons to pass through at a rate proportional to the amount of light focused by the lens on this surface. All camera-generated video signals are born at this point, but in the work of Mary Lucier this physical phenomenon assumes a central role. In *Dawn Burn* (1975), an early videotape installation, she recorded the sunrises of seven mornings during a one-month period. By pointing her camera directly at the sun, Lucier made visible a related characteristic of the video tube—the photoconductive layer can be permanently scarred if exposed to a powerful light source. Lucier thus inscribed on the vidicon tube a sequence of burns which marked the path of the sun's ascents. Since the camera position remained constant, she also recorded shifts in the location of the sun at dawn. The seven thirty-minute tapes were shown on a bank of seven monitors with the tapes playing simultaneously and ordered chronologically. In the installation *Lasering* (1977) and the tape *Bird's Eye* (1978), Lucier aimed a laser directly at the lens. The visual results were somewhat mysterious black-and-white abstractions which are, in fact, documentation of otherwise invisible electronic events.

Attention to large and small physical phenomena are again Lucier's themes in *Planet* (1980), a single-channel, five-monitor video installation. The monitors are arranged in an upward arc; they increase in size from twelve inches to twenty-one inches and each is rotated about forty-five degrees relative to the preceding one. Unlike the horizontal

Originally published in *Afterimage* 9 (February 1982): 8–9.

row of monitors and clearly consecutive tapes in *Dawn Burn* and *Paris Dawn Burn* (1977), which encouraged comparisons, the curve of monitors displaying the same tape creates an effect of amplification and patterning. When movement occurs, as it often does, the viewer experiences a continuous but slightly spinning motion. When the camera pirouettes, the five screens become a constellation of swirling color. Every change—an edit, a fade, a pan, or zoom—plays across the monitors and the rhythms of these modulations reverberate but never exactly repeat.

*Planet* was shot from the roof of the Hudson River Museum in Yonkers, N.Y. (the museum commissioned the installation), and the planetarium dome at the museum provides the central image for the work. Lucier has not left behind her fascination with the physical world, but she has decidedly moved away from conceptual coolness and scientific precision into a realm of subtle colors, rhythmic camera movement, and lyrical editing. This work consciously explores visual beauty, a concern evident in Lucier's earlier work but minimized in favor of positivist ends.

The initial shot shows a blue, blue sky marred by one brushstroke of a cirrus cloud; a quick zoom back and a slight pan bring into view the dome, dappled by the shadows of offscreen leaves. The play of light on this surface, its rounded shape, the sky and the wispy cloud could provide an outline of the motifs which comprise the tape's formal unities. The dome is a recurring icon although its character is protean: initially it suggests the moon with its valleys and craters; in closeup it becomes the ground, Earth; later, juxtaposed with the actual moon, it is a metaphor for the planet Earth. But like the celestial spheres it resembles, it can never radiate light; it is only a reflective body.

After Lucier establishes the dome's possible repertoire of cosmic roles, she introduces her other major character—the sun. As in her sunrise studies, she again explores the phenomenology of direct recording of solar energy. In this work, the dawn is staged, though, with the profile of the dome or the boundaries of the frame serving as the horizon. The sun first appears as a white hole which flares up on the edge of the five separate screens, and an intense whiteness, expanding like rapidly growing crystals, takes over the frame, obliterating all other imagery. In another shot the camera, moving up the white-gray dome, encounters the sun; the color of the concrete instantly shifts to a rich purple. Here Lucier investigates the automatic response of the camera's electronic circuitry to changes in the amount of light coming through

the lens. Elsewhere Lucier opens and closes the iris, creating solar coronae, and gently pans the camera to create nonagons (a characteristic geometric figure caused by a beam of light hitting a curved lens at an acute angle) made of light and subtle colors.

As the tape progresses, autumn changes to winter; blue sky is replaced by gray; tree branches are leafless. Sequences featuring the source of light—the sun—become longer, and increasingly the sun is placed in the center of the frame. Formally related shots of tree branches, the cirrus cloud, grasses, and (Lucier's) hair blowing in front of the lens are echoed by the dark trails blazed on the camera tube by the burning sun. Dematerialized images of brilliant light and variegated color take over; dazzling energy embraces and consumes matter.

Lucier has persistently constructed video installations which investigate the properties of light. But how did these evolve from fixed camera, "real-time" pieces into this highly edited, fluid tape and its corresponding installation? For me, the laser-burn experiments provide the explanation for the transition from intellectual, exterior-determined controlled experiments to metaphorical, interior-determined lyric drama. With her laser/video arrangements, Lucier set up a situation where the machinery actually decided the imagery; the audience, however, saw delicate, enigmatic, almost ethereal light tracings, not adequately interpreted in technological terms. In *Planet,* Lucier accepts that subjective mode of perception—the presence of her hand and eye as well as her mind is obvious. Both the atmospheric spectacle created by the carefully ordered sequence of images and the curvilinear effect of the monitors' placement express a romanticism either contradicted or only hinted at in her previous work.

# Mary Lucier

## *Denman's Col (Geometry)* (1981)

The purpose of architecture is to move us. Architectural emotion exists when the work rings within us in tune with a universe whose laws we recognize, obey, and respect.

—Le Corbusier

*Denman's Col (Geometry)* is comprised of two channels of synchronized videotape displayed on five alternating television monitors. The monitor screens range in size from twelve inches to twenty-one inches and are placed in a progressively rotated configuration from left to right within a sculptural structure which alludes to the architectural skyline of the city.

The work was conceived as a kind of adventure, through there is no visible protagonist (other than the camera) and no explicit verbal narrative. The landscape is composed of obsessive visual and auditory elements, with the use of specific light, motion, and juxtaposition to establish a sense of dramatic progression and meaning. As such, the piece is a personal evocation of certain life states through analogies to the world of functional shapes, large and small—those which we inhabit and those which we can physically hold. Nourishment and inspiration can be seen to derive equally from both, and each gives rise to the other.

The extremes of scale and function merge and are equalized in the image of the buildings in the wineglass. The glass is seen first, empty and out of focus between two clearly focused rear-ground vertical buildings. As the liquid is poured, the city begins to collect inside, and a focal shift gradually reveals a world contained within the glass. Filled with beverage, the vessel becomes poetic, creating a habitation that lies

somewhere between real landscape and fantasy. If the buildings are in a drinking glass, they can be held in your hand and in some sense ingested. Conversely, the glass of wine becomes grand in its capacity to contain a city block: the city is Lilliputianized; the holder of the drink, enlarged.

The architect projects images of humanity onto the skyline, and these complex structures become repositories for thought. In the city, one spends endless time gazing out of windows at buildings. Their outlines, niches, arches, ornaments, and ledges both feed and receive the dreams of millions of people, animating these reveries as they themselves are animated by changing light and seasons. The drink is also a focus of contemplation: the morning coffee or tea, the evening cocktail, cognac in front of a fireplace, the champagne toast. Through the beverage we divine our fates, derive our values, and make up stories about yesterday and tomorrow.

In this congruence of utilitarian shapes, I have employed certain conventions of social/sexual geometry. Ambiguity results from the rotation and inversion of images and shift back and forth between positive and negative form. The subsequent disorientation of viewpoint and multiplicity of presentation—conventions literally turned upside down and sideways—liberate the viewer from horizontal/vertical logic as we normally experience it.

Does function follow form? (Is biology destiny?)

November 3, 1981

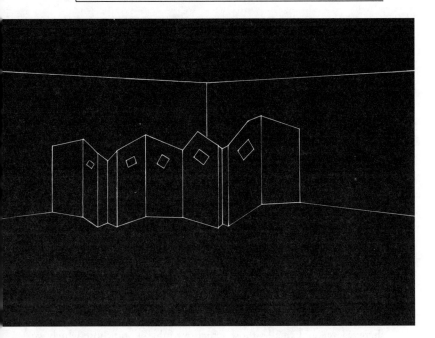

Drawing for *Denman's Col (Geometry)* (1981). Photo by Mary Lucier

**Marita Sturken**

## Mary Lucier's Elemental Investigations

### *Denman's Col (Geometry)*

Mary Lucier's latest installation, *Denman's Col (Geometry)*, shown at the Whitney Museum in November, is a visual adventure of architecture, form, scale, and urban territory—a romantic dialogue of city imagery and sounds which Lucier juxtaposes with drinking glasses and interior props. "The piece is a personal evocation of certain life states," says Lucier, "through analogies to the world of functional shapes, large and small—those which we inhabit and those which we can physically hold."

The installation consists of two synchronous channels of video displayed on five monitors. The monitors are mounted in a jagged sculptural framework representing the architectural skyline of the city. The screens, as in *Planet*, ranged from twelve inches to twenty-one inches in size, but this time were placed in an erratically rotated fashion—as if a monitor had rolled in the wind and been arrested at random stages of motion. Since several of the screens are upside down or sideways, giving the effect of looking at different images, this two-channel piece has the appearance of a five-channel work.

From the first moment of *Denman's Col*, the abstraction of the cityscape is established. Lucier begins with a view of the Manhattan skyline; she then moves to fragments of the buildings against the sky, and the sun moving forward from behind a water tower, its white light enveloping the dark structure. The ambiguity of negative-positive space which she creates in these cropped building sections transforms the blue sky into various images: a series of steps, a serrated leaf, or a geometric shape filled with clouds. The buildings of *Denman's Col* are posed, animate, ever-watching structures; they are the emblems and

Originally published in *Afterimage* 9 (February 1982): 10–11.

sole inhabitants of the metropolis. In this piece, people are only glimpsed—gliding by in slow motion under an umbrella or as the hands which orchestrate the movement and replenishment of the glasses.

To Lucier, the title of the installation represents both a metaphor for her past and an intellectual negotiation of urban landscape. ("Denman" is a family name, a "col" is a pathway between two mountains.) The title also implies an investigation that is almost geological. In an early and central shot, a wineglass appears between two buildings, an urban col. We hear the squeak of a bottle being uncorked and see the glass fill with wine. The camera then changes focus so that the buildings are realized in the reflective curve of the glass, contained in its fisheyed perspective. "Filled with beverage," says Lucier, "the vessel becomes poetic, creating a habitation that lies somewhere between real landscape and fantasy. If the buildings are in the drinking glass, they can be held in your hand and in some sense ingested. Conversely, the glass of wine becomes grand in its capacity to contain a city block."

Lucier's juxtaposition of functional architectural shapes with the sensuality of the reflective glass surfaces forms the central thread of the installation. The rotation of the monitors not only alters the effect of watching five screens at once, but emphasizes a pull of gravity away from sky and camera. The lens traces the buildings' long lines, panning dramatically up their forms to the sky. In the realm of the coolly-lit glassware, this movement is correlated with shots of a tall glass being filled with foamy beer. The stream of liquid (seen pouring both upwards and downwards) evokes the tall, sinewy buildings. When we see both these movements simultaneously upside down and rightside up, they converge as if some magnetic force were sucking them toward its center.

These playful redefinitions of scale and gravity are taken further as martini glasses are juxtaposed with spiraled buildings, champagne glasses are paired with art deco styles, a coffee cup with a squat brown building. The glasses are so elegant and so romantically photographed that they look like advertisements. The buildings, seen through park trees or placed starkly against the metallic blue sky, are presented in the antithesis of that artificial light. Lucier sees the two structures—that of the glassware and that of the architecture—as evocative of moods and thought. "In the city one spends endless time gazing out of windows at buildings. Their outlines, niches, arches, ornaments, and ledges both feed and receive the dreams of millions of people . . . The drink is also a focus of contemplation . . . Through the beverage, we divine our

fates, derive our values, and make up stories about yesterday and tomorrow."

Lucier is ultimately removing the architecture and glass structures from their contexts and their gravitational centers and reestablishing them within a new context, one that combines and interrelates their functional elements. She establishes a specific urban landscape and then reorients the viewer within that space. Distinct, selective sounds highlight the visuals: a distant police siren, that bird call of the city, opens the tape's soundscape; the remote squeak of a clothesline, church bells, soft rain, and wind combine throughout to create a complex audio environment. For contrast, Lucier inserts a less formal moving shot in which a pan by buildings from a car is coupled with a roar of city noise that sounds like it is being played backwards. In the interior scenes, the crisp sound of liquid pouring into a glass, the squeak of a cork, and the soft noise of flowers being dropped are sounds appropriate to the clean lighting of the glasses.

As the sun is revealed as an element in Lucier's tightly constructed urbanscape, the high-pitched sound of a hand spinning on the rim of a glass of liquid begins to fill the soundtrack. Both elements eventually obliterate their environments: the sunlight pouring through the city structures and the light reflecting off a wineglass stream into the lens and bleach out all visible imagery; at the same time the sound becomes one flutelike note spinning outward. This final eradication is the reaffirmation of Lucier's presence as the orchestrator of these interiors and exteriors. The hand which pours the liquid into glasses and scans the architectural structures is, finally, opening the lens to the sun and wiping out the neatly contained environment it has created.

# Ann-Sargent Wooster

## Mary Lucier at the Whitney Museum

*Denman's Col (Geometry)* is Mary Lucier's most complex video installation to date. Lucier's work of the early '70s dealt with process, especially the process by which the sun burned the tube of the video camera, producing a natural overlay of halation that sometimes recalled Robert Delaunay's corona paintings. In *Paris Dawn Burn* (1977) seven monitors displayed the progressive effect upon the camera's vidicon of the sun rising over the city of Paris—a series of "burns" that serves as a permanent record of this limited bit of solar history (i.e., time). With *Planet* (1980), shown at the Hudson River Museum, Lucier began to make use of editing, combining shots of the sky with views of the roof of the planetarium (which looked like the earth seen from space) in a coiling waltz of the spheres.

Urban landscape and the action of light are Lucier's primary concerns. In *Denman's Col (Geometry)* two alternating audio/visual channels were shown on five monitors of graduated size (from twelve to twenty-one inches) set in a pleated, jagged white screen that resembled an elegant stage set of a city skyline. The monitors underwent a gradual rotation from one panel of the screen to the next, so some of the images were inverted. Topsy-turvy trees with trunks like elephant's legs and inverted buildings like Magritte's stone islands floated at times in the sky, subverting the implicit verisimilitude. Lucier's subject is the Très Riches Heures of New York City, and she follows the cycle of the seasons—from the red brick buildings dusted with diagonal slats of snow to bird's-eye views of parks in the spring, street action in the summer, and the ziggurat tops of skyscrapers marching diagonally across the screen in small steps.

Originally published in *Art in America* (April 1982): 138–39.

This is her most thoroughly edited tape to date: the building shots are intercut (and hence the "col"—space between mountains—of the title) with interior shots, primarily of glasses filled with liquid or flowers. These interior objects establish a vaguely metaphorical relationship with the buildings, primarily by virtue of formal analogy. Lucier's virtuoso handling of light effectively suggests larger spiritual import. In one shot the process of light burning the tube combines with the time of day to abstract a skyscraper into a slightly askew rectangle flushed with pink and blotched with dark spots like a color-field painting. The result is a moment suffused with joyous transcendence. In contrast, the recurrence of the glasses roots us in a more limited and knowable reality. These vessels collect light in a manner reminiscent of those in Janet Fish's still-life paintings, while suggesting something of Chardin's attention to surfaces.

At times, perhaps due to the conventions of beer ads, they appear almost comic, as when liquid is poured upward into a glass hanging upside down in an apparently gravity-free condition, the sound of gurgling fluid seeming to assert that all is as it should be.

Sound takes on a prominent role in *Denman's Col (Geometry)*. Sirens and other street noise, pouring liquid, chimes, and zither tones produced by manipulating glasses are artfully combined to produce a soundtrack closer to music than ambient noise.

The buildings possess a sexual charge throughout. A water tower that recalls the mildly phallic structures photographed by the Bechers becomes aggressively sexual as the camera slowly pans it, stroking its contours, making it look like a rocket taking off. In Lucier's hands the dome of Grant's Tomb becomes unmistakably breastlike, and when it is juxtaposed to shots depicting a sculpture of a couple, the figural/sexual aspects of the building are made explicit. The shots of glasses being filled and of a smoking pipe can also be interpreted as symbols of sexual activity. This eroticism, a kind of social geometry, forms a subtext to Lucier's tone poem about architecture—at times enhancing it and at others lost in the sumptuousness of light and form.

**Mary Lucier**

*Ohio at Giverny* **(1983)**

An installation for two synchronous channels of videotape utilizing a seven-monitor display configuration built into a concave wall. The monitors are of progressive sizes from twelve inches to twenty-one inches, left to right along the curve, and are embedded at stepped heights in the structure so as to form a bower, or arch, at the center.

The work is an investigation of light in landscape and its function as an agent of memory, both personal and mythic. It deals with the convergence of disparate entities—geographies, periods in time, sensibilities; with transitions from one state of being to another; and how, within the frame of imagination and collective memory, these "dissolves" take place. It is structured as a journey of the camera from rural Ohio to Giverny, in France. In this adventure, landscape is the sole protagonist: articulated by changing light and by camera movement, animated by highly pictorial sound, and made poignant by the very absence of inhabitants. References to the motifs of Monet function throughout as the "art-historical" memory, underlying the more personal evocation of French and American personae. While a strong subliminal narrative gives the piece a very linear development in time, the alternating spatial deployment of the two tapes across a sweep of seven screens allows a generous exposition of landscape panorama—at once cinematic, sculptural, and theatrical.

February 14, 1983

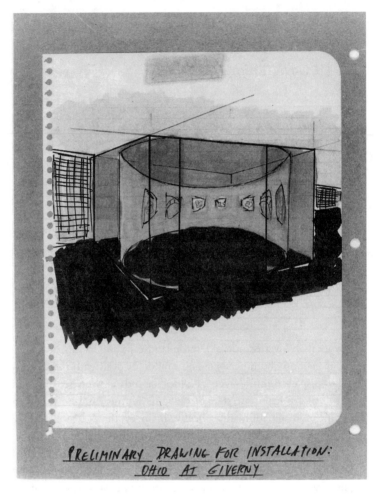

Preliminary drawing for *Ohio at Giverny* (1983), 1982. Photo by
Mary Lucier

**Bruce Jenkins**

## Viewpoints: Mary Lucier

Mary Lucier's longstanding fascination with the optical prop-
erties of the electronic image found its earliest expression in her quasi-
scientific experiments with laser burns on the vidicon tube and simi-
larly graphic (and destructive) video trackings of the sun. Gradually,
Lucier's work shifted toward more poetic encounters between nature,
light, and the video apparatus. Her landmark video installation com-
pleted in 1983, *Ohio at Giverny,* reconciles the analytic and aesthetic as-
pects of Lucier's work in its homage to Claude Monet, whose impres-
sionist landscapes marked the fusion of visual lyricism with a scientific
understanding of the nature of light and perception.

*Ohio at Giverny* consists of two synchronous channels of video dis-
played on an arched bank of seven monitors recessed into a concave
wall. Accompanied by a lyrical, synthesized score by Earl Howard and
the iconic sound effects of passing trains, church bells, and thunder, the
work runs in eighteen and one-half-minute cycles during which the
two video channels appear on alternate monitors. The panoramic in-
stallation forms a bowerlike viewing space that enhances the scale of the
imagery and adds a temporal dimension to the viewing.

A landscape study that mixes Lucier's personal history with a visit to
the significant sites surrounding Monet's home, *Ohio at Giverny* con-
tains a narrative dimension that is at once story and history. With the
video camera serving as protagonist, Lucier begins by returning to her
birthplace in rural Ohio, a Victorian dwelling surrounded by a land-
scape of farmlands, fields, and ponds. In an extraordinary transition,
the camera moves out through a window of the house and magically

Originally published in *Viewpoints: Paul Kos, Mary Lucier.* Exhibition
brochure (Minneapolis: Walker Art Center, May 1987).

boards a train for France. An evocative series of landscapes and land-marks recapitulates the history of western Europe and culminates in the arrival at Giverny.

Monet's home is viewed through an art-historical lens, with its sur-rounding grounds portrayed by turns through preimpressionist, pointillist, and impressionist landscapes. The imagery is replete with vi-sual references to Monet's paintings: the fields filled with red poppies, the Japanese footbridge, the celebrated pond of water lilies. Utilizing a variety of shooting strategies, Lucier mimes the luminous surfaces of Monet's late paintings, eventually pushing her imagery toward com-plete abstraction.

An epilogue shot in the early morning light of Père Lachaise Ceme-tery in Paris suggests, but does not reveal, one of the symbolic links be-tween Ohio and Giverny. As Lucier surveys the landscape of statuary and tombstones, and as the sound of a distant train whistle is heard, the camera comes to rest on a modest memorial dedicated to "Mon On-cle." It is to her own uncle (and his French wife) that Lucier has dedi-cated the work—an uncle who, in the naive imagination of a rural Ohio child, once boarded a train for France.

What ultimately connects these distant landscapes is Lucier's aspira-tion to engage the electronic image in an artistic enterprise that could parallel Monet's—to capture the luminous half-life of objects, to dis-cover natural analogues for artistic vision, to respond to light on land-scape with a mixture of childlike innocence and scientific precision. *Ohio at Giverny* posits a phenomenology of artistic perception, the act of seeing that pictorializes the world and reworks it into art. Lucier al-lows video to return to a vision of the camera arts as the "pencil of na-ture" and, like Paul Kos, extends the grasp of this modern technology by resituating it within the enduring concerns of Western art.

**Kerri Sakamoto**

## Through Veils of Light

To perceive the aura of an object we look at means to invest it with the ability to look at us in return.

—Walter Benjamin

In Mary Lucier's *Ohio at Giverny* (1983), a web of sunlight blinds us to the view from a window inside a room. This room, with its familiar furniture, vases, objects receding into silhouette around us, feels like home, though it is distant in memory. Our listless gaze wanders from corner to corner until the window opens. Momentarily, the camera sweeps us past a flutter of curtains into a white, undifferentiated space that then dissolves into a natural landscape of flowers, drifting reeds in a pond, tree-rimmed fields and roads. An ephemeral sight—dream, memory, visionary space—glimpsed as it often is through veils of light, even through a spider's web, or as reflections across a pond's surface.

As we peer through the window of Shigeko Kubota's *Meta-Marcel: Window* (1976), the view is thick and silent with falling snow. Opaque, light-filled, impenetrable, it is reminiscent of the flurry of snowflakes in Hiroshige's woodblock print; the windowpane becomes a *shoji* screen. This strange and enchanting sight fills us with longing to see beyond it from our place at the window, to the distant place it calls up.

The works of Shigeko Kubota and Mary Lucier present us with video's metaphorical "windows onto the world." Yet it is a particular world rendered through a distinctly female subjectivity and desire. Deceptively veiled, obscured, repeatedly framed without circumscribing

Originally published in *Gazing Back: Shigeko Kubota and Mary Lucier*. Exhibition brochure (New York: Whitney Museum of American Art, 1995).

**131**

its image, the work conceals as much as it reveals. The artists give us fleeting glimpses past the drape drawn over memory as they attempt to eke out a vision of self that invokes a site of origin. As Lucier retraces her family's past from Ohio to France and Italy, Kubota looks from America to Japan. In the process, the two artists draw us into the intense subjectivity of that vision and experience, creating an intimate space for the viewer at the window of their works.

Conceived as a homage to Duchamp's *Fresh Widow*, Kubota's *Meta-Marcel: Window* gestures toward "yesterday" and "tomorrow"[1] in its own idiosyncratic manner. An uncanny sight is revealed through a window whose view is multiply contained—within a box, within a video monitor; a virtual image fragmented and repeated behind a gridlike formation of panes. Kubota inserts a succession of spaces in between that distance the viewer from the image and elicit our longing. Deceptively, the viewer is invited to open the window, only to encounter yet another: that of the video screen holding the iconically Japanese image. That image itself is composed of endless fragmentation, endless repetition obscuring some elusive original site. We are reduced to viewers before an antennaless television set, waiting for the reception to clear and the narrative to resume.

At the same time, the dollhouse scale of *Meta-Marcel* and its elevated placement on a pedestal suggest a particular relationship to the body. In this way, the work is elegiac as it calls up childhood and memory; it transcends its own technologically generated image to convey wonderment through childlike eyes.

In *Video Poem* (1968–76), Kubota herself appears, half-revealed through the fabric of a nylon sack which encases the video monitor like a *furoshiki* (a Japanese cloth). The colorized, processed image of Kubota, open-mouthed, in mid-utterance, is silent and haunting; it is only partially visible as a disavowed sight through a zipper opening in the cloth, which undulates with a breeze cast by a small electric fan inside it. It is a powerful image of female desire.

The female figure recurs in *Duchampiana: Nude Descending a Staircase* (1976), another in Kubota's series of works inspired by Duchamp. Video monitors encased beneath each of four steps, in a staircase fashioned from plywood, flash with the image of a nude woman as she descends a staircase. Sized larger than an actual staircase, it is oddly reminiscent of the dais used to display dolls in homes across Japan on Girl's Day. The video representation of the woman enacts the dynamic movement that is conveyed through multilinear means in Duchamp's

painting of the same name. Paradoxically, the video's dynamism—punctuated, fetishized by processed effects bracketing the woman's body—is limited by the repetition of the woman's descent. The staircase structure becomes the body upon which its own finite movement is played out over and over. Simultaneously, we contemplate the material presence of the staircase, its fixed mass and oversized dimensions, and the stillness of our own bodies before it. Kubota's portrait of contained motion reverberates within its own cycle of loss and recovery.

Mary Lucier's *Ohio at Giverny* is marked by the very absence of the human figure. In allying the camera's eye with our own, she forges a mesmerizing subjectivity within a narrative of remembrance. *Ohio at Giverny* is a two-channel video installation comprising seven monitors embedded in a continuous wall that undulates like the body's landscape. As shifting images across the seven screens divide, multiply, and repeat, we listlessly search for a point of entry into the enigmatic narrative.

Lucier transports us from a window in Ohio to a window in France, our view thwarted by the same blinding sun or lacy drape. When the window opens and the camera carries us beyond the piercing light, an ellipsis occurs, and we find ourselves in another world, yet still behind the window. Our visions may all be reflections, rendered often in the glassy trickling surfaces of ponds and creeks. Hovering on the landscape, human figures are shadowy and abstracted—Lucier's blurry protagonists. They dissolve into vivid blots of color, then materialize as bright poppies. The reflection of two figures on a bridge quivers across water below like a trick of light. It is seemingly a sight too distant to be apprehended in its fullness, too fleeting to grasp; perhaps so melancholy to recall that it can only be viewed through its seductive veil of beauty.

We sit before the seven windows and contemplate the alternating flow of beautiful images—fields of flowers and corn, floating reeds, skies knitted up with clouds. The images slide mysteriously into the blank spaces between the monitors, beneath the skin of the wall that holds them, only to reappear anew on another screen. Memory shimmers, fine and iridescent across the surface of the work, and floats beneath it.

In Lucier's recent installation, *Last Rites (Positano)* (1995), the past and the act of calling it up are made less oblique. The furniture from the rooms depicted in *Ohio at Giverny* now inhabits the gallery as repositories of memory: upended, suspended in midair, vacated of function. When we encounter the portrait of a woman with a child on

the back of a chair, we mourn the absence of the person who once sat in it. *Last Rites (Positano)* recovers the lost realm of childhood—no doubt the artist's own—where objects exist in a wonderland of mystery and discovery. On video monitors, individuals recount memories of a period in the life the artist's mother spent in Italy. These are uncanny, overlapping, repetitive recitations that enact a kind of reconciliation with the past. Yet, as in *Ohio at Giverny* we remain distant from any single, clear truth. Significantly, the individuals on the monitors lapse into stillness until the viewers' own movement resuscitates the image.

In the final frame of *Ohio at Giverny*, a memorial—"A MON ONCLE"— appears across each of the seven screens, a dedication to Mary Lucier's Ohio-born uncle and his French wife. The diminutive memorial, centered in our vision, adorned with its implicating utterance, plaintively gazes back. Shigeko Kubota's *Berlin Diary: Thanks to My Ancestors* (1981) is similarly commemorative. A sheath of translucent pink crystal hand-painted by the artist with the names of her ancestors in Japanese is tied with twine to a small monitor emitting white light. These are singular, illuminating moments in the works of the two artists. In *Ohio at Giverny*, the camera finally lies at rest; the sight of the memorial is clear and unfettered. In Kubota's work, the veiling of the image becomes its source of clarity. Both are moments powerful in their capacity to invoke our own experience of loss and longing and our estrangement from the past.

### Note

1. Shigeko Kubota, in Mary Jane Jacob, ed., *Shigeko Kubota: Video Sculpture.* Exhibition catalogue (Astoria, N.Y.: American Museum of the Moving Image, 1991), 33.

Maureen Turim

## Painting the Image, Framing the Painting:

## Video Works by Mary Lucier

As digital imaging techniques raise in ever more persistent ways the relationship of the video image to drawing and painting, it is intriguing to note that video artists have long been exploring the relationship of the video image to the traditions of painting.[1] Mary Lucier creates images and installations that speak to this relationship: How do the light and color inscription of video work in ways analogous to painterly pigment and brushstroke meant to mimetically render objects and atmos-pheric light and color? How does the video frame and the installation placement respond to the tradition of the framing and display of the painted canvas? Lucier's investigations explore these relations not by a digital process that allows the video artist to "draw" or transform pixels as a painter does a canvas surface. Her work instead rests on a particular way of capturing the image, a careful inscription of videography, and then, equally, on a conceptual process of framing and display.

As an American, Lucier approaches the art of Continental Europe as a distant echo of its thunder, yet resonating nonetheless, brilliantly. A pursuit of autobiographical memory images spurs Lucier to return to her birthplace in rural Ohio at the opening of *Ohio at Giverny*. The views, though anecdotally subjective, are rendered as framed camera images whose mode ranges from the subjective, to the objective, to the ambiguous; rather than narrate this return directly, she does so obliquely, letting the image composition bear the weight of memory. The transition to France moves the image out the window of the two-

Parts of this essay were originally published in "The Image of Art in Video," in Michael Renov and Erika Suderburg, eds., *Resolutions: Contemporary Video Practices* (Minneapolis: University of Minnesota Press, 1996), 29–50.

story, wood frame farmhouse with Victorian accents in rural southern Ohio as a white light overpowers the landscape beyond. This is joined by a fade-in to images taken from a train. This gives way to a montage of French landscapes, monuments, and streets. The exploration of Monet's Giverny house and garden then parallels the Ohio Victorian farmhouse.

Giverny was Monet's last dwelling. The garden he established there became an auxiliary work of art, which he subsequently painted as his only late subject. Some of it is a Japanese-style garden, but Giverny's garden bears traces of English gardening traditions, with lavish beds of flowers. The Japanese aspects of the garden find their echoes in Monet's large collection of ukiyo-e, Japanese woodblock prints. The flowers are likewise echoed in the remarkable color of the interior walls and woodwork in translucent shades of bright pastels. In effect, Monet styled the characteristic belle époque French country home under the influence of Japanese aesthetics.

Lucier's installation alternates images which create temporal and spatial displacements. Tableaux are multiplied in a sculptural space. The preoccupation with light and its inscription of her earlier burn tapes becomes here a fixation on the light and space of Monet, as remembered from childhood, perhaps well before the reference to the Giverny paintings was known to her. The tape makes the connection as a journey across images as one site bleeds over into images at the other. A dedication of the video to Lucier's uncle and his French wife is later echoed in the miniature ceramic memorial to "mon oncle" shot in closeup at Père Lachaise. Connections between Ohio and Giverny, given visually, are imbued with a floating personal memory that informs the work but retains only brief traces of reference to these personal associations. Lucier's eye for detail isolates elements in frames, similar to the way the rich soundtrack mixes distinct sounds of birds, train noises, and electronic music, composed by Earl Howard. These distinctly, precisely presented images repeat in patterns of symmetry and asymmetry from monitor to monitor and moment to moment. Slow motion or rapid motion, sometimes in conjunction with blurred focus, varies the textures of the imagery, creating a rhythm of enunciation that is thoughtful and exciting.

Lucier's installation acts as a reframing. She claims for video an impressionist palette, a subtlety of color, as well as the relationship between the pixels and the fragmentation of the colored brushstroke. The critical reception, mainly in response to the inclusion of the installation

in the 1983 Whitney Biennial, marked this conjuncture. Grace Glueck in the *New York Times* called it "a stunning paean to Monet, . . . [which] orchestrates beautifully a brilliant melange of images in what is certainly the Biennial's most beautiful display," while Victor Ancona in *Videography* called it "a unified poetic narrative structure that rarely surfaces with such acumen in contemporary art," and Ann-Sargent Wooster in the *Village Voice* said, "Her studies of skies, reflections, and pure radiant light build on Monet's paintings and in certain instances surpass them."[2] While critics recognized and praised the work's shared aesthetics with its Monet reference, most left aside the meaning and consequences of Lucier's strategic borrowing, or simply presented them as an aesthetic tautology, as in Paul Groot's praise of "the esthetically balanced work of a fine artist." Bruce Jenkins, in his notes to the Walker exhibit, posits the consequence also in terms of "enduring terms of Western art," though he sees it as part of a more recent subset of those values, based on a "phenomenology of artistic perception, the act of seeing that pictorializes the world and reworks it into art."[3] Wooster, in a separate piece in *ARTS Magazine*, however, contrasts Lucier's installation with Suzanne Giroux's *Giverny, le temps mauve.* She faults the Giroux for seeing video as "ersatz painting" following the path of pictorialist photography. Wooster realizes that Monet's project is by no means unified and fixed for all time, as she gives a sketch of changing perceptions of Monet criticism.

> In 1939 Lionello Venturi called Monet "the victim and grave digger of Impressionism." By the fifties, Monet had come to be seen as a painter of pretty pictures, until Clement Greenberg became instrumental in transforming these late paintings from the limbo they occupied after Monet's death into a precursor of Abstract Expressionism in his essay, "The Later Monet," by showing that his work was a path to Abstract art. The rebuilding of Monet's garden at Giverny, a project that opened to the public in the early '80s, gave Monet's reputation renewed vitality.[4]

This thumbnail sketch of Monet's fortune with art history, of course, selects only a few of the many vicissitudes to which his work has been subject, a flux that depends on shifting the focus on different periods or aspects of his work.

It is this historical flux in Monet and art reception that I feel makes the Lucier work most vital. Despite, or perhaps even due to Monet's posthumous popularity as an artist, recent art-historical work has relegated Monet's art to the "beautiful." This work does not ignore the fact

that reception of Monet's work at first was not by any means uniformly favorable; in its own way the exploration of light, pigment, and brush-stroke challenged the reigning aesthetic and was embraced only by those critics who were able to appreciate its difference. Yet the recent questioning of Monet's surface beauty might be seen as descended from Kant, as he positioned the beautiful as inferior to the sublime;[5] it is more directly influenced by various forms of Marxist art criticism and various theories of modernism. In such a move, the question of a bourgeois aesthetics resides, in which *bourgeois* is meant to indicate a pictorial art of complacency, a visual decoration given over to values that provoke no problematic visions.[6]

Seeing Monet's art as merely beautiful art is also, however, a symptom of a time when aesthetic appreciation is no longer central to art, even though, or perhaps because, it dominates everyday and commercial life. Our culture lives in ambivalence with beauty, seeking it endlessly in fashion, makeup, decor, the human body, but often either ignorant or disdainful of its appearance in art. If the critics in New York termed Lucier's work beautiful, they must have been aware that the adjective could be seen as a condemnation in many circles, at the very least connoting the trivial, at worst, connoting the old-fashioned, the escapist, the reactionary. In a sense Lucier's montage means to take on just such connotations, reworking and commenting on them intelligently.

Lucier herself refers to the shape of the installation, the arched concave wall into which the seven monitors are set, as a "bower."[7] Often this shape is echoed internal to her images. Wooster adds the association of the curving panoramic water lily paintings Monet made for the walls of the Orangerie.[8] The bower, a curved brace for flowering vines, is a construct for palace gardens and estates. It is adapted into a bourgeois vision, the luxury of ordered space. The bower gathers connotations of a sheltering property, a safe and glorious haven. In the United States they have become tied to the image of the picket fence as the border of the proper middle-class household. The "Clos Normand" within Monet's gardens carry the bower to excess, with its central rows of flower beds striped by main linear pathways, with bowers arching overhead.[9] Yet there is a cross-cultural investigation implicit in Monet's garden at Giverny which represents less the seeking of a personal ideal, less complacency than one finds in the social garden of bourgeois contentment. To arrive there, Monet left behind the established bourgeois society of Paris as well as its route to escape in the Midi and the Côte

d'Azur.[10] His Giverny was a cloistered world, intensely devoted to the production of a space and the production of the images of this space. There is much here to debate about visual aesthetics and social context, about the shifts of historical and political concern.

My personal associations with similar lace-curtained windows complementing antique decorated interiors from which you could look out at seemingly endless corn and soybean fields makes Lucier's point of departure particularly rich with association to another house, this one in Indiana, literally moved from a small town and transplanted to its rural setting in the thirties. Contradictions inhere in such Victorian farmhouses between culture and nature, the refined and the earthy, contradictions exaggerated in American film to yield the *mise en scène* of George Stevens's *Giant* (1956) or, more recently, Terrence Malick's *Days of Heaven* (1978). For the Victorian urban style, the house on the hill represents the triumph of the bourgeois in the small town grandeur of American cities. Displaced onto the farm, it highlights even more the conflict in the United States between European culture and the wilderness. I think these are also associations churned by Lucier's *Ohio at Giverny.*

Mary Lucier, when asked in an interview by Peter Doroshenko whether her connection with landscape imagery was closer to the ideas of Caspar David Friedrich or Robert Smithson, took the opportunity to point out the dialectic between romantic and conceptual sensibilities, which allows her an affinity to both.[11] For her the sublime reemerges in Smithson's and her own pragmatic, intellectual way of ordering things, their interest in process and materials, at the moment when the response is "visceral."

This is the tension which orders not only *Ohio at Giverny,* but also her installation *Wilderness* (1986), where a variety of East Coast U.S. land and seascape images recall the Hudson Valley and luminist schools of painting, with some images also reminiscent of Caspar David Friedrich, as well as the English and French romantics. The images of landscape are captured with an eye to the history of art, but also to the notion of wilderness as cultural myth, inscribed differentially in various countries at particular historical conjunctures. To reframe the wilderness at present is to depict the historical, in that wilderness plays such a large role in the grand narrative of U.S. national identity, in the conquest and transformation of lands into states, where wilderness has almost vanished except as ideal and as reserve. *Wilderness,* then, is a virtual landscape at present, more fiction than actual vision, and thor-

oughly nostalgic. Yet Lucier as artist finds its traces, returns to fragments of that historical landscape, collecting and reframing these fragments.

To use terms reintroduced by Jacques Derrida in *The Truth in Painting*,[12] it is productive to view a video installation such as *Wilderness* as redefining relationships between "the ergon," the work, and "the parergon," the frame and framing of the image, its title, its reference to spaces outside itself. He means here more than the image/frame dialectic in its more literal sense, deployed as emblem of modernist self-consciousness or conceptual attacks on the art-object.[13] Instead the parergon refers to extensive, metaphorical framing acts, operations producing truths which Derrida sets out to deconstruct, sometimes through juxtaposing and questioning interpretations, sometimes through citing contemporary works which use fragmentation and multiplication to deconstructive ends. Marin's observation that painting is marked by a centrality and closure of its discourse, as all referential elements are forcibly rendered meaningful only through their discursive disposition within a painting's schematic self-conscious representation and reflexivity, rests on a similar view of the discourse of painting.[14]

The parergon in *Wilderness* includes gray "mattes" that enclose the borders of the video images as they are reduced in dimension, and then golden frames that outline the borders of the landscape images within the gray mattes. Each of the seven monitors is set on a symmetrically arranged series of pedestals designed as a series of columns and urns. As is the case with the bower shape, these formal white supports are echoed in the occasional ruin found in the imagery of the tapes, culminating in the snow-covered New York City Library, which offers itself as a metaphor of the historical and cultural archive. This time a pattern of three tapes, arranged in alternation, surrounds the most repeated tape with the asymmetrical variation of the other two in the pattern, A/B/A/B/C/B/C. It is even more obvious in this tape than in *Ohio at Giverny* that Lucier is interested in her parergons, her acts of reframing, of the confrontation of modernism with the romantic ideal.

More than anything else, *Wilderness* introduces movement, variation, and rhythm into the accentuated framing that others have explored with the single video image as painterly equivalent. One screen, one frame. But here that unified enframing is dispersed to construct an active contrast between the wild and the cultural. The containment of the frame struggles to hold the fluidity of an environment. Even the

frame itself divides and multiplies as gray mattes, golden frames, columns, and urns, the museum-bound decor that supports objects and images in presentation. Concepts are finally what frames the earth images, the fragments of space. *Wilderness* becomes a gallery unto itself, an occupation of space preoccupied with contrasts, framed and emphatically situated.

Pedestals here recall the historical role of the pedestal in proclaming video art. Pedestals elevated the single monitor to the museum object, offering the video image as similar to the display of small-scale sculpture such as the bust or the small figurine. The pedestal can't help but recall the museum tradition of display, the manner in which the nineteenth century borrowed from the neoclassic interior the classical pillar shape to provide an eye-level presentation of its precious collected objects. Just at the time when sculpture itself became largely monumental, abstractions of metal, wood, machinery, or stone that demanded plazas or gardens or large museum halls, even new warehouse museums, video installations served to remind us that not all sculpture had to dominate a space, to be entered, surround, or overwhelm the viewer. Sculpture, even video sculpture, could evoke much more intimacy of scale, a part-object, a head, a hand, a small abstraction.

Yet in *Wilderness* the pedestals accommodate the image series, placing monitors at a certain distance and at a certain geometric relation to one another so to position the viewer in relation to the space of that series, in a manner similar to the spatial configuration of *Ohio at Giverny.* The two installations, *Wilderness* and *Ohio at Giverny,* make a fascinating pair, so similar in form as they reach towards the monumentality of large-scale sculpture. Different in detail, in inscription, in association, both speak to the American landscape in relationship to the remembrance of traditions of landscape representation. Both serve to remark on a profound relationship between video and painting, and each one can be said to enframe the imagery of the other.

### Notes

1. On the question of digital video imaging, see my essay "Artisanal Prefigurations of the Digital: Animating Realities, Collage Effects, and Theories of Image Manipulation," to appear in a volume edited by Yvonne Spielmann, Fink Publishers, Munich.

2. Grace Glueck, in the *New York Times,* April 24, 1983; Victor Ancona, in *Videography,* (May 1983); Ann-Sargent Wooster in the *Village Voice,* May 25, 1983.

3. Paul Groot, "The Luminous Image," *Artforum* (January 1985); Bruce Jenkins, notes to the Walker Art Center exhibit, *Viewpoints: Paul Kos, Mary Lucier* Minneapolis, 1987.

4. Ann-Sargent Wooster, "The Garden in the Machine: Video Goes to Giverny," *ARTS Magazine* (April 1992): 50–53. Quotation on 50.

5. Immanuel Kant, "Analytics of the Beautiful" and "Analytics of the Sublime," in *The Critique of Judgment,* trans. James Creed Meredith (Oxford: Oxford University Press, 1952).

6. Consider this passage from T. J. Clark, *The Painting of Modern Life: Paris in the Art of Manet and His Followers* (Princeton: Princeton University Press, 1984), 72: "It should go without saying that this situation—Haussmann's work and its aftermath—presented painting with as many problems as opportunities. Naturally, it offered occasions for a meretricious delight in the modern, or proposals in paint that the street henceforward would be a fine and dandy place. (I cannot see, for example that Monet's two pictures of *Le Boulevard des Capucines* in 1873 do more than provide that kind of touristic entertainment, fleshed out with some low-level demonstrations of painterliness. Where Monet went, Renoir inevitably followed: his image of the grands boulevards in 1875 is untroubled by its subject's meanings, and not helped by this innocence.)" Clark then goes on to discuss painting of "a more serious cast—the kind that took Manet's example to heart," meaning, I take it, a more problematic and less bourgeois vision.

7. Mary Lucier, notes on *Ohio at Giverny* sent to exhibitors. Lucier is particularly detailed and eloquent in explaining her project, so that many of the journalists reviewing her work use her own enunciations in their remarks.

8. Wooster, "Garden in the Machine."

9. Based on my own visit to Giverny. See also *Monet's Years at Giverny: Beyond Impressionism* (New York: Metropolitan Museum of Art, 1978); Stephen Shore, *The Gardens at Giverny* (New York: Aperture, 1983); and Charles Weckler, *Impressions of Giverny: Monet's World* (New York: Harry N. Abrams, 1990).

10. John House, *Monet: Nature into Art* (New Haven: Yale University Press, 1986).

11. Mary Lucier, interview with Peter Doroshenko, *Journal of Contemporary Art* 3, no. 2 (1990): 85–86.

12. Jacques Derrida, *La Vérité en peinture* (Paris: Flammarion, 1978), trans. Geoff Bennington and Ian McLeod as *The Truth in Painting* (Chicago: University of Chicago Press, 1987).

13. It would be intriguing to trace the use of this opposition as theoretical principle in critical discussion of cubist collage, photography and the photographic series, conceptual art, etc. To begin, consider the way artist Nancy Wilson Kitchell presents the opposition in her series of landscape photographs: "Better perhaps to for me to circle it, draw a line around it with what I do know, find its boundaries . . . The implication of something beyond . . . that

which is unspoken, that which cannot be seen . . . some sense of an unknown . . . an invisible presence. Locating, then crossing boundaries. Stepping across boundaries" (ellipses in original). In *Individuals: Post-Movement Art in America,* ed. Alan Sondheim (New York: Dutton, 1977), 149. Or see allusions to the question of the frame in Lucy Lippard, *Six Years of the Dematerialization of Art* (London: Studio Vista, 1973), such as in Marjorie Strider's notes on her *Street Work* of 1969, in which frames were deployed in streets as environmental, spectator-performance pieces (91).

14. Louis Marin, *Détuire le peinture* (Paris: Editions Galilée, 1977), 29.

# Mary Lucier

## *Wintergarden* (1984)

Seven irregular geometric forms housing six television moni-
tors are grouped in a windowed corner of an urban public space. Two
of the structures are mounted on bases, two are completely freestand-
ing, and one resets propped against another on the floor. The forms are
surfaced with matte Colorcore Formica in the muted hues of the sur-
rounding city buildings. The monitor screens, appearing as recessed
cutouts in the face of each structure, are arranged at odd angles to one
another, presenting images in varying degrees of rotation and inver-
sion. Two synchronized, eleven-minute videotapes play continuously
on the six screens, juxtaposing and contrasting aspects of artifice and
nature in a formal Japanese garden with the texture and detail of the
Manhattan cityscape and extreme intimate closeups of the natural ar-
chitecture of flowers. The accompanying soundtrack reinforces the in-
terplay of synthetic and naturalistic elements in its use of electronic
music and processed ambient sound. "Wintergarden" refers simultane-
ously to the European-style conservatory popularized in the nineteenth
century and still utilized in private homes and public spaces today, and
the ancient form of the Japanese rock garden. In keeping with the lat-
ter, the principle of "captured" scenery has been invoked to pull into
the formal structure of the work the urban scene that lies beyond the
windows of the exhibition space.

December 16, 1984

**Charles Hagen**

**Mary Lucier**

A big question in any video installation is what to do with the TV sets. At this point in the development of TV technology the equipment that generates the illusion can't be physically separated from the image itself.

In *Wintergarden,* installed in a corner of this echoey, glass-walled, modernist-anomic bank lobby, Lucier enshrouded her monitors—six, in various sizes—in chic containers shaped like unusual geometric solids, all covered with mat Colorcore Formica in decorator pastels. TV sets are inherently furniture, and the motif here was Italian modo, with Lucier's five units (one, a long horizontal, held two monitors) clustered together like merchandise in the back room of a Soho design atelier.

Moreover, the shapes of the containers evoked further images for the piece and, by extension, for TV watching in general—for example, a pink pyramidal form, like a squat guard box, had a small screen set at eye level into one of its faces, suggesting a keyhole in a door.

By the same token, though, these crystalline forms had an attractive intimacy, and successfully held their own against the sterile surroundings. Their softly colored facets picked up the gray light that filtered down the canyons formed by the surrounding buildings; perhaps most important, the modish luxe of these "consoles" matched the stylized lyricism of the two tapes shown on the monitors. These tapes, delicate views of Japanese gardens, buildings in Lower Manhattan, and closeups of flowers, are shot and edited in the quiet, gliding style of slow-motion pans and mechanized zooms featured in *Ohio at Giverny*. *Wintergarden* doesn't answer the many questions posed by the chimerical genre of

Originally published in *Artforum* (Summer 1984): 90.

145

video installations—part sculpture, part TV, part audiovisual presentation, part electronic theater—but Lucier's provocative work provided a floral oasis in Manhattan's corporate-modernist desert: a welcome refuge in a cold winter.

**Mary Lucier**

## *Wilderness* (1986)

*Wilderness* is a video installation consisting of three synchronized videotapes displayed on seven large television monitors, mounted on faux classical pedestals and arranged on a series of stepped platforms. At the center of the installation is a fluted urn, flanked on either side by two terraced colonnades that rise to a height of seven feet at their extremities. The three channels of video are distributed across this phalanx of pedestals and monitors in A/B/A/B/C/B/C form, making possible the complex interweaving of temporal narrative and landscape panorama. *Wilderness* is a pictorial adventure into the origins of American landscape art, a reinvestigation of the substance of the American pastoral myth through the lens of a contemporary technology. Part of a continuing series of works exploring visual perception and memory through light in landscape, this installation focuses on a set of paradigmatic motifs derived from the paintings of the Hudson River and luminist schools of the mid-nineteenth century. The tapes are structured as a journey of the camera across the coastal, inland, and upland geographies of the Northeast, ranging as far as the northern bays of Newfoundland. In each locale, the camera examines images of nature, industry, and the home (corresponding to landscape, genre, and still-life painting) within the larger context of man's relationship to his environment. By returning to many of the original sites, I have attempted to reconstitute on video the unique qualities of atmosphere, light, and time as rendered by these artists and, at the same time, to set up an ironic dialogue between the past and present, the mundane and the poetic, real and ideal.

January 1986

## Christopher Knight

## Exploring *"Wilderness"* of Electronic Art

Mary Lucier's *Wilderness* is a hauntingly beautiful, three-channel, seven-monitor video installation. If it never really manages to open up new territory in its exploration of the modern tensions between nature and technology, it nonetheless orchestrates a complex and distinctly theatrical presentation in order to make the awful power of technology viscerally felt. You come out of *Wilderness* feeling awed and solemn.

The installation, which was commissioned by the Rose Art Museum at Brandeis University and had its debut there two years ago, is currently on view at the Museum of Contemporary Art as part of an extended, international tour.

Seven twenty-five-inch television monitors stand atop a row of pedestals, arranged in a shallow wedge, that take the form of classical columns, plaster tree trunks, and a garden urn. Measuring from three feet high at the center to four feet at each end, the stepped wedge of pedestals creates the effect of a traditional one-point perspective. Art and artifice are announced as primary subjects by the composition of the piece.

Nature is the dominant image on the TV screens, and exquisite images they are. The videotapes are in color, but Lucier exploits the silver-blue glow of television light to bathe her chosen pictures in stunning radiance. It isn't often that a television picture makes you gasp, but the sight of shimmering, crystalline, slowly heaving icebergs on a frigid sea, with which the twenty-minute videotapes concludes, is a breathtaking finale.

Originally published in the *Los Angeles Herald Examiner,* February 26, 1988.

Lucier's pictures of icebergs, coastal Maine, the Connecticut shore, the sunrise, verdant hills, and the rest are intentionally derived from well-known paintings by nineteenth-century American landscape painters such as Frederic Church, Fitz Hugh Lane, Winslow Homer, Sanford Gifford, John Kensett, and others. Periodically, the images will recede slightly on the TV screen, only to be captured inside a gilded picture frame. The device for declaring these as culturally and historically framed pictures, not purely natural vistas, is rather heavy-handed and obvious. But, it does bring into the foreground the spiritually inflected quality of these secular scenes: the golden frames are like beatific halos.

Cultural incursions into nature also are pictured in images that derive from English hunt paintings, the classically constructed still lifes of John Peto and William Harnett, and a few references to twentieth-century painters of American industry, such as Thomas Anschutz and Charles Sheeler. On occasion, the almost exclusively American thrust of her pictorial sources blurs into French territory—Degas' horse paintings, for instance, or Monet's *Impression: Sunrise.* (Lucier's best-known work, *Ohio at Giverny,* re-created Monet's garden out of television pictures of America.)

The topic of Lucier's installation might best be described by the title of Leo Marx's landmark literary study from 1964, *The Machine in the Garden: Technology and the Pastoral Ideal in America.* That book looked at the image of America as garden/paradise, and how it was accommodated and transformed with the rise of industry.

Marx ended his study with the dawn of the twentieth century, erroneously contending that the image of the garden finally ceased to function in the face of industrial triumph, but Lucier wisely nudges it ahead with a few references to Sheeler and, most important, with her very choice of video as a medium.

She doesn't take her study of cultural history very far into unknown territory, though. Most of what is suggested by this piece could be generously footnoted, and the gap she leaves between the nineteenth century and our own generation is pretty wide. Instead, the primary achievement of *Wilderness* is the way it looks at "images of the image of" America as garden/paradise. The frame is doubled, once by art, once again by television.

The idea of the TV landscape of contemporary American culture as an electronic wilderness isn't a new one, but Lucier rightly connects it

to its source in the privileged sphere of nineteenth-century culture. Finally, though, the most important feature of her work is purely experiential. For as Lucier's hypnotically beautiful installation establishes a degree of daunting, titanic power of its own, the privileged realm of her subject is revealed as both dizzyingly seductive and inescapably brutal.

**John Russell**

**Mary Lucier**

The most distinguished individual new work of art now showing in town may well be the twenty-one-minute seven-screen video installation called *Wilderness,* by Mary Lucier, at the Greenberg Wilson Gallery. In effect it is a meditation on American landscape, to be precise, the Northeast seaboard from the mouth of the Hudson northward to Newfoundland. We see it more or less as it was when the Hudson River School and the luminists worked it over, a hundred or more years ago, and we also see it as it is now. Ms. Lucier doesn't preach, doesn't deal in flashy contrasts, and leaves us to draw our own conclusions. She suggests, at most, that one kind of hugeness has yielded, in part, to another kind of hugeness.

Urn, column, and plinth hoist the seven screens to seven different heights. The images that come and go are at once the same and not the same. (The sequence of images works to a rhythm that can be identified in musical terms as A/B/A/B/C/B/C.) As a result, and although the tempo is slow and even, there is more going on at any one time than we can consciously absorb. Furthermore, the image may open on the full screen and suddenly pull back until it fills no more than half the screen. At such time an image of an old-style picture frame comes from nowhere and thrusts it toward us.

The seascape is seen in terms either of the sea breaking on rocks in the foreground or of vast, barely ruffled waters stretching away to a distant landfall. In neither case is there any sign of a human presence. But when the image move to shores deep under snow, a threadbare hammock recurs, slung from a tree and blown this way and that by fierce and audible winds. Outside and far away, mountain and iceberg set the tone.

Originally published in the *New York Times,* November 10, 1989.

There is also a bare tree, outlined against sky and snow, that brings Caspar David Friedrich to mind. Horses appear both as working animals and as auxiliaries for the hunter's amusement. Interiors are spare, intense, and free of all trivial encumbrance. (When a pot appears in closeup with the letters WARE conspicuous on it, we can read it as short for BEWARE, if we care to do so.)

From the present day, a gigantic industrial locomotive trundles from time to time through the factory that is its natural home. And when the cycle is all done, indoors merges with outdoors in the memory, and a solitary fisherman appears as a graphic element in the immensities of nature, and the snow is everywhere present to us, just as it is in the last paragraph of "The Dead," by James Joyce. A considerable experience.

**John Miller**

**Mary Lucier**

Perhaps the most intriguing thing about Mary Lucier's three-channel video installation *Wilderness* (1986) is that it implies beauty and cliché through the same set of images. Lucier demonstrates how the popular assumption that the two are intrinsically antithetical is not necessarily true. *Wilderness* consists of a row of seven monitors mounted variously on faux classical pedestals, tree trunks, and a fluted urn. Lucier has arranged these in descending order, from the highest on the ends to the lowest in the middle; she has also mounted all but the urn, the center element, on low risers as well. The monitors play back three twenty-one-minute, synchronized videotapes in an A/B/A/B/ C/B/C pattern. The tapes feature a succession of forests, streams, seascapes, early American interiors, and a fox hunt, and are punctuated with glimpses of trains, bulldozers, and factories. Each scene features only minimal camera movement, if any; the pacing is slow, but never boring. Many of the transitions between scenes are marked with a reverential fade to white. Often Lucier mattes the landscape in gray, zooms out, then keys in nineteenth-century picture frames around the borders. Industrial scenes are usually first shown inset into other pictures, before gradually filling the screen. The vaguely New Age-ish soundtrack, a combination of ambient noise and synthesizer music, is a slight drawback, but the program is technically superb, and it creates a quiet, meditative mood.

No words intrude upon the world Lucier creates, nor can the slightest trace of kitsch be found anywhere. The artist has ostensibly offered nothing but pure imagery; her vision is hushed and stoic. Lucier intends *Wilderness* to evoke the landscapes of both the Hudson River

Originally published in *Artforum* (February 1990): 139.

School and the luminists. If these allusions don't necessarily spring to mind while watching the program, they nonetheless make sense in retrospect. What's really at stake, it seems, is a reconception of humankind vis-à-vis nature, one that differs significantly from the romantic notion of the sublime. If humanity is part of nature, distinguished only by consciousness, then nature, conversely, can only be known as a human idea. Seen in this light, technological development is properly an extension of natural history. In *Wilderness*, neither the flashes of modern industrial scenes nor the nested framing devices (exhibition space/riser/pedestal/monitor/picture frame) are particularly disruptive; rather, they complete the whole. Whether the artist intended this or not is, as always, beside the point. Lucier says she conceived of her piece as "an ironic dialogue between past and present, mundane and poetic, real and ideal." Seen dialectically, however, *Wilderness* is not in the least ironic.

## Mary Lucier

### *Asylum* (1986/1991)

Mixed media installation with video and sound. 12 minutes, continuous

*Asylum* was first constructed in 1986 at the Capp Street Project in San Francisco as the final work in a series of video installations that focus on the image of the garden—the artificial earthly paradise—as a metaphor for mankind's ongoing enterprise to accommodate death within a familiar living structure.

*Asylum* is a three-part environment consisting of an indoor garden conservatory, a rustic toolshed constructed entirely of salvage and found objects, and a video/machine area. The garden is presented as an exhausted icon of regeneration, in the process of decay both physically and conceptually. Here, the traditional solitude and repose of the atrium-conservatory are directly confronted by the inexorable forces of an outside world that is itself in a state of impending dissolution. The videotape which supplies the pulse of the work is a visual and auditory rumination on energy and entropy. It looks at the production and consumption of thermodynamic power as a fundamental rhythm of industry and nature, alternating images of the active with the inert, the live with the moribund, the benign with the malignant.

The structures of production and the by-products of their decay demonstrate a marked ability to seduce us with a morbid beauty. *Asylum* seeks a neutral zone where the threat (or thrill) of an engine at full throttle is offset by the melancholy but comforting lesson of decrepitude—a kind of salvation in rust.

January 12–February 23, 1991

**155**

## Arlene Raven

## Refuse Refuge

Mary Lucier originally constructed *Asylum (A Romance)* in 1986 at San Francisco's Capp Street Project. "Romance" has been banished from the title of her 1991 permutation. But *Asylum*—an installation containing an indoor garden conservatory, rustic toolshed, and video/machine zone—still inspires tales of the seen and touched, remembered and distilled.

Lucier's legend is peculiarly American. "No author without a trial can conceive of the difficulty of writing a romance," Nathaniel Hawthorne lamented (in his 1859 *The Marble Faun*), "about a country where there is no shadow, no antiquity, no mystery, no picturesque and gloomy wrong."

These days the U.S.A. casts an ever-darkening shadow on big purple mountains of gloomy wrong. America's ethereal romanticism, however, remains enmeshed in a troublesome kinship with a realism firmly grounded in matter. Lucier's mixed-media environments provide a unique and flexible compound genre in which the uneasy coexistence of concerns with palpable fact and grand design can coalesce, and where humans and nature can be politically and metaphorically understood as one.

Almost all of the physical elements of *Asylum* are made of salvage— found objects and building materials. Abandoned refuse from an imagined stranger's life, a milk carton, or a child's scooter promises a story— possibly a Gothic romance—to be variously deciphered, interpreted, embellished, or transfigured. There is a sure and certain poetry to the language Lucier has developed for this work that begins as a beat, or a

Originally published in the *Village Voice*, January 15, 1991, 83.

calligraphic rhythm, and flowers as the orchestration of her means expands.

But that story would always contain, Lucier insists, "a metaphor about birth and death, about creation and destruction being enacted in the same moment of a single event, which is the act of making art." Historical, timely, and futuristic all at once, the act of preserving decaying oddments here exemplifies the insight of that single moment and event: There is no asylum from the facts of energy and entropy.

With electronic scenes of clear spacious skies over junkyards and rubbish heaps, *Asylum* seems extreme if gentle. This piece is, appropriately, the final work in a series of video installations that includes *Ohio at Giverny* (1983), *Wintergarden* (1984), and *Wilderness* (1986). In all, the garden is a deliberately graven image for an evolving meditation on the environment. Lucier "paints" an artificial earthly paradise with the lens of the late Monet in his garden at Giverny. In *Wintergarden*, she examines nature and artifice by alternating long views of Manhattan's skyline with short shots of the structures of flowers. Her wilderness is a Garden of Eden as it may have appeared to the nineteenth-century wanderer-artists of the Hudson River School, the first "New York School" of indigenous landscape painting.

Lucier's palette is exquisite, not precious; her workmanship a clear and brilliant understructure; her meaning direct and intense but never superficial. By generously layering visual and auditory fragments associated with a diversity of physical, artistic, and historical traditions, Lucier creates an art that is abundant yet precise.

But not only in visual/conceptual terms.

She draws out the central paradox between the natural and industrial worlds—containing the questions without answers that haunt environmentalists—while at the same time seamlessly juxtaposing visions of nature and industry.

In this respect, *Asylum* is Lucier's most environmentalist piece to date. And, congruently, its form is the most environmental—a site-specific installation with videotaped images and sound rather than primarily video art. Lucier's perspective on the earth's body and soul in *Asylum* is sometimes reassuring; often jarring when you think about what you're seeing; always complex. Her indoor/indoors is uniformly beautiful; slightly withering yet probably transcendent, embodying what she calls the "salvation of rust." The homely indoor/indoors may appear friendly because its many handsome machine-objects demonstrate the effects of natural wear and human use. But random things

(such as a wheelchair and rifle), when seen and put together in the mind, gather disturbing and even bizarre implications.

From the large video monitor raised on a forklift, the major source of light, distant rolling hills reveal their industrial windmills in a closeup. Later, the sun radiates from behind tombstones, memorial statues, and flowers in a cemetery to provide a comforting picture of the inevitable cycles of gestation and mortality. In Lucier's gorgeous parting image, nuclear reactors at Rancho Seco loom in the California landscape as night falls.

And day breaks, with the same windmills twirling at the center of the same hillside. This tape loops continuously. But Lucier lets us know that the world it describes, our "real" world, doesn't come around the same every time. If the Garden of Eden is a mythic American Paradise Past, this garden is an enervated, ever-eroding emblem for a physical, moral, and spiritual state that can no longer promise renewal.

The nuclear accident at Chernobyl occurred during the installation of the 1986 *Asylum (A Romance)* in San Francisco and significantly contributed to its more didactic presentation and tone. In the first days of 1991, during this writing, *Asylum* is, likewise, under construction in New York when another disaster far from American soil—but with serious possible consequences for Americans—threatens.

When day breaks in a great many households in the neighborhood of the Greenberg Wilson Gallery, television monitors are tuned into news channels waiting for (and against) war. Meanwhile, U.S. troops in the Persian Gulf, also waiting, have begun the process of forever altering the ecology of the desert they now occupy.

On my own television I am now playing Lucier's tape. And, for the first time, I see a figure—a man working in a salvage yard. Fully himself, yet also similar to a farmer plowing and, at the same time, to a homeless citizen separating and sorting abandoned urban trash, this figure in a landscape seems to participate in a truly transcendent ecology.

Before 1973, when Lucier took up video as her primary medium, she created performances about female and Third World identities. Now concerns rooted in the beginning of her creative life reemerge when this figure whooshes across the screen and his ambiguous landscape for a few seconds. He and his activity are exemplars of artistic "recycling" that embrace the human body and the earth as if they were the same substance in every realm.

Lucier says that "viewers need to identify something of themselves in the pictures in order to be able to participate in the work." To recognize oneself in these mirrors is to claim mind and emotions at the same time, and to demand of oneself social responsibility as a moral imperative.

# Kirby Gookin

## Mary Lucier

In Mary Lucier's installation *Asylum,* 1986/91, natural history confronts human history against an apocalyptic postindustrial landscape re-created here as an environmental installation and re-presented in video. All natural light has been emptied from the gallery, and only the flicker of the monitors and the dim glow of light bulbs illuminate the room, which has been divided by fences into three distinct areas: a formal garden arrangement, a toxic wasteland, and a rustic clapboard shack. The interdependence of these environments is enforced by a security cage that physically brackets the entire installation, as well as by the sounds of a ticking metronome and the roar of heavy machinery emitted from a video screen. The arrangement establishes a series of cross-references that articulate humankind's problematic intervention with nature.

The crisis we face in preserving our planet's fertility is encapsulated at the juncture of two fences, where the garden meets the wasteland. One fence is made from ornamental wood lattice painted to blend into its setting. The other employs the same diagonal design, but stiff chain-link, associated with security cages and compounds, replaces the wooden grid. Instead of integrating man with his environment, this fence is intended to segregate the two. It seems to be either protecting us from the hazards of industrial waste, or isolating us from the information that may leak out about the pollution and corruption involved in its disposal.

The juncture where the fences meet establishes a boundary between two earthen mounds, each one dialectically opposed to the other. A circle of clean soil that surrounds the base of a classically inspired foun-

Originally published in *Artforum* (April 1991): 120.

tain, adorned with two cherubs supporting a cornucopia, is juxtaposed with a mound of equal size, made of rubble and detritus, completely isolated from the rest of the installation by the wire fence. A surrogate fountain of sorts, the refuse mound spouts sinister nuclear waste instead of water. Suspended above the mound from a forklift like a hovering geyser, a video screen plays a twelve-minute sequence of images showing forklifts and bulldozers spreading toxic waste over a dumping site—the source of the garbage that lies below.

The ideal of the garden as earthly paradise—as a living extension of nature—has been displaced by a new form of landscape: the ever-expanding waste sites, strip mines, and expanses of deforested wilderness. Here the garden's antithesis expands in unison with the human population and with the increase in the production of human waste. The new garden is no longer the product of the gentle interplay between nature and human intervention; it is now a completely man-made creation. The suggestion here is that, with time, natural growth will be outpaced and ultimately overrun.

Lucier's *Asylum* offers little salvation. Her art is critical and establishes a ground from which other art must grow—an art that does not just criticize our living situation but is actually determined to make it better. I am reminded of the work of Peter Hopkins, whose artistic process actually involves rescuing refuse from abandoned industrial sites and using it as material for his art, or of Mel Chin's collaboration with the Department of Agriculture official to develop an environmental installation using plants that absorb toxic metals in order to clean up a waste site. Projects like these instill hope that art can actually make a difference.

## Mary Lucier

### *Noah's Raven* (1992–1993)

*Noah's Raven* is an eight-monitor video and mixed-media installation exploring the imprint of catastrophic phenomena on the landscape and its echo in the lives of individuals and societies. It addresses issues of personal and ecological trauma as seen in the scarring of the land and the human body by a variety of agents—natural disaster, pollution, disease, and age.

The installation is defined by a cluster of eight freestanding elements consisting of industrial and organic forms—specifically forklifts and massive tree trunks—each supporting a thirty-two-inch monitor. A winged skeletal fossil form (an actual replica of a pteranodon) hangs overhead in the center of the space. Four loudspeakers are positioned around the space. The soundtrack is composed of processed ambient and electronic sounds.

The videodiscs examine, at close range, three dynamic biomes of North and South America—locations where productive and destructive forces are in tenuous balance. Footage was shot throughout Alaska, along the pipeline to Valdez and Prince William Sound; in the heavily industrial areas along the Ohio River and in northern Ohio, Indiana, and Illinois; and at selected sites in the Brazilian Amazon, from the rainforest near Manaus to the smoky, deforested states of Rondonia and Acre. The image of the Brazilian rubber tapper appears as the paradigm of hope for the balance between man and nature. Key archival images from some locations are used to provide a historical context—the memory of past trauma.

The work also features anatomical images of women who have been disfigured by cancer, specifically in the upper torso and abdomen. The

Study for *Noah's Raven* (1993), 1991. Photo by Mary Lucier

camera frames these physiological terrains as a kind of human geography. By juxtaposing images of the human figure with aspects of landscape, I attempt to pose analogies between the individual and the environment in an attempt to extend empathy from the human body to the land, and back.

*Noah's Raven* is dedicated to the memory of my mother, Margaret Glosser.

1993

**Mary Lucier**

## Notes and Journal Entries for *Noah's Raven*

*Noah's Raven* is a rumination on impermanence, ephemerality, and the accumulation of data indicating a history, validating a life within the overall template of the earth's and humankind's evolution. The raven can be known by the shadow it casts, the tracks it leaves, the boundaries it delineates, the cultures it bridges, the chaos it creates, the wreckage it deposits, the incisions it makes, the disease it causes: the very imprint of its passing. Tectonic plates grind against each other, mountain ranges rise and subside, continents drift apart, oceans disappear and reappear, species come and go. Cataclysm reforms climate and landscape, extinction fuels the fossil record. The raven, the maverick explorer-adventurer, flies through the chasm between extinction and salvation, theology and ecology, science and mythology.

The body as a site

I. The body/territory is mapped, laid bare

II. The body/territory is explored, invaded

III. Disease is excised; organs are mined (extraction)

IV. The scars that remain attest to both the violence of cutting and the subsequent process of healing.

Scarring has a dual nature. It is ugly and it is beautiful. It provokes repugnance and empathy. It recalls trauma, pain, and loss, even as it represents the body's innate capacity for recovery and regeneration. In-

A shorter version of this text was originally published in Sandra E. Knudsen, ed., *Noah's Raven: A Video Installation by Mary Lucier* (Toledo: Toledo Museum of Art, 1993), 21–35.

cision facilitates removal as it etches new marks on the fleshy land-
scape—marks which become a silent record of a painful and perhaps
liberating process and which, like the wrinkles and lines of natural ag-
ing, suggest our history as organisms. History is written in trauma. The
scar tissue (i.e., memory) presents a visible sign which enables us to
track the traumatizing event, following its map backwards in time to
the source where the wounds are always fresh and the scabs of recovery
and forgetfulness have not yet formed.

From the Arctic Circle to the equator, from the frozen, silent tundra to
the teeming visual and auditory cacophony of the tropical forest—the
contrast between locales could not be greater. Yet there are common
themes which absolutely unite these two landscapes: a vast wilderness
which sequesters its rich resources—oil, gold, timber—challenging in-
dustry to find and exploit it; primary travel by river and by air, with the
recent arrival of roads being a harbinger of the gradual destruction of
the land and its inhabitants; a native people who once lived in relative
harmony with their natural surroundings but now find their lands in-
vaded and their culture in ruins; a sense of mystery and fear about the
deepest interior. The darkness at the heart of the jungle, the blinding
whiteness of the plains of snow and ice: fade to black, fade to white.

Journal entry, July 8, 1991

**Journal Excerpts: Alaska**

*April 4, 1991*
Turnagain Arm
Kenai Spur
Sodotna
Fireweed Lane
Muldoon Road
Resurrection Bay
Beluga Point
Nikiski/Nikishka
Tustamena
Kachemak Bay
Seldovia
Susitna
Homer

*April 13*
Answer Creek
Question Lake
Hurricane Gulch
Savage River

*April 18*
Coldfoot
Finger Mountain
Diamond Willow
Connection Rock
Disaster Creek

*April 25.* Valdez. Terminus of the pipeline, our constant companion since Coldfoot. At a distance, the silver tube snakes its way across tundra and mountains, lofting like a suspension bridge over rivers, disappearing underground in a stand of trees to reappear a while later, high up on the crest of a hill like stitching in the blanket of snow. Close-up, standing underneath the tube, I can see its seams and caulking and multiple patches. Close-up like this, it's a piece of aging plumbing against blue sky. A forty-eight-inch-diameter, eight hundred-mile-long piece of drainage pipe feeding crude oil directly into huge tankers in Valdez Harbor. On March 24, 1989, one of those tankers hit Bligh Reef, disgorging all eleven million gallons into Prince William Sound. Twenty-four years earlier, on Good Friday, 1964, a massive earthquake and tidal wave hit the sound, engulfing the original town of Valdez. Many people were killed on the docks when the wave hit. They say the land dropped six feet in some places along the coast. The town was moved four miles to the west, where it stands today, population 3,271.

The old town site is now a huge, open field marked by occasional clumps of heaved concrete and twisted metal. Two ghost piers remain. The ground is tidal, mushy, with seaweed everywhere. Huge, dirty slabs of melting ice make access seem treacherous, as though some evil abscess were concealed underneath, or a grasping piece of wreckage that could trap you there until the icy tide washes in. Its emptiness and calm are eerie. The only sounds are ravens and crows playing games overhead, endlessly circling and calling to one another. The people who used to live here say the land belongs to the sea now.

**Journal Excerpts: Amazonia**

*August 26, 1991.* Laercio, Mauricio, and I walk into the forest in late afternoon to scout locations. We identify rubber trees that will be suitable to shoot morning and afternoon, keeping in mind the angle and height of the sun and the density of surrounding foliage. The trees (*Hevea brasiliensis*) are extremely tall and straight, and the cuts made by *seringueiros* over the years are as ornamental as they are functional. Some trees are deeply crosshatched up and down the entire trunk to a height of twelve feet or more from the ground, and all have little homemade tin cups stuck in the bark where the milky white latex collects. Simple notched logs wedged at an angle against the trunk serve as ladders for the men to work the upper reaches.

*August 27.* We are out of our hammocks at daybreak and into the forest after a breakfast of fried manioc and strong, sweet coffee. Laercio leads the way with his machete, Mauricio and I follow with VCR and camera. Laercio works all morning, moving from tree to tree, cutting diagonally with a special knife, drawing the milky rivulets through rose-hued sliced bark.

The rubber tree evokes the human body. A vertical stream of latex divides the torso in half as it flows to the delta. Bodily fluid is drawn through the ribbed incisions toward the center and down its belly into the cup. The tree bleeds latex. Layers of scars upon scars attest to the repeated harvesting of the lifeblood—cuts deep enough to draw the sap, but not so deep as to maim or kill the provider. The marked skin of the tree signals its nobility. The skill of the *seringueiro* assures the yield and results in a productive and benevolent scar tissue: a symbol of the ideal symbiosis between man and nature.

February 7, 1993

## Eleanor Heartney

## *Noah's Raven* and the Contradictions of Landscape

The authentic artist cannot turn his back on the contradictions that inhabit our landscapes.

—Robert Smithson

Our landscapes are contradictory because they are never simply tracts of land. Haunted by metaphor, they become repositories for our dreams, our desires, our cultural memories, our feelings of cosmic belonging and cosmic alienation. Our landscape metaphors shape our experience of nature while they influence our relationships with each other and the cosmos. The notion of the Americas as the new Eden, for instance, has had enormous consequences for this nation's politics, art, and literature, manifesting itself in impulses as diverse as Jefferson's pastoral democracy, Whitman's ecstatic celebration of America's new man, and the modern-day ecologist's models of sustainable development.

Because they are such powerful agents in shaping thought and action, metaphors can be beneficial or destructive. In her provocative study, *The Death of Nature,* Carolyn Merchant traces the history of the concept of nature in order to suggest how symbolism determines our possibilities for action. She maintains that for the better part of Western history, the personification of nature as Mother Earth reinforced a strong proscription against mining and commercial exploitation of the land. In the sixteenth century an emerging mercantilist philosophy replaced that metaphor with a mechanistic vision which placed man in an instrumental relationship to nature. This was a paradigm shift of

Originally published in Sandra E. Knudsen, ed., *Noah's Raven: A Video Installation by Mary Lucier* (Toledo: Toledo Museum of Art, 1993), 8–20.

enormous consequences, focusing human action away from a concern with accommodation and toward a belief in man's right to dominate the natural world. As a result activities like coal and strip mining, which once would have been seen as a violation or rape of the earth, were now acceptable as a form of resource management. Thus the shift in metaphor helped lay the ground for the world we know today.[1]

For the last twenty-give years Mary Lucier has been engaged in a study of the meaning and implications of our metaphors for landscape. In a series of video installations she has focused on the contradictions inherent in the pastoral ideal which underlie so much American art and literature. Freed from the corrupting influences of the Old World, proponents of this ideal believed that the vast and fertile land of America would nurture a free and egalitarian society. Properly managed, nature might become a garden willingly yielding its bounty for the sustenance of man. Although traces of this dream remain in the populist rhetoric of politicians like Ronald Reagan and Ross Perot and in our continuing nostalgia for a Disney-perfect rural America, it is clear today that nature and human development are on a collision course.

Lucier acknowledges as much in her interweaving of image, sound, and environment. She may linger over seductive images of wild or cultivated nature, but her works always include the forces which undermine and threaten to destroy the pastoral dream. Images of snow-capped mountains, lush gardens, and dense forests are intercut with the shriek of train whistles and the rumble of industrial machinery. Lucier shifts abruptly from rolling hills and vast, unpeopled tracts of land to the sight of factory chimneys, trucks, and bulldozers. In one recent work the otherwise bucolic countryside is crowned with a pair of nuclear reactor towers.

In Lucier's new video installation, *Noah's Raven,* the folly of utopianism is made explicit. Traveling to the Amazon rainforest and the Alaskan tundra, Lucier finds that even in the most remote and inaccessible regions of the American continents, there is evidence of the devastating effects of industry and development. But *Noah's Raven* is not simply a polemic about the evils of civilization and the death of nature. Lucier also includes elements of hope—evidence of the land's amazing powers of recuperation; reminders, in the lives of Alaskan dogsledders and Amazon rubber tappers, that it is possible to live harmoniously with nature; and, finally, solace in the remaining beauties of the endangered wilderness.

Meanwhile, overhanging the installation like a talisman and a warn-

ing, a replica of a pteranodon skeleton introduces the dimension of cosmic time. Catastrophes occur, species rise and fall, worlds change beyond recognition or disappear altogether. Might this not, our airborne companion seems to ask, also be part of the cycle of nature?

In keeping with this theme, the central metaphor of *Noah's Raven* is the scar. Defined broadly, the scar is any trace of past trauma. It appears as a band of black oil washing up against the Alaskan shore, the cracked earth remaining after the rainforest has been turned to desert by deforestation, the intricate tracery of cuts drawn by the tapper across the gnarled surface of the rubber tree, the skillful incisions of the surgeon into human flesh. It becomes clear that the scar is an ambiguous symbol, representing both destruction and healing. Lucier points out that progress, modernity, human intervention in nature, even catastrophe itself, all have a dual aspect. To ignore this fact is to fall into a useless nostalgia for an unrecoverable past. Worse, it is to frame our alternatives only in terms of stark opposites—a choice between jobs and owls, or between man and nature.

The ambiguity introduced by the scar extends to the work's title. *Noah's Raven* refers to an incident which took place in 1802 in South Hadley, Massachusetts. Having unearthed a piece of sandstone imprinted with a three-toed foot, a local farmer announced that he had found the footprint of the raven released by Noah after the subsidence of the Flood waters. According to the biblical story, the raven failed to return to the ark, so Noah then released a dove. When the dove returned with an olive twig, Noah knew that it was possible to return to land. Subsequently, scientists refuted the farmer's claim. It has since been proved that the sandstone layers throughout the Connecticut River Valley bear the fossil footprints of dinosaurs.

Noah's raven provides a provocative symbol for modern-day environmentalists. Like that of mankind itself, the raven's fate is uncertain. Did it fail to return to the ark because it died or because it found a new home? The South Hadley incident deepens the meaning of the biblical story by giving it an ironic twist. The raven becomes a signal, not from God to Noah, but from the geologic past to us. But what is it trying to tell us? Does it offer evidence of a new beginning or an old ending? Is it suggesting that these may be the same? Is catastrophe the motor of geologic and evolutionary change? Did the demise of the dinosaurs make way for human evolution? And does the reappearance of Noah's raven portend the next great extinction, this time of man himself?

Lucier's raven can be glimpsed flying high over landscapes which re-

veal the urgency of such questions. Lucier has organized the work as a journey through two central locales—Prince William Sound and the Brazilian rainforest. At once awe-inspiring and ecologically vulnerable, these places represent the last American frontiers. We move through them visually as we might physically, hitched to a dogsled, bouncing in a truck along a rough jungle road, rolling downstream in a riverboat, rising above the trees in a noisy helicopter. In the process we are privy to both their glories and their tragedies.

In Alaska we see pristine cliffs and mountains encased in snow, sled dogs being harnessed for a run through the tundra, caribou herds racing across fields of white. Industry appears in the form of the Aleyeska pipeline running like an artery across the landscape as it links the ramshackle settlements which spring up around oil-drilling sites. Quick cuts show us the destination of this black blood—oil refineries in the Midwest belching smoke and breathing fire against the starless night. Meanwhile, back in Valdez, we see evidence of the Exxon oil spill: slick-covered ducks and seals, shiny black sludge washing up against the shore. Black-and-white archival film footage documents an earlier disaster in the same area—the earthquake and tidal wave which destroyed the town of Valdez in 1964. We return to this site today, now covered with snow and returned to emptiness.

The Amazon section begins with an homage to nature's beauty. Shadowy tropical trees break through the morning mist, dense jungle foliage weaves a tangled green tapestry, a boat points its nose down a river framed with thick greenery on either side. Again industry asserts itself, more benignly here, in the dense welter of cuts laced across the trunk of a rubber tree. We watch the tapper score the trunk, working with the precision of a surgeon in order to bring the oozing white latex to the surface without threatening the life of the tree. Then we glimpse the rainforest's great enemy, a herd of cows, for whose pastureland vast acres are being clear-cut and burned. Now the journey turns bleak, as we observe blazing forests, smoldering fields strewn with stumps and charred branches, the parched, cracked earth that deforestation has left behind. Finally we traverse the mud flats, canyons, and eroded valleys created by the mines which leave the rainforest a barren wasteland.

Woven throughout *Noah's Raven* like a parallel journey from purity to contamination are archival images of medical operations and depictions of the scarred and disfigured flesh of cancer victims. Two of these have personal significance for Lucier. One is the artist's mother, Margaret L. Glosser, the other her friend Nancy Fried. These images help

underscore one of the central paradoxes of the work, which is the co-existence, even inseparability, of life and death, health and disease, in our lives and in our environment. Thus Lucier sets the stage for the explorations to come by opening with an image of a woman's body on the surgery table. The rhythmic sound of her soft breathing merges with the sound of wind blowing across the Alaskan tundra. As the Alaskan and Amazon sequences proceed, their continuity is interrupted by scenes drawn from footage of surgical operations. In the beginning these interruptions focus on the starched white outfits of the surgical teams and then come in close to reveal incisions, pulsating organs, operable and inoperable tumors. The work closes with footage of Fried and Glosser. We see closeup shots of mastectomy and hysterectomy scars. The last image is a puckered scar which cuts through a field of flesh like a fissure in the earth and makes us recognize a kinship, both tragic and hopeful, between the scars and disfigurements created by oil spills, rubber tapping, clear-cutting, strip mining, and cancer.

*Noah's Raven* is Lucier's most complete statement to date of her philosophical concerns. It is also her most ambitious installation. Employing four channels and eight monitors, she creates a mesmerizing montage of images and sound. At times landscape images unroll across the screens in panoramic fashion, at others continuity is deliberately undermined with quick cuts to archival material, closeups, discordant elements.

The contraries which are raised, set against each other, and occasionally reconciled in the video screens come back into play on the pedestals on which they stand. An alternating arrangement of forklifts and tree trunks brings the video monitors to the eye level of a standing adult. These objects, at once highly divergent in material and psychological meaning, are also oddly analogous in form, subliminally reiterating the interdependence of man and nature at this stage of human development. Meandering across the floor are eight low benches. These invite viewers to sit surrounded by the eight video monitors and choose which of the two sequences of images to watch. Or viewers may scan all eight, immersing themselves in the blend of sound and images. Meanwhile, above their heads, the pteranodon skeleton hovers like a haunting reminder that no species may expect to rule the earth forever.

The sound track, composed by Lucier's long-time collaborator Earl Howard, employs a mix of natural and synthesized sounds which serves both to distinguish the video's narrative sections from each other and to suggest the rapprochement of nature and culture. The chatter of

birds and monkeys in the jungle or the hollow whistle of wind blowing across the tundra may be interwoven with mechanical and industrial sounds emerging to overwhelm and eventually replace them.

The questions Lucier raises in *Noah's Raven* are complex. Which, she asks, are natural or provident extinctions, and which are "unnatural"? Is man part of the ecological system or has his grasp of technology lifted him outside of it? How are we to regard technology, progress, industry, medicine? How do we reconcile the fact that things which create also destroy?

Although Lucier offers no simple answers to these questions, she does present two models for ecologically responsible behavior. She has remarked that the rubber tappers and the dogsledders are the real heroes of *Noah's Raven*. Each exploits the environment in a way which does not endanger it. The dogsled, for instance, provides transportation for Eskimos who hunt caribou. It does so without burning oil or using valuable resources. Instead of dominating nature, the dogsledder works in harmony with it. A similar necessity connects the life of the rubber tapper to the rhythm of the forest. With their livelihood threatened by the spread of cattle ranches, rubber tappers have joined forces with ecologists in a mutual effort to save the rainforest. Both dogsledder and rubber tapper embody the possibility of a benign and mutually beneficial relationship between man and nature.

But at the same time that Lucier posits these models, she is well aware of their difficulties in practice. Burgeoning populations, the demand of a rising standard of living, and the spread of urbanization make such solutions impractical on a large scale. Eking out a living on the edge of our last frontier, these heroes represent a disappearing world. The self-sufficiency they strive for is simply not possible to inhabitants of the smog-saturated cities of the Middle West or the slums of Manaus. Nor is it even a practical goal for the impoverished miners that Lucier shows panning for cassiterite, tin ore, in the deforested Amazon.

The drifting smoke and steam which waft through all these landscapes serve to unite the pristine wilderness with the world transformed by industrial development. Mist rising from the jungle, steam evaporating from the glaciers, fog rolling over the ocean, and smoke enveloping the burning forest, encircling charred tree stumps, or pouring from factory chimneys, all share a rugged beauty. We are struck by the ambiguous nature of industrial development. Is the machine the engine of progress or the agent of destruction? And can we always recognize

the difference? Ecologists of an ironic bent like to point out that the spectacular hues of modern sunsets have been heightened by the high content of pollutants in the air. And certainly, without the internal combustion engine, few of us would be able to experience the beauties of the wilderness firsthand.

Lucier's ambiguous treatment of smoke and steam finds its precursor in the tendency of Hudson River School painters to introduce the locomotive into depictions of otherwise uninhabited wilderness. In her seminal study of nineteenth-century American landscape painting, Barbara Novak interprets this motif as an indication of the painters' desire to reconcile industrial development and natural beauty. She sees the painters' skillful blending of natural and man-made vapors in such works as a symbol of their desire for a genuine fusion of man and nature: "secular invention subsumed into the larger creation, as the fuliginous emblem of power grazes mildly through the landscape."[2] However, Novak warns that the ease with which the locomotive's steam is absorbed and dispelled into the clear air of these paintings is evidence of the artists' unwillingness to deal with the reality of industrialization. As she remarks, "Certain guilts and repugnances were surely attached to the desecration of nature for the sake of 'human' civilization."[3] This guilt was experienced not just by the artists, but also by the more thoughtful members of the society they addressed. As Lucier makes clear in *Noah's Raven,* this dilemma has not been resolved a century later. In fact, it has become more pressing.

*Noah's Raven* is the outcome of Lucier's ongoing exploration of the use of landscape as a medium for expressing ideas. In a sense she is extending the genre of landscape painting into the very different medium of video. At times she makes this connection explicit, as in a 1986 work entitled *Wilderness,* which is, on one level, an extended homage to the Hudson River School tradition. In other works, *Noah's Raven* among them, Lucier deliberately works against the conventions of landscape painting by introducing scenes and images that run counter to the genre. There is something doubly shocking about the transition from pure white tundra to oil sludge or from the tangled jungle to empty fields of smoldering tree stumps.

The themes which animate *Noah's Raven* can be discerned in embryonic form in Lucier's work as far back as the early seventies. In a 1971 installation entitled *Salt,* she placed cairns of white marble inside an area marked off by snow fencing, metaphorically displacing the landscape of the Great Salt Lake in Utah into the woods of Connecti-

cut. By the mid-seventies, she had become part of a small but influential group of pioneers experimenting with video art. While much of her early work focused on the possibilities of the medium itself, in 1975 she created two works which directly anticipate the theme of *Noah's Raven*. By pointing her camera directly at the source of light, Lucier created burn marks on the surface of the camera tube which obliterated any other visual data and eventually destroyed the tube as a recording instrument. In *Dawn Burn* the burn marks track the sunrise on seven consecutive days. In *Fire Writing* they transcribe the calligraphic gestures "written" in the air by a camera aimed at a laser beam. Both works can be seen as forerunners of the scars in *Noah's Raven*. The marks on the camera tube, like the crevices in the earth and the scar tissue on the human body, present a beauty born of destruction.

*Dawn Burn* and *Fire Writing* also indicate a concern with light which became more pronounced in subsequent work. In *Equinox,* from 1979, her first video piece in color, Lucier's camera followed the sun as it rose over Manhattan. *Denman's Col (Geometry)* (1981) juxtaposed images of the Manhattan skyline with light reflected in a wineglass set upon her studio windowsill.

In 1983 Lucier began the series of video works which led directly to *Noah's Raven. Ohio at Giverny* (1983) was inspired by a mix of personal memories, childhood fantasies, and fascination with the perceptual experiments of the French impressionists. On one level the work is an homage to Lucier's American uncle and his French wife. Shot in two channels, displayed alternately across seven monitors arranged in an arc over a semicircular construction, the piece opens with views of the Ohio landscape where Lucier grew up. Shots of the exterior and interior of a Victorian house lead magically to the French landscape, to Monet's garden, and finally to Père Lachaise Cemetery in Paris. This journey across continents and back in time is also an acknowledgment of the trauma of approaching death, as we begin to see Monet's garden through the fading eyesight of the aged artist.

By re-creating with a video camera Monet's vision of nature dissolved into the abstract play of light and color, *Ohio at Giverny* suggests the timelessness of landscape captured as art. As Lucier delved further into the landscape theme, she became more concerned with the tension between landscape as metaphor and landscape as a real and increasingly vulnerable setting for human life. In *Wintergarden* (1984) she juxtaposed views of a Japanese Zen garden with the skyline of Lower Manhattan and extreme closeups of flowers. A grouping of Formica-covered

geometric boxes clustered like minimalist rocks in the Chase Manhattan Plaza, this installation provided both an oasis in the midst of a busy urban plaza and a rather unsettling image of nature transformed by technology into art.

Lucier's next major work, *Wilderness* (1986), was a video installation which pulled together many of the themes of the preceding years. Again she turned to an exploration of landscape in art, but this time Lucier pointedly incorporated evidence of the painter's artifice. *Wilderness* visits interior and exterior locations associated with the luminist and Hudson River School painters. Lucier punctures the idyll with emblems of industry and technology—among them the train, the bulldozer, and the graffiti-scrawled wall. She underlines the artifice of nineteenth-century landscape conventions by setting the seven video monitors on faux tree trunks and classical columns and by surrounding key scenes within the video tapes with gilt, museum-style picture frames. Thus, Lucier underscores the dream quality of the universe recorded by masters like Thomas Cole, Frederic Church, George Inness, and Winslow Homer. Their representations of a vast and apparently eternal wilderness were in fact created at the moment when such lands were being systematically developed.

The cultural trauma which follows the demise of nature forms the subtext for *Asylum (A Romance)* (1986). A full-scale three-dimensional environment, *Asylum* draws viewers into a ruined indoor conservatory and rusting toolshed before confronting them with a video monitor enclosed within a bleak prisonlike cell. The video opens with what appears to be a lyrical image of landscape but quickly yields to scenes of industrial and natural decay, followed by the image of an overgrown cemetery. It closes with a disquietingly beautiful image of a nuclear reactor silhouetted against the night sky.

*Asylum (A Romance),* as its name suggests, acknowledges modern man's longing to escape from the complexities of contemporary life. At the same time it reminds us, as conservatory ruins and the ominous images on the video monitor make clear, that the escape route back to nature has, for all practical purposes, become closed. The machine has overtaken the garden and left only a trail of picturesque debris in its wake.

Which brings us back to *Noah's Raven*. Seen in the context of Lucier's previous work, her most recent installation offers a reiteration and a deepening of certain recurring themes. One of them is the seductiveness of the garden. As one of America's guiding metaphors, the

garden is the place where man and nature meet in harmony and mutual benefit. America is the new Eden, fertile, pristine, and unspoiled by the corruption of culture. It offers both a refuge from the horrors of industrialization and the promise of an orderly and progressive democratic society.

The dream of the garden exists in uneasy peace with a second great metaphor for America—the Great Frontier. This notion received its most powerful and persuasive expression in 1893 with the publication of Frederick Jackson Turner's essay "The Significance of the Frontier in American History."[4] Turner saw the American frontier as the great safety valve of democracy—the place where misfits, outcasts, and rugged individualists escaping from civilization could find a place to relocate and prosper. Unlike the garden, the frontier was a wild and lawless place where men tested themselves against the rigors of nature and the "savagery" of the native population. Of course, inherent in the myth of the frontier was the notion of conquest, which would eventually consume the very wilderness which made it possible.

Clashing with both the dream of the garden and the myth of the frontier was the driving force of the technological progress which tames the wilderness, lays down the train tracks, builds the cities, and, eventually, despoils the environment. Paradoxically, if the notion of Arcadia is quintessentially American, then so the celebration of the machine. Americans saw themselves as a forward-looking people, freed from the philosophical and technological limitations of Europe. Even today, there is a tendency to see industrial progress as a necessary precondition of democracy in the developing world. In the New World, it was hoped that new means of production and new forms of social organization would prevail.

In works like *Wilderness, Asylum (A Romance),* and *Ohio at Giverny,* Lucier holds these contradictory positions in delicate balance so that we are able to feel the psychological power of each even as we recognize its flaws. *Noah's Raven* advances the argument to the next step. By introducing the element of cosmic time, Lucier persuades us to think beyond the shortsighted distinctions between man and nature which underlie each of these myths. She warns against the hubris of seeing nature as simply the tool, victim, or willing servant of man. Instead, the pteranodon spreading its skeletal wings over the installation is one reminder that, from a paleontological point of view, there is nothing more "natural" than the extinction of entire species, the disappearance of whole ecosystems. And on the other end of the scale, the last video

image showing the undulating terrain of the artist's mother's diseased and scarred body brings home the inevitability of human death and personal loss. Man is part of nature, and its life and cycles are inseparable from our own.

One does not have to know that Lucier's mother suffered from cancer during the three years she worked on *Noah's Raven* to read the work as an elegy. Lucier would doubtless reject alarmist cries that by overdevelopment and industrialization we have precipitated the "End of Nature," as one popular book recently put it.[5] Nevertheless, it is impossible to dispel an inescapable sadness as the camera pans across charred woodland and oil-soaked beaches or to suppress an awareness, inspired by the scenes of frail and failing bodies, of the truth that death comes at last to us all. Alternating between the personal and the universal, Lucier brings us to some of the most basic and inescapable questions of human existence.

Lucier's unwillingness to separate nature and industry or to deny the inevitability of change, death, and the earth's long-term cycles of extinction and regeneration reveals her kinship with Robert Smithson. A thoughtful commentator on the relation of science, art, and environment, Smithson left behind a legacy of art and writings which continues to influence ecologically inclined thinkers. One of his most provocative essays is "Frederick Law Olmsted and the Dialectical Landscape," in which he sets out his philosophy about the many-sided character of nature. Smithson counsels against an ecological romanticism which would separate man and his works from the larger operations of nature. He warns, "Modern-day ecologists with a metaphysical turn of mind still see the operations of industry as Satan's work. The image of the lost paradise garden leaves one without a sound dialectic, and causes one to suffer an ecological despair."[6]

Like Smithson, who chose to build his "earthworks" upon sites ravaged by industry, Lucier rejects ecological despair and its simple nostalgia for unblemished wilderness. And like Smithson she suggests that our survival depends upon placing our own processes of industrialization and urbanization within the context of the earth's larger cycles of geological change.

This sort of systemic approach to environmental problems is not new, but it has been less visible than dramatic invocations of ecological despair. The most pervasive ecological art tends to take the form of condemnations of industrial development or expressions of nostalgia for some lost state of environmental grace. But working more quietly

are a number of artists who, like Lucier, are interested in the contradictions and complexities which inform mankind's relationship with nature. Their choice of media and approach may be very different, but their grasp of the problem is closely related.

Helen and Newton Harrison, for instance, have turned their attention to our polluted watersheds. Working with ecologists, biologists, and planners, they target a specific waterway and design restoration plans aimed at reviving the ecosystem while acknowledging the economic and social needs of the surrounding population. Like Lucier, they work with full awareness of technology's dual potential for creation and destruction. While few of their proposals have been adopted intact, the Harrisons are credited with altering the terms of the debate and opening the minds of local authorities to new approaches and possibilities.

In her thirty years as the unsalaried official artist-in-residence of the New York Department of Sanitation, Mierle Ukeles has turned to performance, installation, and more recently public works projects in an effort to alter public perceptions about the meaning and significance of garbage. She shares Lucier's awareness of the role played by metaphor in governing our behavior. She would like to replace the simple notion of "waste" with the paradigm of "maintenance." In this view, the urban system in which the pile-up of garbage occurs should be seen not as a body to be purged of the "disease" of waste but as a complex organism whose interwoven systems of consumption, production, circulation, and disposal are all inescapable elements of the functioning city.

Another systems-oriented artist is Alan Sonfist. He shares Lucier's long view of the environment. He is best known for his "Time Landscapes," essentially time capsules which restore patches of indigenous forest within the cities which have supplanted them. Other works capture the natural processes of crystallization and condensation, growth and decay, within boxes or displays that make the reality of organic change and transformation visible and comprehensible to a jaded urban audience. The aim of all this work is to place man back within the natural cycles which define the longer history of the planet.

These and other sympathetic artists (others who might be mentioned are Mel Chin, Viet Ngo, Buster Simpson, Agnes Denes, Nancy Holt, and Michael Singer) share Lucier's interest in using art to rethink the ancient relationship of man and nature. The media they employ are diverse, encompassing sculpture, artist's books, performance, installation, and video, but their vision is similar. Like Smithson they ac-

knowledge the contradictions of landscape. And like Lucier they hope to repair the unnatural separation between man and nature.

In the end, *Noah's Raven* is a work which looks backward to the myths and dreams which have governed our sense of human purpose and forward to a different vision of nature and ecology. In its rich and multifaceted mix of sound, image, and installation, it asks far more questions than it answers. It seems appropriate to close this essay with Lucier's own reflections on the implications of *Noah's Raven:* "We are the first species to reflect on the consequences of our actions and to be aware of our role as stewards of the planet. With this sense of history, we have a legacy to pass on to other generations. That is why it is so important to ask questions about the possibility of human-caused extinction. Should our ethics be human-centered? In the long range, is it really right to privilege our species over all others?"[7]

### Notes

1. Carolyn Merchant, *The Death of Nature: Women, Ecology and the Scientific Revolution* (New York: Harper and Row, 1980).

2. Barbara Novak, *Nature and Culture: American Landscape and Painting, 1825–1875* (New York: Oxford University Press, 1980), 170.

3. Ibid., 171.

4. Frederick Jackson Turner, *Frontier and Section* (Englewood Cliffs, N.J.: Prentice-Hall, 1961).

5. Bill McKibben, *The End of Nature* (New York: Random House, 1989).

6. Robert Smithson, "Frederick Law Olmsted and the Dialectical Landscape," reprinted in Nancy Holt, ed., *The Writings of Robert Smithson* (New York: New York University Press, 1979), 120.

7. From a conversation with the artist, May 1992.

## Mary Lucier

## *Oblique House (Valdez)* (1993)

Valdez, Alaska is known throughout the world primarily as the namesake of the infamous oil tanker, *Exxon Valdez,* which, on March 24, 1989, struck a reef in Prince William Sound, spilling eleven million gallons of crude oil directly into the Gulf of Alaska. Twenty-five years earlier, on Good Friday, 1964, a massive earthquake and tidal wave struck Alaska from Anchorage to Homer, virtually destroying the original town of Valdez. Many lives were lost. The earth was reported to have sunk nearly a foot, and the town was subsequently moved four miles west, where it stands today.

In April 1991, I interviewed a random sampling of citizens of Valdez who had lived through both catastrophes, asking them to recall their experiences and to reflect on the ramifications of one or both of these events in the larger context of their lives and their beliefs. The final grouping consists of four individual head shots—Gloria Day, Walter Day, Thelma Cristofferson, and Marian Ferrier—each assigned to her/his own monitor nestled in one of the four corners of the small house structure which forms the physical structure of the work. Their voices have been processed to emphasize resonance and pitch, while their facial movements have been slowed to allow minute examination of gesture and expression. When approached by a viewer, each monitor will speak/sing for a given duration, then pause and wait to be reactivated via motion sensors. Depending on the movement of the audience, the voices will occur as solos, duets, trios, or as a quartet, becoming more and less musical as the density of the sound shifts. Because of the musicality of the processed voices, their intelligibility will vary, and viewers may choose to "play" this quartet for one characteristic or another.

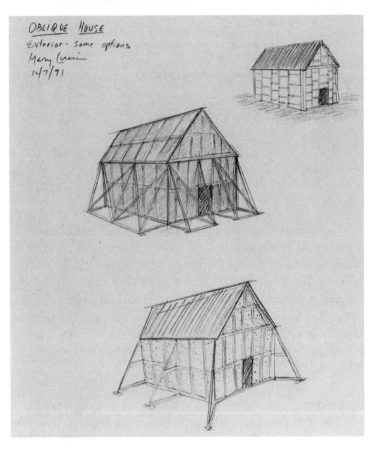

Sketches for *Oblique House (Valdez)* (1993), 1991. Photo by
Mary Lucier

The landscape is also brought indoors. Projected high on the pitched
roof overhead is a view from the center of the old town site, relentlessly
churning in a 360-degree horizontal spin, alternating with the earthy
image of rocks, seaweed, mud, and the occasional piece of twisted
metal or broken slab of concrete, continuously flowing across the un-
dersides of the roof as the camera explores the tidal ground of Old
Valdez. The processed sound of footsteps on wet soil and snow, of rock
hitting against rock, forms an ongoing percussive counterpoint to the
chorus of voices in the room below.

July 1993

Melinda Barlow

## The Architecture of Image and Sound:

## Dwelling in the Work of Mary Lucier

When asked five years ago to describe her early work in the genre of multimedia, Mary Lucier remarked, "I think multimedia was not a genre at all, but was a process of searching, and to be a multimedia artist meant that you were really looking for the medium that would best accommodate the idea."[1] Lucier's process of searching began with sculpture, moved to photography, led to an earthwork, and included performance before arriving, in 1973, at video installation, her primary medium for more than twenty-five years.

Some of the ideas Lucier has explored in this medium are well known: the limitations of video technology, the relationship between human beings and landscape, the way all three experience scarring, the necessity of memory, the inevitability of decay. Equally important but less well known is an idea expressed in her first installation, *Antique with Video Ants and Generations of Dinosaurs* (1973). Installed in a train at Grand Central Station as part of the Tenth Annual New York Avant-Garde Festival, *Antique* featured a secretary/armoire housing a videotape of an ant farm, a cactus garden, a triptych mirror, a magnifying glass, and a series of dinosaur postcards, also on videotape. In front of the armoire beneath a low-hanging lamp lay two black-and-white photographs embedded in glass, both closeups of landscape, stamped near the center with the word "INHABIT."

Begun in June 1972 and continuing on and off through April 1975, the *Inhabit* series expressed an idea to which Lucier has returned again and again. A small notebook dating from July 1973 served as a conceptual studio where she crafted the idea of inhabiting, on paper. A late November entry offers this definition: "inhabit: occupy physical space

Originally published in *Art Journal* (winter 1995): 53–57.

and time. physical space changes with passing of time and the nature of inhabiting."[2] Inhabiting is the activity of living in something; it takes place over time and alters the environment in which it occurs. As a concept, inhabiting implies both location and duration; it suggests the possibility, and the process, of experience.

"Words are clamor-filled shells," writes Gaston Bachelard; "there's many a story in the miniature of a single word."[3] The single word *inhabit* rings throughout Mary Lucier's oeuvre, opening onto a cluster of related concepts—abode, shelter, dwelling, home—each of which transforms an architectural structure into an intimate, physical environment. Lucier has been involved with intimate forms of architecture for as long as she has made video installations, and in the range of locations where her work has been shown, the idea of habitation reverberates further: in a coffin, on the grounds of an estate, at a church, in a loft, on a ferry, on a train, at a stadium, in an auditorium, in a planetarium, in a house.[4]

It is this last location that interests me here, for not only has Lucier built a work in a house, for another she actually constructed a house, and images of houses abound in her work. It is the significance of the house, as idea and experience, as structure and metaphor, as a place where intense habitation occurs, that I would like to explore in four installations: *Antique, Asylum* (1986/91), *Oblique House (Valdez)* (1993), and *Last Rites (Positano)* (1995). Within and across these four works, all assembled rather quickly, and each inviting intimate experience, the poetics and dialectics of the house unfold. We find, in this group, houses real and imagined, inhabited and abandoned, torn down, rebuilt, inside out; houses that provide security; houses signaling prosperity; houses that give shape to daily life. Also here, however, are houses in disrepair and torn by family feuds; bleak, lost, and haunted houses, inhabited solely by memory.

While *Antique* articulates the concept of habitation most directly, it refers to the notion of home most obliquely. It does not include an image of a house, nor was it installed in a house. Made from a found object since lost in storage, a hybrid piece of furniture at home in a parlor, *Antique* was remodeled into a "media sculpture" first exhibited inside a train.[5] With its cabinet closed, its writing desk open, and postcards suggesting travel adorning its "mantel," *Antique* was a whimsical, appealing environment where ants were enlarged, dinosaurs miniaturized, and human beings could envision themselves as Lilliputian. Video

in *Antique* was an agent of change, altering the scale of the ants in the ant farm and decomposing the image on the dinosaur postcard. It was also, however, a technology transformed: freed from its role as commercial television and therefore no longer obliged to entertain, it housed creatures within a monitor placed in an armoire installed for a day inside a train.

In *The Poetics of Space,* Bachelard describes the appeal of different kinds of furniture and also considers the significance of miniature. He calls his method "topoanalysis[:] the systematic psychological study of the sites of our intimate lives." We live most intimately, he suggests, in enclosures, in "felicitous" spaces that make us feel safe. A house is perhaps the most basic enclosure; as our first universe, it is "a real cosmos in every sense of the word." We return to this world whenever we daydream, and in daydreams we invest other spaces with the virtues of home. Shells, nooks, and corners, for example, promise comfort; they are places to curl up, to relax and to retreat. We treasure them because they seem protective; they remind us of earlier shelters we have known. The experience of intimacy triggers both fantasy and memory, and intimacy, writes Bachelard, "needs the heart of a nest."[6]

Chests, drawers, and wardrobes are sites of intimacy that satisfy our deepest need for secrecy; like houses they please us because they protect. The minuscule, meanwhile, opens up a whole world; by engaging the imagination, it invites us to dwell. *Antique* encourages imaginative activity and returns us to earlier protective environments stored in our own private wardrobes of memory. It seems hospitable even in photographs and makes one long for a chance to respond and correspond. In situ this longing must have been stronger: perhaps it was the explicit invitation to "INHABIT," perhaps the sight of oneself in a mirror, somehow already living inside, or perhaps the area for reading and writing that felt so familiar, so much like home. Visitors to *Antique* obviously felt welcome: they wrote Lucier notes and left them inside the desk.[7]

In 1978 artist David Ireland transformed a run-down, one-story frame house into a spacious two-story structure in the mixed residential and commercial Mission District of San Francisco. With an exterior made of corrugated sheet metal and a stark interior designed to catch light, the house somewhat resembled a fortress protecting a private refuge within.[8]

When Ann Hatch bought 65 Capp Street from Ireland in 1982, the spirit of the house inspired a program that gave new meaning to artist-

in-residence because both artist and work inhabited the same space.[9] Hatch knew the effect of placing art in this architectural context: as an artist's concerns merged with the demands of the site, an evolving meditation on the possibility of dwelling would emerge in the process of reinterpreting the house.[10] When *Asylum (A Romance)* was installed at the Capp Street Project, there was an interesting convergence and divergence of concerns: the peaceful hush inside the building was reinforced by the ruminative quality of the piece, yet the subject of that rumination was that secluded retreat is an impossible fiction; in the late twentieth century there is no place to hide.[11]

*Asylum (A Romance)* changed the main floor of Capp Street into a ruined conservatory enclosed in green lattice and filled with wilting plants, old chairs, and broken marble statuary resting on cedar chips, stones, sod, and dead leaves. Weathered planks traced a path past a dry stone fountain and a trelliswork arbor seat to a dimly lit toolshed built into an alcove. Next to the shed in a white-walled room sealed off by blue cage wire was a video monitor on a tall black pedestal. When installed at the Greenberg Wilson Gallery in New York five years later, *Asylum* assumed a somewhat new form.[12] The garden was reduced to its essential elements, arbor seat, fountain, and much less lattice, and was placed in a tighter, triangular arrangement with the toolshed and video/machine area. The monitor was mounted on a forklift behind a pile of debris gathered nearby on the Bowery.

"The videotape which supplies the pulse of the work," writes Lucier, "is a visual and auditory rumination on energy and entropy."[13] Combinations of image and sound stressed the strange coexistence of nature and culture found in our postmodern landscape: a spectral human being rearranged the trash, his body as wrecked as the place where he labored; cows grazed next to power lines and nuclear reactors; as the reactors roared against a flushed twilight sky, crickets began to chirp. This last shot recalled Chernobyl. Taped immediately after the disaster in the Ukraine, this ominous image of California's Rancho Seco transformed a historical event into a site-specific element: what happened over there might also happen here.

*Antique* brought furniture and landscape onto a train; in *Asylum* both garden and shed inhabited a house and were later installed inside a gallery. The shed in both versions inspired speculation: it was part of the original frame house on Capp Street, unaltered by Ireland, entirely intact; it seemed to belong in a movie set of a ghost town; it might be a bomb shelter; it was a makeshift dwelling, a clapboard shack.[14] Filled

with worn objects no longer in use—a toolbox, wheelbarrow, lantern, saw, wheelchair, mower, gun—the shed was alluring but also unsettling. Instead of living, laboring human beings, it was inhabited by the decayed stuff of memory.

Unlike Bachelard's solitary hut, that reliable "taproot of the function of inhabiting"[15] offering protection, comfort, and refuge, the shed was part of a complex installation in which urban detritus, a dying garden, and images of nuclear power lived side by side. A rusty structure in a temporary sculpture installed for awhile and then disassembled, the shed suggested not absolute shelter, but the ultimate impermanence of every abode. Houses, like human beings, erode over time. They weather, wither, and slowly grow old.

In *Oblique House (Valdez)* the house becomes even more anthropomorphic. For Lucier, like Bachelard, it is synonymous with soul: "our soul is an abode," writes Bachelard, and houses suggest "the topography of our intimate being."[16] The house constructed for this installation was a twenty-three-foot high, unfinished plasterboard structure built inside an empty car dealership in Rochester, New York, as part of Montage '93: International Festival of the Image. Inspired by Midwestern slat-wood farm buildings and by simple frame houses found in Alaska, it was an example of a style of American architecture painted many times by Edward Hopper.[17] And like Hopper's houses, also often anthropomorphic, *Oblique House* served many functions and had many moods:[18] on the one hand a stay against the ferocity of nature, it was also a reminder of the fragility of buildings during natural as well as man-made disasters; a cathedral-like place inspiring rumination, it was also a symbol of all domestic loss.

*Oblique House,* writes Lucier, is about "the architecture of image and sound": "outside, the house is blind; inside, television monitors provide windows which look not out to landscape, but further inward to the human soul."[19] Recessed in each corner of the house, these monitors featured interviews with four longtime residents of Valdez who lived through the earthquake that devoured the town in 1964 as well as the oil spill that blackened its shores in 1989. Shown in tight facial closeups vastly slowed down, their voices processed to enhance resonance and pitch, these survivors remained silent until visitors approached the motion sensors controlling their speech. Once activated, they shared their personal tales of well-known disasters in an environment reproducing the sudden upheaval characteristic of earthquakes. With the landscape brought indoors and projected overhead and the angled interior walls

also closing in, visitors could feel the vertigo described by several speakers, and imagine what it might be like to have a house collapse.

The loss of a house often shatters home and family. The speakers in *Oblique House* mourn slightly different aspects of this destruction: one woman remembers the house where she raised her children, saddened on their behalf that they can't go home again; another woman relives her grief at her son's disappearance, returning to the days after the quake when she thought that he was dead; this same woman, later, speaking as a daughter, relays the difficulty of deciding to put her mother in a nursing home. *Oblique House* restored the homes lost by these survivors by providing an environment where their memories could unwind. As visitors released these memories by approaching each monitor, they remembered and relinquished losses of their own.[20]

While *Antique* was made from a found piece of furniture and the shed in *Asylum* featured salvage from San Francisco, *Last Rites (Positano)* filled a gallery full of antique furnishings not found but handed down from mother to daughter. Consisting of a Victorian love seat covered in deep orange velvet, an oval-backed chair in the same rich fabric, a sewing cabinet known as a Martha Washington, a wrought-iron lamp with a decorative design of lovebirds, a piano chair reupholstered in warm floral tapestry, and an austere, cane-backed chair, this was furniture that Lucier knew intimately. It was in her mother's living room and in another room in which she died. In *Last Rites (Positano)* it was rearranged in a new room that took in her mother's life and let go of her death. Here, angled and suspended in midair, the furniture was liberated from its traditional function and seemed to dance joyously, thrilled to be free.

For Lucier this furniture had only one gender. Each piece was somewhat anthropomorphic and suggested her mother's presence: her photograph sat on one of the chairs, her touch was apparent in the careful reupholstery, and her body was recalled by the plush, curvaceous love seat. Near three pieces of furniture, her mother's memories seemed to well up from inside as they were released by visitor movement triggering stereo speakers.

In *Last Rites (Positano)* Lucier explored the first twenty-one years of her mother's life: her childhood in Ohio, her adventures as a young woman in Europe, and her move back to the United States as a divorced parent just prior to the outbreak of World War II. Of primary importance in this personal narrative was the time Margaret Glosser spent with her first husband and their infant daughter, Jessie, in the

small Italian town of Positano for several months in 1935–36. Here, after the idyll was over and life with Wolfgang became less than ideal, Glosser left him and moved to a house she adored with Maria di Lucrezia, a Positanesi woman who helped care for the baby. It was in her new home, she recalls, that she began to know who she was and to come into her own.

Glosser's memories of her life are challenged and reiterated by Jessie, Maria, and her brother Samuel Beer, who inhabited video monitors also triggered by motion sensors arranged around the periphery of the room. Two long overlapping video projections of water and two pairs of enlarged photographs were also included in the installation. A metaphor for the reflective surface of memory, and a luminous, moving painting reminiscent of images in *Ohio at Giverny* (1983), the projections formed a constantly changing backdrop for the stories of the speakers as they unwound in response to visitor movement.[21] The two pairs of photographs brought together people and places from different moments in time: one compared Glosser as a young woman in Europe and as an elderly cancer patient; the other juxtaposed Positano as it looked in the 1930s with an old family home in Ohio.

The summer shot of the seaside town of Positano, with its charming, boxy houses built into a hill, stands in sharp contrast to the grim image of the Ohio house in the dead of winter, cold, forbidding, and lonely in the snow. As somber as Hopper's *House by the Railroad* (1925), as sinister as Norman Bates's house on the hill, and as mysterious and strangely sentient as the crumbling House of Usher, this house suggests the life that Glosser tried to leave behind but returned to with her child on the eve of World War II. A house with no future, only a past, a house filled with feuding, with creatures, for Glosser, that "galloped up and down the stairs," this house, now torn down, was a living, formidable symbol of family disintegration, isolation, and demise.[22]

> The house is one of the greatest powers of integration for the thoughts, memories, and dreams of mankind. The binding principle in this integration is the daydream. Past, present, and future give the house different dynamisms, which often interfere, at times opposing, at others, stimulating one another.[23]

For more than twenty years, Mary Lucier has brought furniture and architecture together in structures deeply concerned with the process of habitation. If video installation is the medium that best accommodates this idea, it is because in an installation we learn to inhabit, to live with

an experience we must ultimately let go. An installation, like all felici-
tous, intimate enclosures, is also a "eulogized space," a place, like a
house, that integrates experience, where memories and daydreams
conflict and cohere. In Lucier's temporary houses and transfigured
rooms we gain facility in the art of living by remembering what it
means to dwell. "And by remembering 'houses' and 'rooms,'" as
Bachelard suggests, "we learn to 'abide' within ourselves."[24]

### Notes

1. Mary Lucier, interview with Cynthia Nadelman, typescript, Archives of
American Art, Smithsonian Institution, New York, N.Y., April 18, 1990, 122.

2. Mary Lucier, notebook in the artist's possession, July 1973.

3. Gaston Bachelard, *The Poetics of Space* (Boston: Beacon Press, 1969), 179.

4. I am referring, respectively, to *Color Phantoms* (1971), *Journal of Private
Lives* (1972), *Word Fragments and Recycled Images 1* (1974), *Second Journal
(Miniature)* (1972), *Antique with Video Ants and Generations of Dinosaurs*
(1973), *Chalk Writing with Air Writing/Video* (1974), *Dawn Burn* (1975–76),
*Planet* (1980), and *Asylum (A Romance)* (1986). For descriptions and specific lo-
cations of works, see Melinda Barlow, "Mary Lucier: Biographical Notes," in
Sandra E. Knudsen, ed., *Noah's Raven: A Video Installation by Mary Lucier*. Ex-
hibition catalogue (Toledo: Toledo Museum of Art, 1993), 41–48.

5. "Media sculpture" is the term first used by Lucier to describe her work.
Mary Lucier, interview with the author, New York, June 22, 1992.

6. Bachelard, *Poetics of Space*, xxxi, 4, 8, 65.

7. Lucier, Nadelman interview, Archives of American Art, 149.

8. See Sally Woodbridge, "Light Metal," *Progressive Architecture* 8 (August
1982): 72–75; and Ann Hatch, introduction to Kathryn Brew, ed., *Capp Street
Project, 1985–1986*. Exhibition catalogue (San Francisco: Capp Street Project,
1987), 6.

9. For a three-month period, an artist granted a residency at Capp Street at
this time lived and worked in the same space where, and when, the work was
exhibited.

10. See Ann Hatch, introduction, and Leah Leavy, "Capp Street Project In-
augural Exhibition and 1984 Residencies," in *Capp Street Project 1984*. Exhibi-
tion catalogue (San Francisco: Capp Street Project, 1984), 5, 7–13.

11. Critics of both the Capp Street and Greenberg Wilson versions of *Asylum*
commented upon this phenomenon. See Christine Tamblyn, *"Asylum (A Ro-
mance),"* *High Performance* 35 (1986): 98. Arlene Raven, "Refuse Refuge," *Vil-
lage Voice*, January 15, 1991, 83, remarked that the work suggests that "there is
no asylum from the facts of energy and entropy."

12. Another version of *Asylum (A Romance)* was included in *Earthly Delights:
Garden Imagery in Contemporary Art*, at the Fort Wayne Museum of Art, Fort
Wayne, Ind., September 10–November 6, 1988.

13. Mary Lucier, *Asylum (1986/91),* artist's statement, 1991.

14. See Lucier, Nadelman interview, Archives of American Art, 452; Peggy Cyphers, "Mary Lucier," *ARTS Magazine* 65 (April 1991): 96; and Jude Schwendenwein, "Mary Lucier: *Asylum,*" *High Performance* 54 (summer 1991): 52.

15. Bachelard, *Poetics of Space,* 31.

16. Ibid., xxxii, xxxiii.

17. I am thinking especially of the single roadside frame house depicted in Edward Hopper, *Solitude* (1944).

18. Gail Levin remarks upon the anthropomorphic quality of Hopper's houses in *Edward Hopper: The Art and the Artist* (New York: W. W. Norton, with the Whitney Museum of American Art, 1980), 44–45. Describing another painting of simple frame houses, she continues, "In *Two Puritans* (1945) the houses seem strangely animated, as if they had personalities all their own. The windows, shutters, and doors read almost like facial features, elements of personalities that make their presence felt."

19. Mary Lucier, talk given at Montage '93: International Festival of the Image, Rochester, N.Y., July 28, 1993, 8.

20. For more on the experience of *Oblique House* and the way in which it serves as a companion piece to *Noah's Raven* (1992–93), see Melinda Barlow, "Personal History, Cultural Memory: Mary Lucier's Ruminations on Body and Land," *Afterimage* 21 (November 1993): 8–12.

21. *Ohio at Giverny* is Lucier's meditation on Monet, dedicated to the memory of her American uncle and his French wife. In her statement about the installation, Lucier writes, "The work is an investigation of light in landscape and its function as an agent of memory, both personal and mythic . . . References to the motifs of Monet function throughout as the 'art-historical' memory, underlying the more personal evocation of French and American personae." Mary Lucier, artist's statement, February 14, 1983.

22. Margaret Glosser, interviewed by Mary Lucier, included in *Last Rites (Positano).*

23. Bachelard, *Poetics of Space,* 6.

29. Ibid., xxxi, xxxiii.

## Mary Lucier

### *Last Rites (Positano)* (1995)

In 1988 I recorded nine hours of conversation with my mother, Margaret Glosser (then seventy-three), shortly after the first of her surgical procedures for ovarian cancer and four years before her death. In the edited narrative, she reminisces about the first twenty-one years of her life: her childhood growing up without a mother in a small Midwestern town, her adventures and misadventures as a young woman in Europe in the mid-1930s, and her return to the United States as a divorced parent prior to the outbreak of World War II. During several periods in 1935 and 1936 she lived in Positano, a small town on the Amalfi Coast, south of Naples. A rustic and very isolated fishing village at that time, it was an occasional retreat for American, German, and Russian expatriates. Margaret and her then-husband, Wolfgang Meiners (correspondent, philanderer, and con artist), had a led a peripatetic bohemian life in Yugoslavia, Spain, and Rome where, in September 1936, my older half sister was born. The three of them returned to Positano, where Margaret began to be independent for the first time and, with the help of Maria de Lucrezia, a local Positanesi woman, set about finding a house and creating a home for herself and the infant. Eventually, she became disaffected with Wolfgang and their life, leaving for the U.S. with the six-month-old child, never to return to Europe. She subsequently remarried and spent the rest of her life in the small Ohio town where she was born and where I too grew up. The *idea* of Positano in my mother's recounting of her youth came to have almost mythic resonance as a place of glorified but ambiguous status. It came to signify both the fulfillment of an American romantic longing and the ultimate failure of that ideal to sustain a productive and rewarding life. It represented happiness and misery, adventure and peril,

an ending and a beginning—a personal drama played out against the backdrop of history.

Motivated by my own fascination with the overall trajectory of my mother's life, I traveled to Positano (now a fashionable resort) in August of 1994. Through a series of seemingly miraculous coincidences, I located the very Maria, now in her late eighties, who had been my mother's housekeeper and confidante and my sister's godmother, recording an hour-long interview with the help of a Positanesi friend. Additional interviews were conducted with my sister, now fifty-eight, and an uncle, eighty-three, in an effort to gather multiple firsthand and recollected stories of that period. Each of these "witnesses" testifies to a somewhat different story, skewed to his or her self-image and personal view of the past.

The piece is an interactive audio and video installation based on the original interviews, which have been edited and processed through frequency shifting and tuned resonance filters to create a "chorus" of pitched voices, accompanied by extremely slow motion, nonsynchronized video of the witnesses' faces, and an "ambient" wall of slowly rippling water. The installation occupies a room delineated by sparse groupings of antique furniture hanging at angles and at various heights from the ceiling, photographs, and suspended loudspeakers, along with three wall-mounted monitors (for the witnesses) and a continuous, overlapping dual projection of water against the rear wall. Each of the furniture clusters and monitors has its own voice, recorded on laserdisc as a series of musically processed episodes and activated by the viewer's approach to the installation's visual elements. Thus, parallel narratives become layered and interwoven according to audience movement, allowing for the voices to sing alone or in various combinations and creating a counterpoint of spoken text and musical figures. This responsive system is intended to facilitate a constantly changing dynamic structure and texture determined by audience interaction rather than by a set of decisions predetermined solely by the artist. Ultimately, the work is intended to be, not merely a biographical portrait, but an investigation of relationships and reconciliations between people and places, memory and history, present and past, aging and illness.

1995; revised August 3, 1998

Charles Hagen

## The Unsolved Mysteries of Memory

The persistence and fallibility of memory has been a central, if often hidden, theme in Mary Lucier's video installations of the last two decades. In *Last Rites (Positano),* her terrific new piece at the Lennon, Weinberg Gallery in SoHo, Ms. Lucier addresses the fluidity of the past and the urgency and impossibility of preserving it, in what is by far her most explicitly autobiographical work.

Combining still photographs and interviews presented on video monitors and through speakers scattered about the gallery and items of furniture suspended in midair as if in the wake of an explosion, the piece recounts a central incident in Ms. Lucier's family history. As with most such stories, details and even crucial facts are remembered differently, with family members offering competing tales that are fragmented, repetitive, and contradictory.

The work is based on events in the life of Ms. Lucier's mother, who in 1934 traveled from her home in Ohio to England, where her brother was a Rhodes Scholar. There she met and married a charming German correspondent; after the birth of a daughter, the family settled in Positano, the picturesque fishing village on the Amalfi Coast south of Naples. Two years later, Ms. Lucier's mother divorced her husband and returned to the United States with her daughter. She later remarried, and spent the rest of her life in her hometown, Bucyrus, where Ms. Lucier herself was born.

This complex narrative is never presented directly. Video monitors present interviews with three secondary figures: Ms. Lucier's elder half sister, her mother's brother, and the Italian woman who worked as the

Originally published in the *New York Times,* April 7, 1995.

family's housekeeper in Positano. Each recalls aspects of the overall story, but with significant gaps and apparent distortions.

The main characters, though, are absent. Ms. Lucier's mother, who died several years ago, is heard on speakers suspended from the ceiling, and large photographs show her both as a beautiful young woman and as an older woman, her gray hair cropped in a severe cut. But her video image is missing, and as a result she seems ghostly, an invisible character.

Her first husband is even more invisible. The other characters speak of him endlessly, describing him as engaging and witty but neglectful and a heavy drinker. Soon after the divorce, he disappeared; some reports said he had been interned by the Nazis and sent to fight in Russia. The family quickly lost touch with him.

Also apparently missing from the cast of characters is Ms. Lucier herself. She appears nowhere in the installation—neither in the video or audio interviews nor in the photographs. But she is still clearly present, as the drama's narrator and stage manager.

Underscoring the installation's autobiographical nature are the pieces of family furniture suspended throughout the gallery. These come from Ms. Lucier's childhood home; the open drawer of a nightstand reveals graffiti she put there as a girl.

Sophisticated but unobtrusive technology allows this richly evocative work to achieve striking effects. For example, as viewers approach the video monitors, motion sensors cause the static figures on screen to spring magically to life. As visitors pause to listen to the interviews, the tapes lapse into silence. But when the viewers move on, the monitors start up again, as if anxiously tugging at the visitors' sleeves to keep their attention.

Projected onto the back wall of the dimly lighted space is a huge video closeup of undulating waves colored with splotches of pastel light. This mesmerizing image not only suggests the exotic dream that Positano must have represented for Ms. Lucier's mother, but also evokes the shifting crosscurrents of conversation offered by the characters of the story.

The image also brings to mind Ms. Lucier's earlier installations, many of which have been based on similarly romantic landscape imagery. In particular, it shares the mood of *Ohio at Giverny*, her 1983 work relating closeups ups of Monet's gardens with shots of the Midwest.

In fact, that well-known piece can be seen in retrospect as a rehearsal

for *Last Rites (Positano).* In her powerful new work, Ms. Lucier directly addresses issues she dealt with metaphorically before, about the lasting influence of the past, and about the role Europe has played in the American imagination as a place of romance and culture.

That these questions turn out to have such a strong personal dimension is no real surprise. In recounting in all its ambiguity a pivotal episode in her mother's youth, Ms. Lucier points to the sense of mystery that permeates the stories most families tell about themselves.

**Jenifer P. Borum**

**Mary Lucier, Lennon, Weinberg, Inc.**

Through a rich interweaving of different media, Mary Lucier's *Last Rites (Positano)*, 1995, reconstructed a distant moment of her recently deceased mother's past. Lucier transformed the gallery into a dramatically lit, cavernous space, and filled it with speakers, video monitors, her mother's furniture, and photographs. The result was less a testament to the loss of her mother than to the mechanisms of memory itself.

At the center of *Last Rites* was a narrative of adventure, romance, and tragedy: Lucier's mother, Margaret Glosser, an Ohio native, traveled abroad as a young woman, met and fell in love with a bohemian German writer named Wolfgang, settled in the Italian fishing village of Positano, bore a child (Lucier's older half sister), and finally left her husband just before the onset of World War II to return with her daughter to Ohio, where she settled and remarried. Lucier's installation—a cross between a memorial service, a courtroom trial, and a really strange dream—reconstructed this period in her mother's life.

In three separate areas of the gallery, a speaker suspended from the ceiling played a different section of Glosser's taped recollections of her European romance. Her furniture (either hanging from the ceiling or resting on the floor), along with numerous photographs, helped to ground her somewhat unsettlingly disembodied voice.

The videotaped testimonies of three "witnesses" to Glosser's youthful adventure—Glosser's brother, her daughter by the mysterious Wolfgang, and an Italian friend from Positano, each of whom appeared as a talking head on a suspended video monitor—were shown in slow motion to emphasize the speaker's facial expressions, giving them the

Originally published in *Artforum* (October 1995): 102–3.

uncanny look of people floating in a dimly recalled dream fragment. Both the monitors and the speakers were wired to motion sensors so that any attempt to stop and focus on a narrative produced a frustrating silence, perfectly capturing the necessarily partial and fleeting nature of memory. In another evocation of a long-forgotten time and place, overlapping images of flowing water—its rushing sound sometimes interspersed with the music of Italian church bells resonating in the distance—were projected onto a wall of the gallery to form a triptych of sorts.

Lucier's thematic consideration of memory's imperfections was echoed in her choice of media: her work foregrounds the inability of memory and technology alike to re-create experience. Yet *Last Rites* revealed these shortcomings to be not a curse but a blessing. For Lucier, memory, like artmaking itself, is a poetic response to what remains just beyond our grasp.

**Mary Lucier**

*Aspects of the Fossil Record, or From Here On,*

*Dance* **(1996)**

*Aspects of the Fossil Record* is a video sculpture consisting of three monitors and two loudspeakers suspended at various heights from the ceiling. Each object is hung by a single point, according to its precise center of gravity, in order to be able to turn freely on stainless steel turnbuckles. Multicolored video, audio, and power cables are draped and coiled loosely underneath. Three laserdisc players, a video controller, and an audio amplifier are simply placed under the sculpture itself, on the floor, with AC power cables leading to the nearest wall or floor outlet.

The video imagery consists of three continuous loops: 1. *Top monitor* (sky): a direct view of the sun as seen through an intense camera iris flutter resulting in a violent strobing of the image, slowed to a heartbeat pulse; 2. *Middle monitor* (horizon): a blue heron attempting to take flight, performing a kind of endless elliptical dance in extreme slow motion, never lifting off; 3. *Bottom monitor* (ground): a view from the camera traveling rapidly over the ground just outside the Amazon forests. Here, dead leaves and other detritus appear to cascade down the surface of the monitor as a dizzying flow of frames, sharply defined through the use of high shutter speed and slow motion.

The audio is an electronically processed and layered mix of ambient sound suggesting ocean waves, thunder, and dry rustling leaves.

March 25, 1996–April 1, 1997

**Annette Barbier**

## *Aspects of the Fossil Record*

Mary Lucier's preoccupation with mortality resounds in her recent video installation *Aspects of the Fossil Record, or From Here On, Dance.* The three-channel piece consists of three twenty-five inch monitors suspended at different heights, distances, and angles from the viewer. Each monitor is fed by a video loop, the top one consisting of a flashing white sun emanating rays and surrounded by a dark blue field; the middle one showing a great blue heron dancing in slow motion and reverse on a shoreline; and the bottom containing footage of a forest floor seen from above in closeup while walking. Each source is processed in a way that subtly affects our perception. The sun fades to black in quick, rhythmic bursts. The heron, reversed and slowed down, was shot with the shutter at typical video speed—so the motion when slowed smears across the screen. The forest floor, shot with a very fast shutter speed, produces artifacts of repeated edges (of leaves, sticks, etc.), turning the forest floor into a mosaic tile. There is a sense of progression through the monitors—as of an individual's journey, with both a connection to the earth, a destination which transcends the earth, and a reveling in the pleasures in between. The heron presents a complex set of issues, however, as a being whose medium is air and water, but who is here earthbound, flapping her wings but never rising into the air, caught in an eternal and repeated present.

Originally published as part of "Conference Review: The Total Museum," *Leonardo Electronic Almanac* (November 1996), <http://mitpress.mit.edu/e-journals/LEA>.

**Mary Lucier**

## *House by the Water* (1997)

*House by the Water* is a mixed-media video installation commissioned by the Spoleto Festival USA (1997) and installed in a turn-of-the century brick warehouse in downtown Charleston, South Carolina. Modeled after a small weather station and other types of architecture commonly found along the coast in the low country, the structure is elevated on stilts seven feet above the ground and surrounded by a six-foot cyclone fence. It is situated diagonally in the center of the space with simultaneous video projection on all four sides and sound emanating from loudspeakers in the four corners of the room. There is no ideal vantage point. In order to view all four channels of video, the audience must be, more or less, in continuous motion around the house.

The work depicts aspects of extreme weather and culture, juxtaposing simultaneous images of natural phenomena (such as Hurricane Hugo) with vignettes shot in the master house and the slave quarters of the Aiken-Rhett plantation in Charleston. This environment is intended to convey some of the drama and mystery of living close to the primal forces of nature, as it suggests relationships between social history and the temperament of climate.

1997; revised August 2, 1998

**John Beardsley**

*"House by the Water"*

The setting is the darkened interior of an old brick warehouse off an alley in the commercial district along Charleston's upper King Street. In the center of a room about thirty-five by fifty feet long and thirty-five feet high is a single architectural structure, angled so that its walls face the corners of the room. It is a simplified house on stilts about eighteen feet high with white siding and a metal roof, enclosed in a chain-link fence and faintly illuminated from within by two blue bulbs. It suggests a weather station. Images flicker on all sides of the structure, emanating from video projectors hung from the roof. From any vantage point, only two walls of the house are visible at a time, but the images appear to be perfectly synchronized. At times, they follow each other around the building; at others they offer multiple perspectives on the same scene, creating a fragmented narrative. Sound fills the space. Most of it seems to be derived from taped conversations, which are sometimes intelligible. But at other points, the sound is slowed down, processed, or amplified, creating a distorted, ghostly effect. At moments, the sound seems to have a directional character, starting first in one speaker, then the next. Drawn by the movement of image and sound, you revolve around the house, assembling the parts of this puzzle into a composite mental picture.

The sequence of audiovisual experiences is baffling at first. Sunlight glimpsed through the branches of trees shines from the walls of the structure, accompanied by the songs of birds. Choppy water is seen close-up, with the sound of waves breaking against the bow of a boat.

Originally published in John Beardsley, *Art and Landscape in Charleston and the Low Country,* a Project of Spoleto Festival USA, (Washington, D.C.: Spacemaker Press/Spoleto Festival USA, 1998), 102–5.

The interior of a grand but deteriorated house comes next, along with a spoken narrative about enlarging the slave quarters to shelter more servants. A girl in a white dress pirouettes in front of a full-length nineteenth-century portrait of a woman in a formal gown; the girl's long twirling skirt fades to become the ghostly radar image of a hurricane making landfall on the Carolina coast. The room goes black.

When the images return, we are looking down the corridor of a weatherbeaten dwelling, presumably the slave quarters mentioned in the narrative. Two figures appear in sequence: an African American man and woman, both in the nineteenth-century clothing of domestic servants, run separately down the corridor in slow motion to the prolonged and amplified sound of pounding footfalls. As they approach the camera, they vanish. On a contemporary street, the camera passes small, fragile-looking houses and waving black men. Back in the interior of the slave dwelling, the man and woman read in separate but simultaneous scenes projected on opposite sides of the structure. We see the Bible over their shoulders, open to the book of Isaiah. As the camera zooms in on the page, we make out some of the text from chapter 41, verse 17: "When the poor and needy seek water and there is none, and their tongue is parched with thirst, I the Lord will answer them, I the God of Israel will not forsake them." Then waves crash against a coastline, driven by furious winds. The radar image of a hurricane appears again, this time in color. The walls of the house go dark. After a few seconds, sunlight appears, and the cycle begins again.

In brief, such was the experience of Mary Lucier's multimedia installation *House by the Water*. It included footage shot in Charleston—in the street and on the estuary—with radar and video images of hurricanes that have ravaged the city. It also featured vignettes with white and black actors produced at the historic Aiken-Rhett House, an unrestored antebellum mansion maintained by the Historic Charleston Foundation. Lucier taped both the main house and the slave quarters, both empty and animated with actors in period costumes who evoked the lives of people who once lived there. While exploring the connections between social history and the environment, *House by the Water* also dramatized the perils of living close to the primal forces of nature.

A pioneer in the relatively new field of video art, Lucier has been creating multimedia installations since 1973. Like *House by the Water*, many address the experience of landscape. *Dawn Burn* (1975), for example, composed of seven monitors in a freestanding arc, was made by pointing the camera at the sunrise every morning for seven days and

creating a solar burn in the video tube, while *Ohio at Giverny* (1983) was videotaped both in the artist's home state and in Monet's renowned garden in France.

Lucier has also worked with architectural forms before. For a 1993 installation called *Oblique House (Valdez)*, for example, Lucier designed a rectangular plasterboard structure with a peaked roof twenty-three feet high. Inside, monitors in each corner played interviews with four residents of Valdez, Alaska, who had survived various disasters, including an earthquake that flattened the town in 1964 and the notorious oil spill in 1989. These monitors were interactive—motion sensors turned them on as viewers approached. Overhead, images of landscape were projected on the ceiling, inverting inside and out, sky and ground. Cataclysm was presented here in both its human and natural forms in recognition of the fact that culture, like nature, can be both creative and destructive.

As suggested by these synopses, Lucier typically ventures far beyond simple depictions of landscape to explore the ways that humans occupy an environment. Like Charles Simonds, she has created extended meditations on the body and landscape as different but analogous forms of habitation. *Noah's Raven*, a four-channel laserdisc installation for eight monitors in an arrangement of trees and forklifts beneath a hanging fossil, drew parallels between environmental and bodily health. It juxtaposed the clearing and burning of forests with the body in surgery, enforcing connections between the scarring of land and of flesh. The installation registered her response to the destruction of the Amazon rainforest, "which I think is one of the most futile exercises on the face of this planet." But it was also made during the time that her mother was fighting a three-and-a-half-year battle with cancer. "I wanted to look at scarring as a common issue that could be seen as benign or malignant. Some scars are beneficial in that a disease has been cured. Others are the scars of destruction. So I looked at the body and I looked at the landscape with that duality in mind."[1]

Duality was also a pronounced part of *House by the Water*. The installation contrasted inside and outside, shelter and vulnerability, beauty and terror. The house provided both the basic structure and the dominant metaphor for the project. It was present both as a literal object and as an imaginative space. An actual house, in good condition, stood before us in the warehouse, but another, aged and worn, was represented in the video images. We saw the house from the outside in the literal construction; we plumbed its interiors in the video. In the ware-

house, the house occupied our present; in the video images, it was the repository of memories. We expect houses to offer us shelter, but *House by the Water* presented a structure exposed to fierce storms and grievous loss, represented in hurricanes and vanishing figures.

*House by the Water* drew other comparisons as well. It contrasted the lives of white and black inhabitants of the house even as it expressed the connections between psychological experience and the external forces of nature, suggesting the ways that people adapt to the vicissitudes of life. Perhaps most poignantly, the black couple was seen fleeing, perhaps from the advancing storm, perhaps from a life of involuntary servitude. They were also pictured in a quiet moment, reading the Bible, in a sequence that was recorded almost by chance. "It was my idea that they should read, but their idea to read the Bible," Lucier recalls. "We were really coauthors of that scene." Coincidentally, when Lucier focused in on the book, it was open to the passage in Isaiah in which the Lord promises succor to his people and vengeance on their enemies. "Fear not," an adjacent verse reads, "for I am with you . . . I will strengthen you, I will help you, I will uphold you with my victorious right hand." While serendipitous, this reference underlined the theme of refuge conveyed by the figures in the house. Portrayed in bondage in a land prone to hurricanes and flooding, they nonetheless knew the prophecy: "I the God of Israel will not forsake them." Their house in this instance was more than a literal dwelling. It became a metaphor for faith, a bulwark—however battered and frail—against the adversities of nature and culture alike.

### Note

1. Mary Lucier, quoted in Nicholas Drake, "Artist Uses Life Experiences as Basis for Mixed-Media Works," *Charleston (S.C.) Post and Courier,* May 29, 1997, Spoleto Today (special section), 2.

*Polaroid Image Series: Room* (1969): *a,* original image; *b,* fifth generation; *c,* thirteenth generation; *d,* twenty-first generation. Photos by Mary Lucier

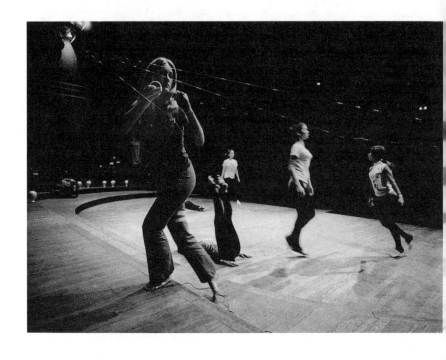

Mary Lucier (*front*) performing *Hymn* (1970), by Alvin Lucier and
Mary Lucier, Sanders Theater, Memorial Hall, Harvard University,
Cambridge, Mass., March 25, 1970. Photo by Norman Hurst

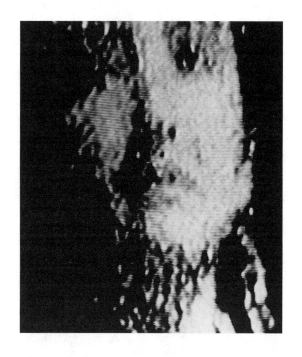

Offscreen video image of Cecilia Sandoval from *The Occasion of Her First Dance and How She Looked* (1973). Photo by Mary Lucier

*Antique with Video Ants and Generations of Dinosaurs* (1973),
installed at the Women's Interart Center, New York, 1976. Photo
by Mary Lucier

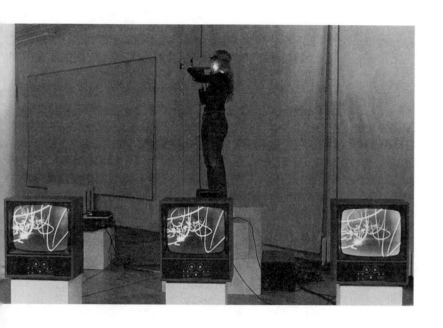

Performance of *Fire Writing* (1975–76) at the Kitchen, New York, 1975. Photo by David Arky

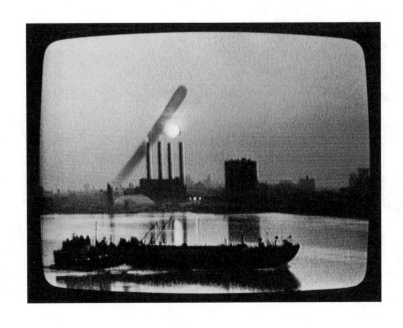

Offscreen video image from *Dawn Burn* (1975–76). Photo by
Mary Lucier

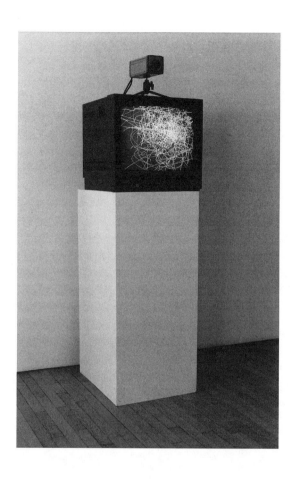

*Untitled Display System* (1977/1997). Photo by Mary Lucier

Installation shot of *Planet* (1980), Hudson River Museum, Yonkers, N.Y., 1980. Photo by Mary Lucier

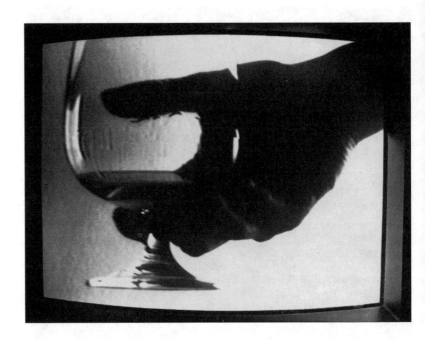

Offscreen video image from *Denman's Col (Geometry)* (1981). Photo by Mary Lucier

Offscreen Video Image from *Denman's Col (Geometry)* (1981).
Photo by Mary Lucier

Installation view of *Ohio at Giverny* (1983), installed at the Whitney
Museum of American Art, New York. Photo by David Allison

Offscreen video image, *Ohio at Giverny* (1983). Photo by
Mary Lucier

Installation view of *Wintergarden* (1984), installed at Whitney
Museum of American Art at Philip Morris, New York, 1985.
Photo by David Allison

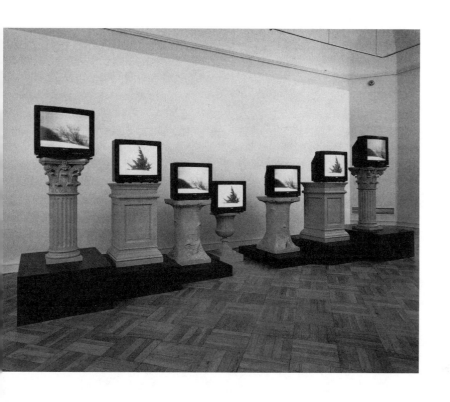

Installation view of *Wilderness* (1986), installed at the Henry Art
Gallery, University of Washington, Seattle, 1988. Photo by
Richard Nicol

Installation view of *Asylum* (1986/91), installed at the Greenberg, Wilson Gallery, New York, 1991. Photo by Mary Lucier

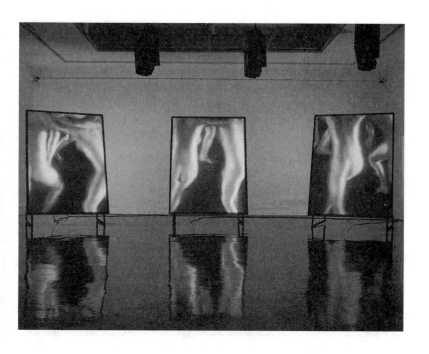

Installation view of *MASS* (1990), by Mary Lucier and Elizabeth
Streb, installed at the Arts Center, Portsmouth Museums,
Portsmouth, Va., 1992. Photo by David Simonton

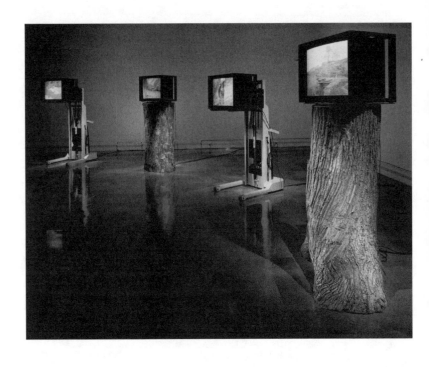

Detail from installation of *Noah's Raven* (1993), installed at the
Toledo Museum of Art, Toledo, Ohio, 1993. Photo by Tim Thayer

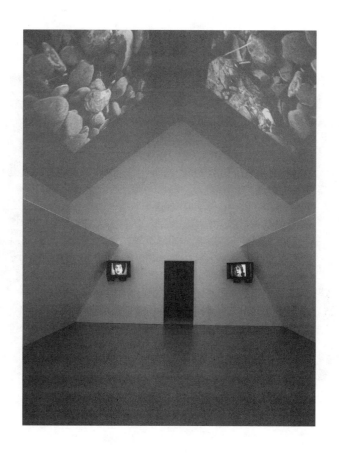

*Oblique House (Valdez)* (1993), installation included in Montage
'93, International Festival of the Image, Rochester, N.Y., 1993.
Photo by James Via

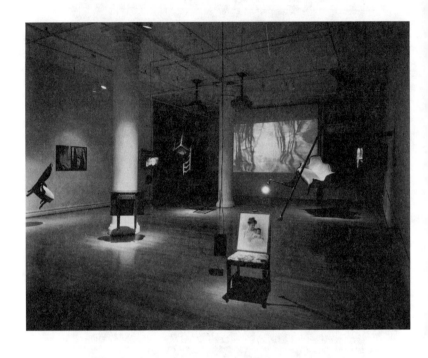

Installation view of *Last Rites (Positano)* (1995), installed at Lennon, Weinberg Gallery, New York, 1995. Photo by David Allison

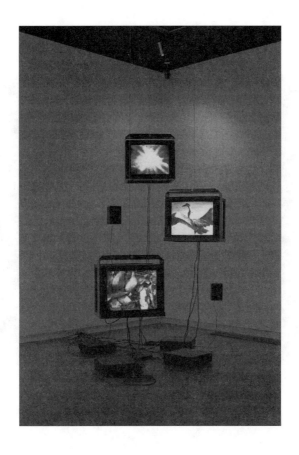

Installation view of *Aspects of the Fossil Record, or from Here On, Dance* (1996), installed at the David Winton Bell Gallery, Brown University, Providence, R.I., 1996. Photo by Mary Lucier

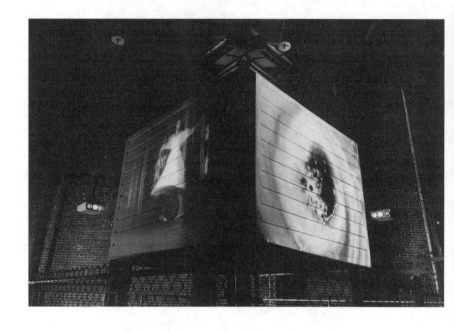

Installation view of *House by the Water* (1997), included in the
Spoleto Festival USA, Charleston, S.C., 1997. Photo by Len Jenshel

# IV Interviews

## Nancy Miller

## An Interview with Mary Lucier

**MM:** In *Wilderness* your subject is the American landscape.

**ML:** I'm dealing with landscape from various points of view, and I've been dealing with this subject since I began making art. That subject has something to do with national identity and personal identity, increasingly expressed in the investigation of landscape and light in landscape. But it's important to mention that I wanted also to get images not only of pure nature—what you might call wilderness—but cultivated nature and aspects of design or domestic architecture. Also industry. So that the piece is really a mixture throughout, an interweaving of all those kinds of images from all those places. It's not merely a trip into the wilds. The scenes of pure nature are almost always seen in counterpoint to the hand of man and what has been wrought in the environment. The wilderness is a metaphor for what I'm really interested in, which is ultimately the conflict between the wild and the civilized and where that is taking us. I think *Wilderness* has primarily to do with my focus exclusively now on themes that are indigenous to America; themes that are, in fact indigenous to American culture and have been from very early times, in literature as well as painting. I'm coming to focus exclusively on what I consider to be the American condition or archetypal American concerns. The piece is about the state of wilderness as a condition of origin for the United States, both as a reality of life and as a projection from the Old Testament for the first settlers, as well as an aspect of assimilated myth for the contemporary American.

Originally published in Nancy Miller, ed., *Wilderness*. Catalogue (Cambridge, Mass.: Rose Art Museum and New England Foundation for the Arts, 1986).

Wilderness was at first the dark opposite of the Garden of Eden, something to be tamed, cultivated, and purified. As the natural wilds began to disappear, the idea of the wilderness became nostalgic, and the notion of preservation became a cause. Americans began to discover that it was important to retain some concrete aspect of wilderness, in order to preserve the national identity, that of a garden having been righteously won from the wilds.

**NM:** Let's talk about the painters you have been researching and your unique use of the sites they painted.

**ML:** The painters I've been interested in include Thomas Cole and the Hudson River School, Albert Bierstadt, Frederic Church, and John Kensett. Martin Johnson Heade and Fitz Hugh Lane are also important, as are George Inness, Albert Pinkham Ryder, and Winslow Homer. I did a great deal of research and looked at a lot of paintings at the Metropolitan Museum, the Brooklyn Museum, the High Museum in Atlanta, and others. Nineteenth-century paintings became the models for my approach to the subject of American landscape and culture. Initially I thought it would be a very interesting task to go back to the original sites to see how they had changed or how they were the same. Or to see if, in fact, you recognized and felt the presence of the paintings. As to the sites I've taped for *Wilderness*, they almost all derive from paintings. When I returned to the actual locale, sometimes I found I could reconstruct paintings, directly or indirectly. Or, if I didn't actually go to the salt marsh at Newport, where Kensett worked, for instance, I did shoot in a salt marsh near Wellfleet and I've allowed that to be accurate enough. If that genre of painting is one of the motifs I've found repeated throughout the period, and if I felt it fit into the fabric of the piece, then it doesn't actually matter whether I've videotaped the exact location or not. What's remarkable, one way or the other, is this extraordinary sense of connecting to the past through a contemporary technology.

**NM:** Why do you feel a connection with the nineteenth century is of value to you?

**ML:** I think there is a parallel between the nineteenth century and the present time. In the mid-1800s, the onrush of the process of industrialization was possibly the most significant issue of the time. Certainly

American writers responded to it in a very particular way, and I think the painters did also. I see a direct parallel between, say, the dilemma of nuclear power that we face now, and what was implied at mid-nineteenth century. The achievements of science and technology are both spectacular and terrifying. The B-1 bomber is gorgeously designed, but it is also an instrument of death. Nuclear power, as the extreme example, has the potential for tremendous usefulness, yet it is ultimately life-destroying. Industrialization is both an instrument for beneficial progress and the spoiler of the land. As Leo Marx points out in his book *The Machine in the Garden,* the symbol of the train cutting through the pastoral stillness was a harbinger of what was to come. We can see what has transpired in the past hundred years since the advent of the railroads across the continent and the inexorable encroachment of industry throughout the land. In that time we have grown more cynical as, I think, we have come to face a more apocalyptic condition than they did.

**NM:** Could you give an example of how you have used a scene that derives directly from a painting?

**ML:** There is a painting called *Lake George* by John Kensett dated 1896 in the collection of the Metropolitan Museum. My assistant and I went to Lake George. Everyone we met offered an opinion as to where the site might be. So we hired a motorboat and went into the lake. Our driver kept the picture right in front of him the whole time, referring to it. We drove up and down the lake five or ten miles in either direction looking for the vantage point when Kensett may have been when he made that painting. Well, what I think we found was that he cheated. What we concluded is that the mountain to the right in the painting is Black Mountain, but it doesn't really have such a sharp peak, and the two banks never do appear to converge as much in reality as in his picture. He used poetic license.

**NM:** John Kensett's paintings are so extraordinary. The sense of measured space and the quality of the light give the paintings a subtly transcendent quality.

**ML:** Yes. All his work is like that. It has a quality of the ordinary about it, yet it's very pure and contemplative. I liked Lake George a great deal and felt I knew it from the paintings. I recognized the islands, the con-

figurations in the land, the color of it. It really has that yellow-bronzy patina in late summer. I try to see what someone like Kensett wanted to convey. I'm not sure how much he's striving for a kind of ideal reality. He's very close to the truth and has pushed what he has seen only a little bit in one way or another toward the "ideal."

**NM:** Did you ever return to a site and find it had changed a great deal?

**ML:** Yes. I went back to the Connecticut Valley around New Haven to find the site of Frederic Church's *Haying Near New Haven;* the same painting is sometimes called *West Rock, New Haven.* The rock formation is so distinctive in that part of Connecticut and in the painting, but it's very pastoral in Church's picture; the signs of civilization are just rudimentary. I spent three days there driving around. I found, ultimately, that I couldn't deal with the overwhelming development of the area. I can scarcely describe how it defeated me, how there was no way I could photograph that scene. I decided to drive to the top of West Rock. When I finally got there, I found a cabal of occult teenagers or something. There we were high on this great promontory, where you can see for miles around. There was elaborate graffiti all the way up on the road and over all the rock. It was after twilight, and I had driven around and around and finally arrived, only to encounter hundreds of people in their vans and trucks and cars—rock music playing, drinking, getting high. More was going on than just partying. It was as if I'd come upon one of those young Satanic cults you read about in the newspapers. It was really a wild scene. I also noticed that the turnpike was built through the best vantage points, and I really searched the New Haven area to try to find some way to record this contemporary view of West Rock. I was unable to commit the scene to videotape.

**NM:** If you had been able to get a vantage point, would you have taped it?

**ML:** I would have tried. I feel it's my task to cast some new light on an old topic. I think one of the reasons I found that area of New Haven to be such a defeatist situation for me, however, was that, visually, it makes such a loaded statement, that it didn't leave any room to draw independent conclusions. It's so overwhelmingly a contemporary wasteland along the turnpike, in so many ways a contemporary wilderness of technology run amok. My statements, the episodes about tech-

nology that occur in my piece, are actually much more extrapolations from reality, more paradigmatic. They emerge suddenly out of the landscape and disappear again. They make a statement, but I don't see it as total devastation.

**NM:** One of the unforgettable images from *Wilderness*, that of the icebergs, is a motif that appeared in nineteenth-century art. Your expedition to the icebergs reminds me of the way some nineteenth-century landscape painters took grand expeditions to new frontiers outside the country.

**ML:** The motif of the iceberg came directly out of paintings by Frederic Church, though I'd been fascinated with the idea of icebergs for a long time. I wanted to make one grand expedition, whether it would have been to Peru, the Rockies, or Labrador, in addition to the smaller ones. The iceberg is something you wouldn't initially think of as American, but it becomes an American emblem by inclusion in the body of Church's work. And it's part metaphor. An interesting note is that the nineteenth-century American painters very much identified with the pioneer spirit. They went into the wilds, taking certain risks in making their expeditions too. It has long been a part of the American identity that the artist is also an explorer. I've always felt an identification with the American pioneer, and it's very much a tradition in my family.

**NM:** Let's talk more about the role of literature in the making of *Wilderness.*

**ML:** I believe literature has been more successful than the visual arts in encapsulating and describing American cultural history and its dilemmas. Writers from James Fenimore Cooper to Herman Melville, Henry David Thoreau, Walt Whitman, through F. Scott Fitzgerald, and even up to the present time, have tried to deal with our rush toward a completely technological civilization at the expense of the natural wilds. The great American novels all embody this essential paradox in the conflict between artifice and nature, the civilized and the wild, technology versus nature. In some ways I'm just reinvestigating that most American of subjects.

**NM:** Many artists today are reconsidering and consciously using material from the past tradition of art.

**ML:** I think that's a valid tendency. There are very few truly new images being produced now. That's theater, though. Theater has always tended to be an assimilation of a lot of different ideas and directions. I think that at some level all artists working since the 1960s are dealing much more with theater whether they are painting or making video. We're drawing on a variety of eclectic sources, including the past, to make something that's ultimately fresh.

**NM:** In conversations we've had, you've referred to *Wilderness* as an "epic fable."

**ML:** I think of an epic as being the tale of some hero and his encounters with all sorts of life-threatening situations in which he eventually prevails. I am thinking here of the journey through a re-creation of a part of history. A fable has some sort of moral or instructive tone to it. *Wilderness* will be a fable in the sense that it confronts apocalypse. Apocalypse is epitomized in the biblical tale of the end of the world, which comes about as the result of man's sins, or the contemporary fable about nuclear disaster, which comes about as the result of man's tragically limited vision.

**NM:** Earlier in our conversation, we were talking about sequences with obvious messages about death and destruction, and you said you had to determine exactly what you thought about them before you could place them in the piece. Does the process of making a tape involve the process of self-discovery?

**ML:** Each of my pieces has involved intense self-examination. In the process, I have had to make up my mind about where I stand on many issues. In this instance, I'm trying to figure out what I really do think about the course of civilization in America. That sounds terribly grandiose, but it's true.

**NM:** Before you started shooting tape, you seemed to know exactly what you wanted to do. You'd pinpointed locations on the map, you had systematized the types of subjects painted most by American landscape painters into three classifications: coastal, inland, and upland. However, in the end you've expanded your original notions. For example, now you have included scenes of domestic interiors. Though

you did return to some specific painting sites, in other instances generic landscapes were sufficient.

**ML:** That's very much how I work. I go to an environment with a very rigorous conceptual agenda, but what I discover there is always the most important thing. Often I set up rules and then break them, forcing myself to reinvestigate my entire working method. The original project description—you're right—had a very methodical, schematic base, which I did follow to a certain extent. The piece has two primary conceptual hooks. The first is its broader plan, which is to address coastal, inland, and upland geographies. That's the original tripartite division that's partly the rationale for the three channels of videotape. The second was, within these classifications, to locate specific sites of paintings. What I found was that I had constructed for myself an expedition, an adventure through the Northeast over a year's time. What I'm creating, then, isn't so much the fulfillment of a conceptual exercise as a narrative work that will flow from image to image and convey meaning without use of words.

**NM:** The designs for the installation of *Wilderness* and the way in which you edit your tapes reveal a systematic way of thinking, a structure based on numbers.

**ML:** The piece will consist of three channels of videotape, three separate tapes, synchronized in playback and displaced on seven monitors in the sequence A/B/A/B/C/B/C. This patterning of images will serve to extend the landscapes physically into lateral space, intentionally invoking the panoramas that were so popular in the nineteenth century. These were paintings, immense lengths of canvas, that were slowly unrolled before a paying audience to the accompaniment of music and commentary. The content was usually documentary and scientific, describing a particular geographical site. In one of his essays, Thoreau reports having gone one week to see a panorama of the Rhine and, the next, a panorama of the Missouri and being favorably impressed with grandeur of the latter. Before movies, the panorama was a way for the public to experience distant lands and unseen areas of their own country.

**NM:** You've said you see both the beneficial and destructive aspects of technology. You must be aware of the irony of your use of a techno-

logical medium. This should be especially apparent in your use of exposed TV sets on top of classical pedestals.

**ML:** Definitely. In *Wilderness*, I'm using modern technology as a bridge to link the past and present. I wouldn't for the life of me take away technology and return to a pre-electronic state of existence. However, I am ambivalent about it, like most Americans. On the one hand, I see television as a tremendous incursive threat in American life. On the most clichéd level, it is a kind of Big Brother. It is the epitome of the technology that watches you and controls you, and it can take over your life, becoming your system of relating to the world at the expense of real human contact. Perhaps using television as an art form is a corrective to that.

New York, October 22, 1985

## Margaret Morse

## An Interview with Mary Lucier

[This interview was done before the work on her show at Capp Street, *Asylum (A Romance)*, cosponsored by BAVC, was completed. In it, Mary Lucier describes how this new work fits into the trajectory of her recent video works on landscape.]

**MM:** I want to question you about the garden as a metaphor, because it seems to be important for a whole series of work you have done—*Ohio at Giverny, Wintergarden, Wilderness,* and now *Asylum (A Romance).*

**ML:** There is an excellent book that makes the connection for me, *The Machine in the Garden,* by Leo Marx. It's about the American pastoral myth in literature, from Hawthorne and Melville to Fitzgerald. What he describes is a kind of dilemma. There are two kinds of pastoralism: the "simple," of which the "back-to-nature" movement is one example, and the "complex," which arises from an ambivalent relationship to progress and civilization. In the latter, the conflict is never resolved. There is a myth that America would be the Garden of Eden, but the reality has been, for a long time at least, that it is becoming not a Paradise, but a kind of technological-industrial wilderness in its own right. Americans are ambivalent about progress: on the one hand, it's beneficial, it's a God-given right to wrest the Garden from the Wilderness; then, on the other hand, people perceive that this wonderful civilizing process is in fact eliminating the wilds. The transcendentalists began to look at the natural landscape that was left as something that needed to be preserved rather than eradicated. The Puritans thought that man in the wilderness reverted to bestiality; Thoreau believed that man left

Originally published in *Video Networks* (July–August 1986): 3–7.

alone in nature was innately good. The landscape made him a better human being—a complete turnabout. American painting began to show signs of nostalgia for the natural landscape. *The Great Gatsby* showed how, reaching ahead for the orgiastic future, you are really reaching back into the past forever and ever, and there is no reconciling the two.

*Wilderness* is a continuation of the examination of that theme of the American pastoral myth. The project at Capp Street takes it to its most didactic, logical conclusion.

**MM:** Can you tell how you deal with this theme in *Wilderness*?

**ML:** It juxtaposes generic or specific images from known paintings of the nineteenth century by Church and Cole through Winslow Homer. *Wilderness* is a revisitation to those sites in the paintings juxtaposed with examples of the industrialized landscape. The little quote from the book *The Machine in the Garden* where the train breaks through the pastoral stillness couldn't be more obvious. The natural landscape comes up on the videotape and acquires a gold-leaf picture frame around it; that dissolves and the train comes charging in from the center and takes over the complete picture—an elementary device that's just one of the things operating in the piece.

**MM:** The landscape images I saw in an excerpt of *Wilderness* still showed something very pristine, very preserved and beautiful.

**ML:** I go back to the sites and I do succeed in re-creating the motifs found in the paintings the way I re-created the French motifs in *Ohio at Giverny*. But what I didn't do in the Monet was to inject modern life, contemporary life, or a sense of change and decay, other than a decay as it occurs through death or natural collapse. In *Wilderness* the train is beautiful, but it is also the harbinger of the destruction of the environment.

There are actually four such moments in the piece: the first example is a horse breaking through, the first technological beasts; then the train, then a bulldozer, which is actually from a strip-mining operation in the midst of the Adirondacks; then the very last example is a jet stream in the sky. Then there is the example of the natural entity, which is already fated and doomed anyway, the icebergs. Icebergs are magnificent and grand in their own way, but completely doomed. The

pathos of nature itself is as strong as the pathos of the relation between man and nature, something which has always been there.

**MM:** This cycle of life and death or mortality seems to be one of your most fundamental themes.

**ML:** I don't know where it comes from, it just seems to be an integral part of life. I think it's the purest and most interesting factor of human life, human death. And regeneration, the cyclical nature of it, the fact that you're gone and you're a memory. Memory is another subject in my work—memory as the trace of a human being. It's somewhat reassuring to see the cyclical side of nature; it makes us seem somewhat less insignificant, but reenactment of the primal cycle is everywhere. I don't know when it first became an important part of my work.

**MM:** This brings up the aspect of memory. It seems you are very interested in linking up with the past. It makes me think you thought it was lost for a while.

**ML:** I think it is a way to reclaim what might be lost. It perhaps is a concern that develops as one gets older. It used to be that in my earlier work, memory was fairly short-lived. It was no longer than it took to burn a mark on the vidicon tube (*Dawn Burn,* 1975), or the fact that day seven of the burning of the vidicon tube contained the traces of day one—that is no more than seven days, a very short memory. It is vivid; it's obviously a trauma. I think I've moved from the traumatic to a longer view of history which in some way is also a struggle against mortality. Pulling in the vestiges of the past gives one the sense of having an extended history yourself. The trauma of the scarring of the tube, or whatever that might metaphorically imply in my life as outlook, is lessened by taking the broader view. It's an attempt to pull everything into one's lifetime, to make a circle out of it all.

**MM:** The dedication of *Ohio at Giverny* to your American uncle and French aunt and what you said about the mixture of personas in the piece made me think that it is not just about your aunt and uncle, that it is about you.

**ML:** It appears to be about Monet on one level and about my uncle on another, but of course it's also about me.

**MM:** That brings together two strands of video production you mentioned—the strand which focuses on the self (Vito Acconci and others) and the strand which focuses on nature (you mentioned Beryl Korot and Davidson Gigliotti as forebears)—the landscape and wilderness is a metaphor for the self and its development. You really are looking at yourself.

**ML:** I think that's true.

**MM:** Can we talk about your Capp Street piece and how it ties into the problem of *Ohio at Giverny* and *Wilderness*?

**ML:** It relates to both of them, but what I didn't do with the *Giverny* piece was bring in the presence of the present time and technology, other than the implied presence of my camera—but that is not evident in the images. *Wilderness* carries that picture making further and tries to deal with the aspects of change, technology, and the industrial landscape.

The Capp Street project is more didactic and literal than either of those other two pieces. It deals specifically with a garden, the small intimate landscape, whereas *Wilderness* deals with the broad landscape. *Giverny* dealt with both, but mostly it focused on the garden. The Capp Street piece is in three parts. The primary element of the installation is a kind of indoor conservatory of unspecified origin. It appears to be abandoned, in decay. It isn't new and pristine; it is very eclectic. Another adjacent environment is in an old toolshed. The third is a video area. There is a videotape playing and there is a physical distinction between the environment of the videotapes. The images on the tapes are from assorted industrial landscapes around the Bay Area, because it has all been shot since I got here, of machinery, some functioning, and some completely derelict and in decay. It's much more about energy and entropy and the whole cycle of collapse and regeneration. The video is very literally the representative of the functioning and the dead technological landscape and the (installation) environment is the dead garden.

The whole notion of *Asylum* tries to take up where *Giverny* left off, the garden of the nineteenth century being a refuge, the protected haven, a place of replenishment—all the services a garden can provide, at the cost of and as a relief from the outside world. What I am trying to deal with is the irony of the concept of there being any asylum what-

soever, particularly in the light of the last couple of months, with the attack on Libya, the proliferation of terrorism all over the world, and nuclear meltdown in the Soviet Union. It seems that, if anything, we are not protected, we have nothing, and whether or not my piece refers directly or not to those events—it is timely in that it should be clear that there is no place to hide. The attempt to do so is an attempt to block out reality.

**MM:** Your earlier pieces seemed to select exquisite scenes. You begin to work against this selection in *Wilderness* by mixing in an industrial present. But *Asylum* still develops a separate space of the garden—as if it were still an asylum.

**ML:** But you walk from one space to the other and you hear the sound throughout the installation. From one space you also see the other, through a grid, a lattice, or a fence. That is the path, the journey in this piece.

**MM:** Someone asked if you were criticized for using beautiful images, for this kind of selective act. Is your work moving away from beautiful images?

**ML:** Probably not. It is constitutionally impossible for me to create an ugly picture. I have been trying to figure out why that's true, even when the subject matter I am dealing with may have nothing to do with beauty per se. But *Ohio at Giverny* is about beauty; it's about beauty being seductive. That seduction is also the seduction of death. There is an aspect of death that is beautiful. That's what gardens are about also, making death beautiful, palatable. I tend to see things, to frame them, with a sort of balance; I see beauty everywhere, even in the detritus in the junkyard. And surely, when I frame it in the camera, it will have a certain formal composition and a sensuousness. That's part of how I perceive daily. It's absolutely integrated into the ways my eyes function.

**MM:** You talked about pictorial narrative in relation to *Giverny.*

**ML:** It is a method that came into my work around 1980, about the same time that color came in. I've never used words (except in a single channel tape); I never used characters, but I do attempt to structure the

sequence of pictures in such a way as to create a journey which is in fact a kind of story. It takes you from one place to the other. That's especially possible from my point of view in multichannel video where you not only have images running sequentially in time, you have this wonderful spatial juxtaposition, side by side, so that you can fragment a picture at the same time you keep the logical progression. It is an intricate way of telling a kind of story spatially.

In *Asylum (A Romance)*, the "romance" suggests that there is a story. "Asylum" is about a place, mythological, or lack of place or an imagined place, a safe or a threatened place. "(A Romance)" suggests that there is something Gothic going on, or something has happened, or something will happen. The condition of the place should suggest or move people to think about what might have gone on: If in fact this place is abandoned, what caused it to be abandoned? If it is in disrepair, what caused it to disintegrate? I am not sure how much the single videotape itself will carry a narrative quality; it may be just pictorial background, which will create a sense of a narrative when it is placed in juxtaposition with the environment. It is not as linear or as focused a linear sequence as these other pieces. On the videotape there are natural as well as industrial images. I shot a graveyard and a salvage yard, for instance, which is like a technological graveyard. The video is a pulsing of images and it will be narrative through interaction. The images on the tape will be all from "the outside world" and the inside is all the sheltered environment. The outside is the landscape of technological waste.

**MM:** Unlike *Ohio at Giverny,* which eventually created a kind of blend of spaces, any mixture would have to be in the viewer.

**ML:** People won't be watching a tape from beginning to end as with *Giverny.* Either the environment will evolve in some way as people spend time in it or there will always be a disjunctive relationship. There will be a direct interaction between the video images and the environment.

**MM:** It sounds like even though you plan things way ahead, you let yourself be surprised.

**ML:** Oh, I have to. This piece has been in a proposal stage for over two years—I wrote it out in November of 1984. I thought about it the

whole time I was making *Wintergarden, Amphibian,* and *Wilderness.* I made three other pieces while this sat on the shelf.

**MM:** I'd like to hear a little about what you think being a video artist involves today. It sounds like you are very optimistic about the greater acceptance of the medium.

**ML:** My career has been going very well, without complaints, and I've been making video since 1972 or '73. I have always been excited about the medium, and when I found it, I thought I had found the answer. It combined all the mediums I was interested in before: it can be three-dimensional like sculpture; it can tell stories, so you can deal with a literary kind of content; it's theatrical; it's cinematic in its way; it's architectural—it has all the elements of the things I was interested in. Maybe I've been fortunate in attracting an increasingly bigger audience, a sizable and decent amount of support and funding; I am working faster, making more pieces in one year than I've ever done before. I am really reaching my audience now and that makes me happy. I show work in public spaces and museums and I've shown a little bit on television, but not very much.

I feel there is a movement, a wave building toward video work becoming increasingly recognized in the art world. Nam June Paik's retrospective at the Whitney did a lot to help that—actually all the recent Whitney Biennials. *Ohio at Giverny* at the Whitney Biennial of 1983 was a major step forward for me; it brought me an enormous amount of recognition. Since then, I have had more and more commissions; I have shows booked through 1989. I have a piece that is touring for two years; there is a possible survey of my work in a major museum. There is a lot that is happening that is very rewarding. I work all the time, though, but that is what I'd rather do most of all. And I think that it is happening for other artists as well. Nam June Paik, Bill Viola, Dara Birnbaum . . . are doing very well—this is just the tip of the iceberg. The people who make tapes are doing well in terms of distribution, recognition in Europe and at festivals. There seems to be a real energy now in video that hasn't been there since the beginning and it's more sophisticated, it's more supportive of video at a better state of development. In the beginning it was exciting because people like Bruce Nauman and Vito Acconci were doing it, but even so, what they did was primitive. Now you have a generation of video artists, people who started in video, or who switched over to video from other things by

choice like me, rather than just doing it as one of many media. Somehow you have a pretty sophisticated bunch of video artists who are dedicated to it. I see installations as the form which has probably benefited the most from this recent upsurge. There was a big show in the Stedelijk Museum two years ago, *The Luminous Image,* which was a very important show; John Hanhardt is doing a major history show of video installations at the Whitney next fall. Finally, finally it seems to be happening for installation artists.

**MM:** And collectors? That would make video more of a commodity, not supported by foundations.

**ML:** A number of video artists, myself included, have sold work. (*Ohio at Giverny* is in the permanent collection of the Whitney Museum.) Nam June Paik is selling very well in Europe. Some private collectors have shown interest as well as museums. I would say it is about to break. It just needs a couple of really courageous collectors to put the stamp of approval on this work for it to be seen as collectible. I look forward to that happening. I would like to be able to make a living from my work and not always be on public subsidy. I've been subsidized for twelve years now and it has given me opportunities I could not possibly have had without it, but I would like to feel, as I get older, that I am in a field that can make a living for me. My dedication is total—and what if something happens and the government support ceases? We're dead unless we have some sort of private market. Will we have to go out and get waitressing jobs in our mid-maturity? I can't see that happening. So that's the only thing I worry about. Economics, there is some terror in that—but it certainly looks better than it has.

**MM:** I read a piece by Bill Viola which talked about the role of video in exploring what television has narrowed into a limited and circumscribed experience.

**ML:** I don't believe there is necessarily a relationship between video and television, and I don't choose to refer to either industrial or professional television in my work. There is only an ephemeral connection— if there is any at all, it is because the display medium is the same. Television is a political, social, economic form that often uses film as a recording medium. I don't think art video will have an impact on the

domination of television, but it can change the climate in which the audience receives images. I believe that perceptual changes are also changes in spirit.

**MM:** Thank you very much for this interview.

Peter Doroshenko

Mary Lucier

**PD:** How would you compare video as an art form in the 1970s as opposed to the 1980s?

**ML:** The main characteristic of the early 1970s was an exploration of the medium itself—the process of investigation and discovery that tested the very limits of the technology physically, temporally, and aesthetically. A shift began to take place around 1976 when affordable, portable color equipment came along, when a more structured sense of editing began to work its way in, and when artists began to have an opportunity to show their work in museums and on television.

The sculpture show that was just at the Whitney (*The New Sculpture 1965–75: Between Geometry and Gesture*) brought back a very important moment, with works by Bruce Nauman, Robert Smithson, Eva Hesse, Keith Sonnier, Richard Serra . . . the art that followed minimalist sculpture. I very much came of age as an artist in that period and was drawn to video as a kind of offshoot of conceptual art's exploration of commercial materials for aesthetic structures. My work at the time was very much about process, very much about an examination of the technology of video—the interaction of light with the medium, the response of the medium to its technical limitations, and the graphic black-and-white image. As the 1970s progressed, video art "discovered" color. For me it happened in about 1979, when I bought my first color camera, and it had a huge impact on the way I approached the medium, and the handling of certain ideas which I had been working with for years. My three-dimensional concerns pretty much stayed the

Originally published in *Journal of Contemporary Art* (fall–winter 1990): 81–89.

226

same but underwent a major shift towards a more personal, less rigorous, less analytical kind of investigation.

**PD:** How has your work changed from the 1970s to the 1980s?

**ML:** The major change was a shift from a completely obscured narrative core to an overt "pictorial narrative" form. My work still doesn't use characters or dialogue; it isn't cinematic or, rather, it isn't filmlike; it's still very sculptural. But the tapes themselves have become more theatrical in that they proceed from a beginning to a middle to an end, though that "program" recycles endlessly within an installation format. This is especially evident in *Ohio at Giverny* (1983), *Wilderness* (1986), or *Denman's Col (Geometry)* (1981).

The earlier work always embodied some central paradox, some metaphor that wasn't dealt with in a direct way. It was implied in the confrontation of the technology with the sun or laser beam as in *Dawn Burn* or *Fire Writing* (both 1975), where the tube itself was traumatized—burned and scarred—by the experience of its own severe limitations. I made a whole series of pieces in the mid-seventies that were not edited at all. They were completely about real-time phenomena and about this traumatic encounter with the source of light. Embedded in that encounter is a metaphor about birth and death, about creation and destruction being enacted in the same moment in a single event, which is the act of making art.

Eventually I began to move away from the simple demonstration of phenomena, which had dictated the basic structure of the work, to a more internally controlled, edited form that gave the work a more narrative cadence. I wanted to explore all the possible meanings and implications in a more expressive, less formalist way—what some people call "lyrical," but which I think is simply narrative.

Gradually the work started to reach out to other sources, to begin to have overt references. At the same time the inquiry became more personal and exploratory, and less experimental and didactic.

**PD:** In the works *Ohio at Giverny, Wintergarden, Asylum,* and *Wilderness,* there is a strong attachment to landscape imagery. In today's fast-paced electronic media world, why do you choose such a passive genre?

**ML:** I don't think that it's at all tame or passive. I think the landscape is ferocious. Nature is the one thing that we can't conquer. It's demonic.

Look back over the last couple of years, at the fantastic occurrence of drought, hurricane, fires, volcanoes, earthquakes. You see what a phenomenal force nature still really is. To me there is nothing passive about it.

It's also a venerable medium for expressing ideas. Look at the romantic poets. I think of my work as romantic, in the sense of Wordsworth and Coleridge, who were also politically very conscious and very aware. Or Thoreau, who positioned the natural world in a dialogue with the industrial world of the nineteenth century. They were completely attuned to the terror and the sublime in natural events but were able to use nature as a podium for humanist ideas.

What I've tried to do with landscape is to create a language based on a pictorial narrative form that can speak to states of human consciousness and experience. I am not setting up a condition that is in opposition to human life. On the contrary, what I am trying to do is create a vocabulary of images that will speak to us about ourselves as social and individual beings and about the way in which we are alienated from aspects of our environment.

I also believe that there is a need for work that reflects ecological concerns and that says something about our attempts to control and dominate the planet. But my primary underlying theme is simply that man and nature are ultimately one, and any injury to one is injury to the other. We have forced an unnatural separation between the two, and in contemporary life some factions have tended to make that estrangement greater by implying that you cannot care equally about both.

My earliest performance pieces prior to working in video were about female and Third World identities. And I'm now beginning to come back to incorporating elements of the human form along with landscape. One of the things I find is that some viewers need to identify themselves in the pictures in order to be able to participate in the work. I'm still trying to refine the visual language to merge the human image and the landscape image.

**PD:** Is your connection with landscape imagery closer to the ideas of Caspar David Friedrich or to Robert Smithson?

**ML:** Well, I really like them both. Smithson wasn't all that far from Caspar David Friedrich, really. It would have been interesting to see Smithson's work evolve, had he lived. He was interested in the origins

of the earth, he was interested in geology, he was interested in landscape, but in a scientific way. He took the longest possible view of time. But he also was a closet romantic. If you read his account of flying over the *Spiral Jetty*, he gives a euphoric description of the water in the lake looking like red, bloody meat in the sunlight. But that kind of visceral response was tempered by a preoccupation with process and materials and a pragmatic, intellectual way of ordering ideas.

Friedrich as a nineteenth-century German is a different issue. His work is more about the sublime and about an implied relationship with God. It's about Christian symbolism and German mysticism. Friedrich is someone I came across much later when I was already deeply involved in landscape work. My sympathy lies more with Smithson, the natural historian. I connect with him and feel that I owe him some debt. After all, my approach to work in the 1970s was not unlike his: bringing landscape indoors and giving the elements a numerical logic, trying to remove it from its romantic implications. I think it would be fascinating to see what he would be doing now.

**PD:** Of what importance is sound and music to your work?

**ML:** Sound for me functions as another layer of image. Since the 1980s, I've used sound as a secondary image source, to add a whole other layer of pictorial information.

In *Ohio at Giverny,* for example, there is a sequence beginning with a dungeon on a hill. It occurs before you actually arrive at the garden of Giverny, but after the camera has made its journey to France. You see a medieval castle high on a hill (at La Roche Guyon), then a group of people in soft focus walking briskly, then the camera pans rapidly into darkness and there is lightning over the rooftops of Paris, and it all comes to rest in a very quiet image of flowing water. Well, that sequence is my recapitulation of the history of Europe: migrating tribes, the aristocracy, wars, and finally the River Styx, which is death. If you were just to look at the image of the castle, in silence, you would see almost a postcard picture, very still and non-threatening. But the sound with that section could be the sound from inside the dungeon—clanking chains and exploding bombs, very ominous and foreboding.

I am interested in making an ambiguous art which has many readings, not just one correct reading. And I believe that picture and sound can act together in a subliminal way to encourage a multitude of meanings and interpretations.

I should mention that I have worked with a composer, Earl Howard, since 1983. Earl is blind and therefore doesn't see the pictures. So I have incorporated an additional process in my work where we sit together and I describe every image to him, and he gives me back the auditory equivalent. I am forced to be extremely clear about what the images are, what they mean, and how they function in the piece, so that I can get from him the interpretation in the soundtrack that gives additional richness and layering.

**PD:** Where do you place your work among your fellow colleagues in terms of material?

**ML:** I think it's obvious I have more in common with Bill Viola than with Martha Rosler. In terms of work, though, I respect both of them highly. There is a small school of landscape artists in video art whose work is in some way congruent. But on the other hand, I hate categorization. *Asylum,* for instance, is in many ways a political piece. I like it to be interpreted both for its relationship to landscape art and for its implications about the political aspects of landscape. My work is not primarily preoccupied with spirituality the way I think Bill's or Rita Myers's is. I think I have a more pragmatic approach. I'm trying to build a meaningful vocabulary that can be applied to many different contexts. As far as building vocabulary, I feel very connected to Bill Viola's imagistic language, which uses elements of landscape, but I think that we "write" in very different ways. In general, I'm more interested in artists being aligned by virtue of their work's content and its meanings, than by its form or its appearance.

**PD:** Are you working on any new projects?

**ML:** Yes. I have just finished a new piece, which has two parts, a single channel tape and an installation. It's the final work in a series of collaborations with choreographer Elizabeth Streb. The piece is called *MASS,* with the single-channel version subtitled *Between a Rock and a Hard Place.* The three-channel installation is designed for three large slanted ramp forms grouped at angles to one another with three video images projected vertically onto their surfaces. It's extremely kinetic and spatial.

*MASS* plays with the idea of a group of particles, or human bodies,

acting as a single entity. It's about force and resistance and struggle, about the individual and the social—the artist in society.

I'm going to be revising *Asylum (A Romance)* for a show at the Greenberg Wilson Gallery this winter. I did it originally at the Capp Street Project in San Francisco in 1986 and have shown it once since, at the museum in Fort Wayne, Indiana. I'm looking forward to adding several video elements and restructuring the piece for a smaller room. It is a rather large mixed-media environment made almost entirely of salvage—found objects and building materials—with a singular but very dominant video and audio presence. It is concerned with issues of energy, both benign and malignant, as we encounter them in the natural and technological landscape.

I also have a major new project in the works called *Noah's Raven,* which I've just been funded to work on through the Toledo Museum. This will be a landscape installation dealing with the scarring of the land and the scarring of the human body, and will attempt to set up an empathetic correspondence between the two. It should be finished and ready to travel in the winter of 1991–92.

New York City, spring 1990

**Nicholas Drake**

**Texture, Grace, and Drama:**

**An Interview with Mary Lucier**

[Mary Lucier began her career as a sculptor, but has concentrated on video installation since 1973. Her works in that medium have been exhibited all over the world. For *House by the Water,* created for the Spoleto Festival USA's 1997 site-specific exhibition *Human/Nature: Art and Landscape in Charleston and the Low Country,* Lucier built a house on stilts, on which were projected images of South Carolina's nature and history, including plantation life and hurricanes.]

**ND:** How is your project for the Spoleto Festival related to earlier installations like *Noah's Raven?*

**ML:** *Noah's Raven* (1992–93) evolved from a couple of sources. One was that my mother had cancer for over three years. I went through the entire process with her, making this piece for her. The piece is also tied into my way of looking at the relationship between the body and the land. I wanted to look at scarring as a common issue that could be seen as benign or malignant. Some scars are beneficial scars in that a disease has been cured. Other scars are the scars of destruction.

**ND:** Are you making a connection between Gaia, the concept that Earth is a living organism, and the human body?

**ML:** Actually the Gaia concept bothers me. I don't feel that you need to create a goddess to have empathy. I had been working with landscape for so many years that I had a natural proclivity for it. After my mother

Originally published in *Sculpture* (January 1998): 32–37.

became ill, certain things became explicit. So I carried these ideas about landscape to their ultimate conclusion.

**ND:** Can you talk about your background and the kind of work that you've been doing through the years?

**ML:** Back in college I worked in welded sculpture. In 1962, I met the composer Alvin Lucier and became involved with the avant-garde in music and dance. This had a profound effect on my aesthetic. I became involved with video in 1973. I was a pioneer—well, not quite. Nam June Paik really gave birth to it. I had done performance work prior to 1970. This led to an interest in video installations. It pretty much encompassed everything that I was interested in about time and space and sound and light. I think I made my first installation in '73. I have worked with installations ever since.

**ND:** Chris Burden is an influential artist in this field.

**ML:** Chris Burden has gone through some changes. He's a hot seller now and his work is very much a commodity.

**ND:** Do you mean that his work has become more conservative?

**ML:** I don't think that he has gotten conservative. Sometimes you explore all there is to explore in an idea. Then you have to move on to something else. I think that ideas that might seem radical have their limits. There is only so much that you can do to take an idea to the farthest point. I think that is what Burden has done. In the meantime, he has begun to make object art. So has Vito Acconci. So has Dennis Oppenheim and a lot of other people who were considered radical in the '70s. They are now producing objects.

I don't think that calling the work conservative is a fair assessment. Not making a commodity is not so radical anymore. What would be conservative is to still continue the same thing that you were doing twenty-five years ago. My work has followed a similar path. A good example is a piece that I made in 1975 called *Dawn Burn*. When I first borrowed someone's video camera they said, "Don't ever aim this camera at the sun." So of course that was the first thing I did. I aimed the camera at the sun for seven days at dawn. Those were the days of black-

and-white vidicon tubes that burned easily. So the sun rose each day for thirty minutes and burnt a new track on the tube.

Once I discovered burn, I made a series of burn pieces. Now that work—which at the time was antiobject and ephemeral, and pushed the medium beyond its optimum capabilities—is part of the collection of the San Francisco Museum of Modern Art. It travels. It has become history. Interestingly, that work was about scarring too—scarring of the video tube.

But it has become a commodity. I don't have anything against it. It is kind of wonderful to see your old work restored and exhibited. These are pieces I thought at the time were a one-shot deal. It's fascinating. I especially like being involved in the restoration process and making all those choices. Do I dare make a fade here? Or do I have to leave it exactly the way it was in 1975?

**ND:** How did your work for the exhibition *Human/Nature* evolve from your previous work?

**ML:** There is a definite step after *Noah's Raven*. I began to make pieces that were interactive and that involved voices. Instead of just videotaping the landscape and then trying to develop this elaborate metaphor for the human spirit, I did something that was in some ways simpler and in other ways harder. I allowed the people to speak for themselves.

*Oblique House (Valdez)* (1993) and *Last Rites (Positano)* (1995) involved talking heads and interactive monitors. As you approached the monitor, the faces and their voices were activated. What I wanted to do was to give grace to people who had experienced some kind of trauma. The trauma in *Noah's Raven* was medical and ecological.

I chose Alaska and the Amazon as two seeming opposites that had an immense amount in common. They are both wildernesses and can defeat you if you are not knowledgeable. You can't just get in a car and drive to the nearest motel. These are both landscapes that are exploited for their mineral resources. They have native populations that know how to survive in extreme climates—though they are gradually being pushed into small enclaves.

My shift after *Noah's Raven* was to allow the voices of the people who are experiencing these various traumas to speak for themselves and not only to create a metaphor out of landscape images. At the same time, I was constructing installations that flowed with the viewer who moved from station to station. My previous work depended on a single

or ideal vantage point from which to view a more theatrical presentation.

So now I have taken yet another step, to use people as actors. I videotaped the Aiken-Rhett House, which I think is a phenomenal place, both the main house and the slave quarters. I included empty corridors and textured, crumbling walls. I taped people performing in period costumes to animate the space. This is a completely experimental direction for me. It may sound as though it is getting closer to cinema, but I don't intend the work to be filmic at all, or to be explicitly dramatic.

**ND:** Before you discuss the video part of the installation, first describe the actual physical structure and why you had it constructed that way.

**ML:** The physical structure is a hybrid house on stilts, set within a brick warehouse space. Several things impressed me about life near the water. I saw the house on stilts as part of the defense against nature. Houses are raised up because of hurricanes and rising tides. It is a common structure in other waterside places I've been to, like the Amazon. Houses are built up on stilts because the water may rise and fall twenty feet in the course of a year.

The other form that the house symbolizes is a weather station. When I was here for my very first site tour, we came across a little weather station that was raised up on four steel legs. It had siding all the way around. It had no doors or windows. So the piece becomes like a station that is receiving and reporting data.

The building is sided with shiplap, which presents a flatter surface than conventional clapboard. Yet distortion still occurs when you view the projected images from an angle. The image will not stay straight. It zigzags in and out. When you stand directly in front of it there is a moment when the siding seems to disappear. There are moments when you feel as if you are looking at the outside of a house. Then there are other moments when you feel as if you are looking through the house. That is intentional, to keep the wall shifting back and forth between being a screen and actually being a surface.

**ND:** Who were the two actors that you used in taping the reenactments?

**ML:** They were Linzy and Karen Washington, who are local to Charleston. I had wanted to work with interiors, and chose the Aiken-

Rhett House. It had two very delineated spaces. It is traditional planta-
tion style, with the main house and the slave quarters and kitchen
house out back. I knew that I wanted to videotape in both those loca-
tions. The main house has this wonderful old decaying quality, reveal-
ing layers of history.

I think that members of the family lived there until the late '70s.
What they decided to do, instead of restoring it to any one of the pre-
vious periods, is to leave it with all the layers of added paint and recon-
struction. It is slowly decaying, but they are preserving the infrastruc-
ture. So it has a particular texture and beauty to it as all these decades
peel away.

Out in the slave quarters, I walked upstairs into a long hallway. The
vista down the hallway stimulated so many images in my mind of tun-
nels, of escape, of entrapment, and of routes to freedom. I stood there
for hours with the camera just looking down the tunnel of that hall,
videotaping nothing but light in that corridor. In order to make these
spaces come alive, I asked people to come into the spaces and perform
specific vignettes. In the main house, I used the image of the spinning
girl in the white costume.

**ND:** Did you use slow-motion special effects on that?

**ML:** The spinning girl is slowed down to about six frames per second,
along with a little motion decay which additionally softens her. When
she dissolves into the eye of the hurricane, it is as if she becomes the
hurricane. It's very gauzy. I normally would not use an effect like that
but for her it really worked.

**ND:** What I really thought worked was that her dress was white and
gauzy, yet the environment that she was in was brown like a Charleston
interior—lacquered and varnished wood.

**ML:** There is also that enormous portrait in the background of a very se-
vere-looking woman. It's a floor-to-ceiling painting. There is also an
angel—it reminds me of that Walter Benjamin story. Laurie Anderson
made a piece out of it, about the angel of history who is being blown
backwards into the future because there is a storm blowing out of par-
adise. The storm is progress. I thought of that when I was making this
piece. The young woman who is spinning is my angel.

**ND:** What insights did you acquire while working with members of this historically charged community?

**ML:** As a Northerner, I had apprehensions about saying to black Charlestonians, "Will you come and participate in period costume in a location like this?" However, they were more than willing. As gospel singers, the Washingtons perform in those costumes. They keep that history alive. They have taken control of their history. The Washingtons took charge of being in that space. They did what I asked them to but they also contributed their own ideas. They brought the Bible that was used in the reading sequences. They brought the reed brooms that are accurate to the period. They also wore their own costumes. Everything they did brought us chills because they performed beautifully and with such extraordinary command of the space and the concept.

**ND:** Talk about your editing a little.

**ML:** I do my off-line rough cut at home. Then I go to a professional postproduction house to do the final edit.

**ND:** What do you use for your rough cut?

**ML:** I shoot on Betacam and make my window dubs on three-quarter inch. We went from Beta to digital tape (D-2) and then from digital to laserdisc. It all plays back on laserdisc within the installation.

**ND:** Talk about what was going through your mind while you were editing the images in the studio.

**ML:** Getting the form of a piece like this is always the hard part. You have a fully fleshed-out concept in advance. But when I get to the site my ideas always shift, whether it is just landscape or a house with human beings. In this case there was an incredibly loaded history. I knew that it was not going to be exactly what I had described in my proposal. I saw that it was not going to be so much about exterior weather with a suggestion of psychology as it was going to be about interior climate. Weather would be more metaphorical. That was the first main shift. As I was working with the footage, I found that I was not able to put together a coherent narrative or even a subliminal narrative the way I often do.

What I like about these pictures is that they suggest a lot of possibilities. I was also reading Edgar Allan Poe at the time, and I thought that these images suggested stories that have a sense of mystery. So what I ended up doing was not making it coherent. I let it be confounding, suggestive of a multiplicity of narratives. The burden falls on the viewer to put it all together.

In this sense, I feel that the piece is interactive. First, you have to be in motion walking around the house to get a sense of all the images. Secondly, you have to put all those pieces together to come up with whatever story that you can. It's not given to you. Also, in producing the sound, instead of having dramatic peaks and valleys, there is a steady state sound with events that occur. There is something of that in the visual images as well. Though some of the images are on the edge of being dramatic, they don't come off as theatrical. They hold back.

Because there isn't a coherent narrative to support any single meaning, I think people give it various interpretations—whether they are from Charleston, from outside Charleston, or they are Northerners, Southerners, white people, black people, old people, or young people. I think that everybody will look at it differently. I would have liked to have been able to sit on-site for the full month and talk to everybody to see how people read it as they came and went. I would really like to know.

**V    Essays, Talks, and Notes by Mary Lucier**

# Mary Lucier

## Organic (1978)

I am concerned with making work that is organic: organic, as defined by Webster, meaning "inherent, inborn; constitutional; organized; systematically arranged; fundamental; in philosophy, having a complex but necessary interrelationship of parts, similar to that in living things."

Organic art is art in which the artist's material is seen as having a complex nature which, when it is expressed, largely determines the composition of the work. Creating work becomes, for the artist, a task of carefully articulating this nature according to its inherent principles and within the parameters of his/her own intentions. Some work has no intention beyond expressing a particular phenomenon, and the artist's job in such a case is to determine the context and to set up the conditions for the enactment or unfolding of the process.

It is characteristic of artists whose work can be thought of as organic to be especially respectful of their media—in the sense of being highly cognizant of the technology that surrounds it and focusing on that technology, not merely as a facilitator of work, but as an element of content. Subject and matter become interchangeable.

My work investigates a technology and exposes its idiosyncrasies. By exploring the flaws or failures of (photographic, video) materials and equipment, I reach a point where the quality of the processed image manifests, at once, aspects of its own generation and decay.

In 1969 I collaborated with the composer Alvin Lucier on a sound/image piece called *I Am Sitting in a Room.* He recorded a brief paragraph describing the procedure in the piece, then played back that statement, re-recording it acoustically through the same audio system.

Originally published in *Art and Cinema* (December 1978): 23–27, 66–67.

He then played back the second recording—the copy—also taping that, and so on thirteen times, making copies of copies. By about the tenth generation the sound had gradually begun to evolve into a bell-like ringing music, retaining some of the rhythm of speech, but no longer decipherable as words.

I made a black-and-white Polaroid photograph of a corner of the same room, containing a chair, table, and lamp, with sunlight falling in stripes across the arm of the chair and the rug through Venetian blinds. I copied that picture, as nearly 1:1 as possible, and continued to make copies of successive copies through 51 generations. (These photos were transferred to slides for timed performance with the twenty-three-minute audio composition.) In this and six other Polaroid series varying in length from 32 to 132 generations, the original image is transformed by such factors as a slight enlargement in the copying process: being multiplied each time by itself, a tiny ratio in the first copy becomes mammoth growth by the fifth generation, and by the thirteenth generation, pictorial elements have become totally abstract. Loss of detail and increased contrast are progressively pronounced. Dirt, dust, scratches, and other imperfections are magnified. The familiar is pushed out of the frame from the center as new, self-generated shapes take over. As the technology fails to hold, we see an image continually disassembling and reassembling itself.

In one sense this exemplifies the decay which occurs when a technology feeds on itself. Like families that intermarry, the system of reproduction continues to function as the peculiarities of the progeny grow more and more extreme. But, while it emphasizes the flaws of the system, the process also provides something new and original.

An event without a goal other than transformation, it yields imagery with an inexorable logic. An art gallery dealer to whom I showed the work in 1971 indignantly asserted that in those pieces I had destroyed the mystery of abstract art.

*Lasering:* A helium neon laser and a video camera are suspended from the ceiling, free-swinging and facing each other. When at rest the laser is aimed directly into the camera's lens, striking the vidicon tube inside the camera. As the suspended objects move, due to natural vibration, air currents, or human intervention, the laser beam sweeps back and forth across the surface of the tube creating constantly changing optical diffraction and interference patterns. At the same time, the intensity of the laser light causes burn tracks to accumulate which describe the

path of the laser's motion throughout the duration of the installation. These phenomena are visible live on the closed-circuit video monitor.

But to produce a video image, light is focused through a lens onto a photosensitive target, i.e., the surface of the camera's vidicon tube. This target surface consists of many tiny dots which change their resist-ance with the amount of light falling on them. When an intense light such as that from the sun or a laser is focused directly onto the tube, the sur-face of the vidicon is shorted out and the photosensitive mate-rial visi-bly altered. The burn markings become a kind of calligraphy describ-ing movement of a source of light, or of the camera in relation to the light, in time and space.

Vidicon burn is a phenomenon of pure light and pure video. Light is essential to video, but the excitable substance on the surface of the camera tube has a limited range within which it functions acceptably. When light fails, the video image disintegrates into noise. Above the acceptable range, light becomes not the illuminator but the tool which engraves its mark on the tube. The laser is like a knife; the sun, a blunt instrument.

In the burn pieces, time and motion are etched onto the surface of the tube, which is not destroyed but becomes an artifact—redis-playable, with its highly individual markings. In the laser-burned tubes, light seems to have been transferred into the vidicon itself so that the burn images become internally luminous when the camera is turned on, and the lens opening remains blocked to keep out light.

Work that is organic has a (more or less) dynamic relationship to its en-vironment. It does not simply exist in a space, it inhabits it. A live in-stallation like *Lasering* depends on architecture, wind, humidity, and passers-by; it is an open system with the capacity to reprocess its own environment. A piece like *Dawn Burn* or *Paris Dawn Burn* has two en-vironments: the one in which it was recorded—and which is present on the tapes—and the one in which it is exhibited. These interior and ex-terior spaces are interdependent, and meaning must flow back and forth between the two.

*Dawn Burn* (1975–76) is a multichannel work for seven horizontally aligned video monitors with a single 35 mm color projection. This work consists of seven days' cumulative taping during July 1975, of thirty minutes of sunrise each day over the East River in New York City. Each sunrise is burned onto the vidicon tube according to the

variations in the sun's actual path each morning. The camera remains in a stationary position throughout the seven days' taping, and at the same focal point, except for a search-and-register process during the first five minutes of each tape following the first day. In playback, all days' dawns are viewed simultaneously but separately on each of the seven monitors, every new day containing the accumulated burn of those before it. A wide-angle color image from the same location is projected large above the line of monitors. There is no audio.

Although the work may seem esoteric because it implies specialized knowledge of sophisticated technology, in fact all the visual ideas are working very simply within the physical manifestation to clarify, rather than to cloud, its meaning. If it is successful—and if the viewer is successful in dealing with it—a piece can be read from the inside out and the outside in, without mystery. The clues are all there; one only has to pay attention.

*Paris Dawn Burn* (1977) is for seven channels of black-and-white video, with single color slide projection. This work was recorded on location for the Tenth Paris Biennale from the fifth-floor balcony of the Cité des Arts, 18 rue de l'Hotel de Ville, between August 31 and September 10, 1977. It consists of seven thirty-minute videotape recordings of sunrise displayed on seven monitors of ascending sizes arranged in an arc. Each tape (each day) begins with a shot of the Centre Pompidou in the distance to the northwest, followed by a slow pan to the east where the sun is seen rising over the dome of St. Paul's, le Marais. In making the tapes, the camera was placed in the same position each day. There is a gradual day-by-day telephoto zoom prior to taping on days two through seven from the original scene—a corner of the city to the final closeup shot of the dome of the church. As the sun rises it burns a black mark on the surface of the camera's vidicon tube, so that by the last day there are seven burn tracks on the tube representing the cumulative positions of the sun during all of the days' tapings. (Burn paths from days two and three virtually overlap by accident.) The spaces between the burn paths are a combination of the gradual telephoto increment and the natural motion of the earth in relation to the sun. A color slide, taken at the same hour from the same location, is projected in a keystone fashion against the rear wall and somewhat above the curving line of monitors. The audio is the natural sound of Paris at dawn heard through three channels.

Seven events which normally could not be seen simultaneously have

been excerpted from their real context and placed next to each other. In this restructuring of memory there is a gradual focusing in, day by day, on the central components of the image: the dome of the church, the rising sun, and the cumulative burn. In effect, each tape shows a slightly enlarged portion of the tape preceding it, yet each is clearly a different day with varied weather and additive burn. When displayed alongside each other, the result is a landscape comprised of segments of time. In the progression across the seven screens, the eye scans both space and time.

Exterior form is dictated by the logic of the interior narrative. The internal landscape as displayed makes a crescendo which is echoed in the exponential swell and curve in screen sizes and the enclosing seven-part structure, and is reinforced two-dimensionally in the rear wall projection. The seven monitors, which increase in size from eight-inch to twenty-three-inch diagonal, are joined by placing the seven enclosures, also of increasing size, height, and top angle, tightly together to form a smooth but jointed unit. The video has determined the shape of the sculpture. Time is laid out as a lesson in perspective.

My work is closer in its basic concerns to sculpture and architecture than it is to TV. What I do get from television is its central nervous system—video. I have found that my focus on organic principles in making video work has allied me with a number of artists—painters, composers, sculptors, and other film and video artists—who are developing a common aesthetic language based on this approach. The vocabulary of organicism is a vocabulary of elements. Its practice is the continual disassembling and reassembling of images.

**Mary Lucier**

**Landscape, Culture, and the Fossil Record**

**(1988/1989)**

> The uniformity of the earth's life, more astonishing than its diversity, is accountable by the high probability that we derived, originally, from some single cell, fertilized in a bolt of lightning as the earth cooled. It is from the progeny of this parent cell that we take our looks; we still share genes around, and the resemblance of the enzymes of grasses to those of whales is a family resemblance.

—Lewis Thomas, *The Lives of a Cell*

> For every atom belonging to me as good belongs to you.

—Walt Whitman, "Song of Myself"

The true history of landscape lies in the study of geology. Its text is the deeply layered crust of the earth, revealing to us in order of progression from its (recent) surface to its (ancient) depths, a record of "deep time" some 4,600 million years old. In this daunting scale of an almost incomprehensible past, the history of mankind appears as no more than a tiny sliver at the very top of the fossil record, underneath which lie eons of dramatic geologic and environmental upheaval and gradual change.

Ecology, the study of interactions among organisms and their relationships with the physical environment, offers us a "cultural" view of landscape—an interlocking picture of plant/animal/habitat in which the destiny of one entity must be seen as irrevocably linked to that of the others. Within the 800 million years since life on Earth began, a multitude of forms—both plant and animal—have arisen to claim their hour in the sun. Many have perished in the great periodic extinctions that scientists now speculate take place roughly every 26 million years. The most discussed and debated of these is the extinction of the di-

nosaurs at the end of the Cretaceous period some 65 million years ago. After dominating life on this planet for 140 million years and surviving several widespread extinctions themselves, dinosaurs abruptly disappear from the fossil record at the Cretaceous/Tertiary boundary. Paleontologists disagree about the exact nature of events that led to the demise of the great reptiles—whether it was gradual or sudden, whether it may even have been precipitated by an extraterrestrial event such as the impact of a gigantic asteroid. But they do agree that whatever happened was catastrophic in nature, global in impact, and involved the death of nearly half the genera on earth. (Descriptions of the process by those who propose the theory of asteroid collision are uncannily similar to predictions of nuclear explosion and the resulting "nuclear winter.")[1] Ironically, it was this cataclysm that made way for the unfettered rise of mammals, who did survive and who would, in their own time, come to dominate life on Earth.

The concept of catastrophism is as old as written history. Flood, pestilence, conflagration occur in most of the world's major religious myths, often as a device for retribution by an angry God. It was prevalent in naive form in nineteenth-century paleogeology as a means of explaining evolutionary change within the limited time scale and belief systems imposed by the Bible. And it has come around again as the central metaphor of an age in which, for the first time in Earth's history, the power for global annihilation—with full cognizance of the means and consequences—lies in the hands of man himself. Many scientists fear that we are already in the beginning throes of a major extinction as severe as that which eliminated the dinosaurs. With whole species presently dying at the rate of a hundred a day, there are predictions that over 1.2 million species will vanish within the next twenty-five years.

> Virtually all students of the extinction process agree that biological diversity is in the midst of its sixth great crisis, this time precipitated entirely by man.[2]

> Dinosaurs, it seems, are no longer simply a synonym for obsolescence or the dead-and-gone; their doom is increasingly recalled as a cautionary metaphor for the fate that could befall mankind . . . In our exploration of time, we have driven down a highway and searched under the junipers for some dinosaur bones and come face to face with ourselves.[3]

Today, the preeminence of *Homo sapiens*—in place of the descendants of *Tyrannosaurus rex*—might be seen to represent both the pinna-

cle of evolutionary development and the scourge of virtually unimpeded species growth. In our biological and evolutionary success, we have come to form the greatest threat of all to the realm of our own sustenance and survival.

> We have grown into everywhere, spreading like a new growth over the entire surface, touching and affecting every other kind of life, incorporating ourselves. The earth risks being eutrophied by us.[4]

The endangered health of many of the world's environments and peoples is no longer a parochial concern. We now know that overpopulation, pollution, deforestation, or toxic waste anywhere in the world ultimately affects us all in some way, wherever we live. The principle of ontological "oneness" within biological diversity, formerly the province of philosophers, poets, and the esoteric sciences, has become the imperative world-view.

### Notes

1. The reports of Walter and Luis Alvarez on this subject are quoted at length by John Noble Wilford in *The Riddle of the Dinosaur* (New York: Vintage Books, 1987), 263–77. Other descriptions in *National Geographic* 175 (June 1989): 686–87.

2. Edward O. Wilson, *National Geographic* 174 (December 1988).

3. Wilford, *Riddle of the Dinosaur,* 325.

4. Lewis Thomas, *The Lives of a Cell* (New York: Penguin Books, 1978), 105.

# Mary Lucier

## Light and Death (1991)

I

Sometime around 1970 I became obsessed with the idea that video had been invented to satisfy an ancient longing: to allow the human eye to gaze directly at the sun without damage to the retina. Unlike Icarus, who died flying too close to the sun, or Prometheus, who was punished for his appropriation of fire, we have obeyed an old taboo out of a deep and instinctual fear of loss. Direct, unmediated confrontation with the source of light means, paradoxically, the death of vision—the clouding over of the eye that dares to look, that surrenders to the persuasion of desire over reason.

Video technology made it safe for the human eye to look directly into the source of power but, at the same time, showed us that such an act of hubris is not completely without penalty. The price one paid, until recent technology replaced the camera's vacuum tube with state-of-the-art chips, was an irrevocable marking of the image-recording element itself, a permanent burn scar in the phosphors of the vidicon tube.

*As the sun rises in* Dawn Burn *(1975), giving heat and light and life to the city below, it engraves a signature of decay onto the technological apparatus; thus, light emerges as the dual agent of creation and destruction, martyring the material to the idea, technology to nature.*[1]

This scarring of the anthropomorphic camera eye serves as a graphic metaphor for the surrogate relationship between the lens/tube/VCR

Originally published in Doug Hall and Sally Jo Fifer, eds., *Illuminating Video: An Essential Guide to Video Art* (New York: Aperture, 1990): 456–63.

**249**

system and iris/retina/brain. The result of this primal encounter is a trauma so deep that its scars cannot be erased but, instead, accumulate on the image surface as a form of memory, and any picture subsequently recorded by that camera must be viewed through the scar tissue of prior trauma.

## II

*Fire Writing*

> *The performer writes in air with a portable video camera, allowing an intense light source such as a laser beam to cross the vidicon tube. As she writes, the camera repeatedly sweeping a given area, the laser light will cause bits of the text to be cumulatively recorded until, in time, the surface of the tube is entirely inscribed with the burn calligraphy. The performer is situated on an elevated platform with the lasers placed in an arc around the periphery of the space and focused directly at the camera. The video image is viewed on monitors placed near the performer and facing the audience.*

—*Mary Lucier, performance piece, 1975*

Applying the methodology of writing to camera technique was a means by which I sought to extend video's referents beyond its own limited history. I was interested in the displacement that occurs when one tool is assigned the function of another, the result being to infuse or enrich one set of aesthetic practices with those of another system commonly thought to be incompatible. The critic and artist Douglas Davis has been widely quoted for his manifesto stating that "the camera is a pencil." The camera is a tool like any other tool which an artist uses to render signs and symbols onto a receptive medium. By equating it with one of the most elementary of artist's implements, we are able to demystify the technology, to bridge the gap of specialness and privilege that often adhere to an advanced technology, and at the same time, to elevate the camera's status as a potential facilitator of great art.

Beyond its physical accessibility and convenience as the handiest way to transpose images and ideas, the pencil functions as a conduit between brain and paper. It is an object whose very presence in the hand stimulates both an extraordinary reflectiveness and a highly organized kinesthetic response. Of course, a camera does not inscribe a mark by direct, physical abrasion on a surface; to accomplish its task, a conver-

sion step is required between subject and instrument, during which the subject matter is, in a sense, absorbed into the instrument itself and its likeness imprinted onto a medium through electromagnetic recording. In *Fire Writing,* light seems to have been transferred into the camera and retained in the phosphors of the vidicon tube through the act of writing. The luminous inscription that results during performance consists of layers of text, each line of script fused with the preceding lines until time, space, and movement become compressed into a two-dimensional etching of scar tissue. The tube remains a permanent, displayable artifact of that process.

The scars on the vidicon tube represent a kind of knowledge. If an inanimate system can be said to have self-awareness, this is where it resides: embodied in the burn hieroglyphs of the damaged phosphors is a memory that will be imposed on every new subject placed before that camera until its tube is replaced with a fresh one that has not yet been exposed to the shock of its own limitations. Burn is the emblem of video's capacity for self-reflection and thus, perhaps, a template for our own. It forces the viewer to investigate the technology, making us conscious of its boundaries and compelling us to ask questions about how a medium composes and decomposes itself.

### III

*It is possible to argue, as Malevich did, that the twenty paintings which Monet made in the early 1890s of the facade of Rouen Cathedral, as seen at different times of day and under different weather conditions, were the final systematic proof that the history of painting would never be the same again. That history had henceforward to admit that every appearance could be thought of as a mutation and that visibility itself should be considered flux.*

—John Berger, "The Eyes of Claude Monet"

Monet painted outdoors facing the sun. Viewed this way, scenes seem to become irradiated from within as light and image mingle on the retina and are then "projected" back out, onto the canvas. Aim a camera toward the light and luminance becomes "caught" within the object, diffusing it through a veil of reticulation. As Monet gradually lost his eyesight, his brushstroke became more abstract, almost violent. His late paintings are charged fields of light and darkness, color, and pure energy—the anxious energy of a man yielding the familiar to the unknown, grasping a glimpse now and then of the light

that irradiates, while plunging deeper into a world of darkness and mutable forms.

> *The new relation between scene and seer was such that now the scene was more fugitive, more chimerical than the seer.*

—*John Berger, "The Eye of Claude Monet"*

Monet isolated himself from the world at large, creating an "eternal" motif that served as both art and nature. The garden fed his palette, which, in turn, enriched the hues of his flower beds and lily ponds. Master gardener and master painter become indistinguishable in this hermetic universe where even war does not intrude. An intimate, constructed landscape, the garden is at once natural and artificial, metaphoric and literal. Its fundamental service in human society is to familiarize us with the cycles of birth, death, and regeneration and to nourish some sense of power and control over our own ephemerality.

*Ohio at Giverny* (1983) was an attempt to concretize ephemera and to link disparate entities—geographies, histories, and personae—through a common exploration of light in landscape. The displacement of Ohio onto Giverny, suggested by the sweet but improbable union of my Midwestern uncle and French aunt, to whom the work is dedicated, is but one of those linkages. Observation and memory, present and past, collapse and regeneration are all bridged by the act of recording. The juxtaposition of my Ohio birthplace and Monet's restored gardens anchors a circular journey that leads forward and backward in time, utilizing an accessible body of French paintings as signposts in a very personal adventure—one of confrontation and reconciliation between the "new" and "old" worlds, youth and age, art and life, representation and abstraction, technology and nature.

**IV**

> *The American artist cherishes in his innermost being the impulse to reject completely the gospel of civilization, in order to guard with resolution the savagery of his heart.*

—*Perry Miller,* Errand into the Wilderness

> *Let me live where I will, on this side is the city, on that the wilderness, and ever I am leaving the city more and more, and withdrawing into the wilderness . . . I must walk toward Oregon, and not toward Europe.*

—*Thoreau,* Walking

*Wilderness* (1986) restages the Ohio-Giverny journey as an odyssey into a collective American past—a panoramic survey of landscape images with nineteenth-century visual and literary antecedents. It invokes Hudson River and luminist paintings as vehicles for revisiting a shared cultural and psychic history and, ultimately, as devices for reflecting upon the present time, while it poses an ironic view of the consumability of landscape as art in the face of the apparent frailty of the environment itself. Where Monet's garden was created as an eternal motif —a kind of endless and closed loop, continually regenerating both itself and the painter's palette—the American landscape is experienced as vulnerable, as having a brief though glorious life before being transformed by the forces of industrialization and development.

The tapes are structured as an adventure across coastal, inland, and upland geographies of the Northeast, ending with a coda in the icy waters off Newfoundland. Each of four major geographical sections is defined by a simulated gold picture frame that wraps around a receding landscape as a particular motif is achieved. These motif episodes are laid throughout the piece among longer sections of "narrative" exposition that carry the journey forward from location to location.

*The camera travels over water, coming to rest on the decrepit mast of a wrecked schooner, dissolving through water (Davey Jones's Locker) into the vacant captain's bedroom, dissolving back out again to the heroic little oysterman who becomes a cloud or the sun itself in the sky, and is eventually obliterated in pounding surf. Later, the early American Peto-like pewter and letter rack still lifes emerge out of the snowstorm; then the Beaux Arts Estate, eclectic mansion, and gargoyles epitomizing the follies of the Robber Barons, accompanied in the soundtrack by the call of crows and a hint of* Masterpiece Theater, *fading into the faux American aristocracy at play with red coats, bugles, and hounds, and an abundance of horses' ass and dogs' tails, dissolving into the Gothic romance of the estate in ruins, pausing at a contemporary anthem—"sex, drugs, and rock 'n' roll"—wiped away by the sound of fire transformed into rushing water, which becomes the woodland waterfall that segues slowly into the axis mundi— the still, deep pond that might be Walden itself 100 years ago, but becomes the lapping waters of Kensett's Lake George.*

Technological "breaks" mirror the gold picture frames in reverse, puncturing the image from the center outward as a square wipe:

*Horses break through the interior still life—the books, the little chest, the powder horn (symbolizing learning, savings, and battle); the paradigmatic iron*

*horse charges out from the center of the snowbound luminist cove, its roar blending with the sound of the winter gale; the strip-mining truck blasts the mountain reverie but is reabsorbed into the twilight sky, itself etched with jet vapor graffiti.*

The original American wilderness represented both the Garden of Eden and the Gates of Hell. To the Puritan settlers, the new land offered the promise of bounty, beauty, wealth, and comfort, but not before its supposed evils could be tamed and the land opened up, weeded out, cleared of its terrifying "beasts and savages," converted to pasture, village, and highway in the service of civilization. As the natural wilds did indeed begin to disappear, the concept of wilderness grew nostalgic, and the notion of preservation became a cause. In a complete about-face, nineteenth-century Americans began to conclude that it was important to preserve some concrete aspect of wildness in order to preserve an authentic national identity. Industrialization, the single most significant issue in the creative lives of nineteenth-century Americans, was viewed by painters and writers as an inexorable force, destined to transform the environment and forever alter man's relationship to "nature."

This dual aspect of modernity, with its mixed portents of enlightenment and destruction, is epitomized in the landscape, now a focus of the struggle. Like the graffiti-scarred vidicon tube—born of crisis, incorporating both hope and failed vision—the land has become an aestheticized ruin. Finally, what we have is an ersatz wilderness, a TV/video wilderness, that sits like sculpture on faux neoclassical pedestals: the faux pedestals that bear the "real" televisions which depict the video wilderness that becomes a simulated painting in a synthetic gold frame, within a frame, within a frame.

### Note

1. Writing in italics not identified as by another author is from previous texts by Mary Lucier.

## Mary Lucier

## Virtually Real (1995)

I am an anomaly in my field: a technological artist who doesn't own a computer. I was an anomaly as a child, being the only kid I knew on the block without a television set. My parents didn't get a TV until after I went to college in 1961, and that was because my grandmother gave it to them. My mother was afraid we wouldn't read.

Our entire family was anomalous in that we didn't even own a car until sometime around 1952. It was a '48 Ford. As many of you will remember, 1952 was the year the shape of automobiles changed from buglike to longer, sleeker, two-tone. I guess my mother was afraid we wouldn't walk.

I was so humiliated by our gray, buglike '48 Ford that I used to hide in the well between the seat and the dashboard every time my father drove me downtown or to a football game. Fortunately, we lived right across the street from the school, so I didn't have to be driven to class or to proms and, besides, my boyfriend's father had a *very* cool Packard.

Eventually, my father bought a two-tone green '53 Chevrolet, also used, but no longer embarrassing. The shift was right on the steering wheel—first, second, third, reverse. That's the car I learned to drive on, and to this day I've never really understood the need for more than three forward gears and reverse.

On rainy days, when I couldn't go out or ride my bike or go swimming or play, I remember hounding my mother. It's a familiar refrain: "Mom, I'm bored." She'd reply, "Read!" Me: "I'm too bored to read."

Talk presented at the Miami Art Fair, on a panel entitled Art on the Eve of the Millennium, January 6, 1995. Originally published in *Millennium Film Journal*, no. 28 (spring 1995): 100–106.

Mother: "Draw!" So eventually, I did a great deal of both, along with exploring the backyard jungles, catching night crawlers, and playing Doctor with all the neighborhood kids.

There was one piece of electronic magic in my life, however, which made an indelible impression, and that was an enormous Magnavox console, consisting of a 78 rpm turntable enclosed in the upper left-hand cabinet, and a radioactive green radio dial on the right side, with AM, FM (which required a special antenna that we did not have), and my favorite, shortwave. Underneath all this in the console, at a perfect height for a ten- to fourteen-year-old girl seated in rapt attention four inches from the cloth grill, were the most magnificent loudspeakers I'd ever heard.

I neglected to mention that we lived in a drafty old Victorian house without heat on the second floor. In the winter we'd open these rather beautiful, ornate cold air registers in the ceiling, which were supposed to allow the heat from below to rise into our frigid bedrooms, but which mainly allowed my brother and sister and me to spy on one another or to overhear all the quarrels and secrets we shouldn't and needn't have been exposed to. As a result, I developed quite a taste for voyeurism—for viewing life through a rectangular metal frame with vertical slats and curious patterns and a picture that was sometimes nothing more than an empty sofa and part of an armchair. When I was not reading or drawing or exploring or building something peculiar, I'd just as likely be lying flat on a cold floor, peering into the depths, straining to hear some drama being enacted just out of view below, or I'd sit up late at night, long after everyone else had gone to bed, with both hands and eyes on that luminescent radio dial and my body pressed close to those fabulous loudspeakers, scanning the dial nonstop until I could recognize Hank Ballard and the Midnighters or Ray Charles or Fats Domino or Etta James or Laverne Baker or Elvis, by just a few bars, via stations that came in only at night, illuminating a landscape from Nashville to Cleveland to Detroit and beyond.

But the real thrill was listening to shortwave. The staticky squawks and rhythmic bleeps, punctuated by fragmentary bursts of mysterious speech, made up another, more bizarre landscape that I fantasized as space and time travel. Hunkered down there against that machine for hours on end, cross-legged on one of my mother's somewhat threadbare Oriental rugs, I experienced a deep crisis of faith. In the same spirit with which I used to pray intently to God, or at least Jesus, "Please, oh please appear to me or give me a sign," to make Himself

known so that I could partake of a transformative miracle, become a believer, and leave behind, once and for all, my deep ingrained agnosticism and my dreary small-town life, I tried to *will* that carpet to fly.

Shortwave radio, Jules Verne, Tom Swift, 1001 Arabian Nights, Grimms' Fairy Tales, Mowgli the Jungle Boy, Dracula, Frankenstein, Alice in Wonderland, The Wizard of Oz, Alexander Nevsky, the Bible itself—a massive illustrated King James version with pictures so horrifying, I trembled to look (irresistibly) at the Red Sea closing over helpless horses and terrified men in armor with spears and eyes raised hideously heavenward—this was my television. A technology primarily of the imagination. An imagining of a technology.

How I got from there to here has everything to do with my sense of the enormous mystery surrounding the very stuff of life itself: its molecular composition, the phenomena of light and sound waves, the technology of nature—earthquakes, volcanoes, tornadoes, evolution, extinction, and a continuing quest to resolve that unanswered crisis of faith, to find a noncorporeal medium of travel that could dematerialize the physical body, reconstituting it as a series of electrical impulses, an aggregate of magnetic particles, a compendium of bits and bytes, bridging an incomprehensible past with the unknowable future.

Pure spirit.

**Mary Lucier**

**Notes for a Panel Discussion**

**Art/Sci '98 Conference at Cooper Union (1998)**

One career challenge? It's impossible to narrow it down to only one. Every day is a challenge. Getting up. Getting to work. Getting work. Making work. Surviving. What is particular to me, to my life as a multimedia person, a sculptor/video artist-in-residence in a new digital world, a responsible citizen at large in an expanding universe? I think immediately of two things, two concerns—having to do in two utterly different ways with how my work gets accomplished and its place in that world.

### One

The challenge/the pressure/the compulsion/the necessity/the siren's call/the threat of the moment is to transform myself from a creature of linear, analog habits and practices to one who dwells comfortably in nonlinear, digital space and time. As a video installation artist whose work has evolved over the past twenty-five years from sculpture, photography, and performance, I find myself at some distance from what used to be called "the cutting edge," where all video used to live just by virtue of simply being video. Until quite recently, the very act of making video as art was a radical pursuit. Its electronic, ephemeral nature seemed to challenge everything Western culture had come to valorize about the heroic ideal of artmaking and the value of the Masterpiece. With the advent of interactive computer technologies, digital imaging, and the Internet, all that has begun to change. Bill Viola now refers to some of the equipment in his recent retrospective at the Whitney Museum as "old-fashioned," and describes an encounter with a college student at this computer station who says to Bill, "Oh, yeah, video. That's my dad's medium."

The real issue is, where does value lie? Where does the spirit of a work actually dwell? Do pixels have soul? (For that matter, does paint?) Does meaning reside in a circuit board? Or God in a microchip? To quote William Blake:

> Does the Eagle know what is in the pit?
> Or wilst thou go and ask the Mole?
> Can wisdom be put in a silver rod?
> Or love in a golden bowl?
> (From *Thel's Motto*)

Is the instrument or tool or container integral to the idea, the substance, the value of what it produces, or, more correctly, what you and I produce with it? We can go swirling round and around these questions, but finally I think we have to acknowledge a kind of intelligence inside the machines, an intelligence we have placed there, based on the brain as a model—one which makes us want to get inside and explore. Because the means now exist to access thoughts and images, forms and sounds from a vast pool of information, to experience them as one might in the imagination itself—not in a continuous, orderly narrative but as they occur—in irrational bursts and spasms and obsessive flowing rhythms. Becoming nonlinear means relying on an entirely different part of the mind. It means learning to trust and cultivate the bursts and spasms, give up the anchors of the familiar, and leap off the cliff into cyberspace. You know why so many lemmings throw themselves into the sea? They're trying to get to the other side. (Isn't that linear?)

## Two

A year ago, in Grand Forks, North Dakota, the Red River, one of only two rivers in the United States which actually flows north, crested at fifty-four feet—that's twenty-six feet above flood stage—following a winter of record blizzards and frigid cold. Grand Forks is a city accustomed to hard weather and high water. It is ringed with fifty-two-foot-high dikes and inhabited by a tough breed of Plains people who assiduously patrol the dikes looking for leaks and are willing to sandbag for days on end without rest until a higher power orders them to quit. When the National Guard did just that last April, thousands of citizens waded through the muddy rising waters, leaving their homes and life's possessions to the river, not knowing what would remain or what they would find when they were allowed to return. Just when they thought it couldn't get any worse, it did. On April 19, fire broke

out in the flooded downtown, destroying eleven city buildings. Through struggling, with no way to fight the fires and no homes left to save, the evacuated population of Grand Forks and East Grand Forks watched at a safe distance as their city was consumed by "hell and high water."

A few months ago a now-famous photograph of downtown Grand Forks ran in the Art and Leisure section of the *New York Times*—an image that looked for all the world like Berlin or Dresden after the war. It was Apocalypse for sure. I was still pondering that image when Laurel Reuter from the North Dakota Museum of Art called asking if I might be interested in coming to Grand Forks to create a new piece there as part of a commemorative flood project in the museum. (By the way, if you think there's no justice, the museum was one of the few buildings not damaged by the flood.) I've chased icebergs off Newfoundland, the burning rainforest in the Amazon, earthquakes and oil spills in Alaska, hurricanes in Charleston. Floods in the Great Plains? This I could do.

I have been to Grand Forks twice now and am about to go back a third time to do more shooting. It has been a full year since the flood, and they are just getting around to tearing down thousands of condemned houses. I've been tracking around in what used to be people's homes with my camera, intensely scrutinizing ruined interiors whose appalling damage and decay has severely altered how I look at any ordinary domestic scene. It's the mud caked up to the second story. It's the black mold coming back to life as spring approaches. It's the debris of everyday life thrown by the river from one room to another and heaped to the ceiling in great gooey piles. It's shredded paint and wallpaper still peeling from walls that ooze moisture. It's family china and wineglasses in their cupboards and kids' stuffed animals and sofas and TVs and photographs and books—all blackened and foul. It's an evil stench of rotted food and mildew and sewer-soaked carpet. It's warped floors and broken windows, appliances upended and twisted bicycles hanging off collapsed porches. This landscape of destruction has created a new template through which I now view every living room, kitchen, bedroom, bath. It's a sensation of total decay—like being inside a grave—and all of life becomes infected by it.

The challenge here is not just to make art out of all this but to make a piece to be shown to the very people who experienced the disaster.

What new insight or perspective or point of view can I bring to this place? What do I have to offer these resilient but exhausted inhabitants of a ruined city? What role does art play when confronted by life at the extreme edges of physical and emotional tolerance? Should the work be cathartic? palliative? commemorative? factual? transcendent? angry? optimistic? ugly? beautiful? spiritual? descriptive? immersive? objective? painful? reassuring? The challenge for me is no less than a complete reevaluation of the function of a work of art in the context of its intended audience who, after all, complete the piece for you and without whom it does not exist.

March 31, 1998; revised August 1998

## Chronology

*Note:* Videotapes are included in numerous public and private collections. Permanent collections are noted for installations only.

1969    *Polaroid Image Series #1: Room*
Black-and-white Polaroid photographs and slides, using the technique of copying and recopying a photograph over multiple generations. First presented in conjunction with "*I Am Sitting in a Room,*" audiotape by Alvin Lucier at the Solomon R. Guggenheim Museum, New York, March 25.

1970    *Hymn*
Amplified live construction of human-scale web. Collaboration with Alvin Lucier. First performed at Sanders Theater, Memorial Hall, Harvard University, Cambridge, Massachusetts, March 2.

*Polaroid Image Series #2–6: Shigeko; Croquet; City of Boston; David Behrman; Three Points*
Black-and-white Polaroid photographs and slides.

1971    *The Caverned Man*
Performance with old man, puzzles, and miniature projected images. First performed at Wesleyan University, Middletown, Connecticut, February 23.

*Color Phantoms*
A series of projected images composed of 35 mm sandwiched slides superimposing landscapes and television imagery. First exhibited at Wesleyan University, Middletown, Connecticut, with a sensory environment by composer Richard Martin, May 10–12.

*Salt*
Large-scale outdoor mixed-media environment using snow fencing, tobacco cloth, marble chips, and amplified bird calls to evoke a layered image of the Great Salt Lake and the Connecticut River

**263**

Valley. Constructed at St. Clements Estate, Portland, Connecticut, October 29.

1972    *Journal of Private Lives*
Performance with slide projections, film projection, and live projected writing on three large screens. First performed at Spencer Memorial Church, Brooklyn, New York, March 19.

*Second Journal (Miniature)*
Four rear-screen miniature slide projections with magnifying glasses. First exhibited at Ninth Annual New York Avant-Garde Festival, on the *Alexander Hamilton* at the South Street Seaport, New York, October 28.

*Red Herring Journal (The Boston Strangler Was a Woman)*
Performance with slide projections, live projected writing, and spoken text, exploring female criminal behavior and sexual identity. First performed as part of an evening of work by Red, White, Yellow, and Black at the Kitchen, New York, December 16.

*Media Sculptures: Maps of Space*
Series of conceptual performance photographs for Pauline Oliveros, Lin Barron, and the Mirror of Venus Ensemble. First published in *Women's Work,* ed. Alison Knowles, Brooklyn, the Print Center.

1973    *The Occasion of Her First Dance and How She Looked*
Performance with videotape, slide projections, and audio text in a mixed-media stage set. Black-and-white videotape. 30:00 min. Collaboration with Cecilia Sandoval. First performed as part of two evenings of work by Red, White, Yellow, and Black at the Kitchen, New York, April 20–21.

*Antique with Video Ants and Generations of Dinosaurs*
Mixed-media installation with video, antique cabinet, black-and-white photographs, plants, and other artifacts. Black-and-white videotape. Silent. 30:00 min. Continuous. First exhibited at Tenth Annual New York Avant-Garde Festival on board a train at Grand Central Station, New York, December 9.

1974    *The Trial of Anne Opie Wehrer by Robert Ashley*
Single-channel videotape. Shot as part of a performance of the Merce Cunningham Dance Company at Cunningham Studio, New York, March 23 and 24. Performers: Robert Ashley, Anne Wehrer, Kathy Beeler, and Mary Lucier (camera). Black and white. Sound. 52:00 min.

*Word Fragments and Recycled Images 1*
Installation of photographs, artifacts, and miniatures. First exhibited in *About 405 East 13th Street,* curated by Jean Dupuy, 405 East 13th Street, New York, April 18–21.

*Word Fragments and Recycled Images 2*
Installation of photographs and photo collages. First exhibited in *A Generation of Brandeis Artists,* Rose Art Museum, Brandeis University, Waltham, Massachusetts, September 11–October 13.

*Chalk Writing with Air Writing/Video*
Mixed-media performance with single channel black-and-white videotape, photographs, and text. First performed at Eleventh Annual New York Avant-Garde Festival, Shea Stadium, Flushing, New York, November 16.

*Polaroid Image Series #7: Anne Opie Wehrer*
Black-and-white Polaroid photographs and made from an original video image.

*The Viola Farber Dance Company*
Single-channel documentary videotape. Black and white. Sound. 13:00 min. Collection of the Performing Arts Library at Lincoln Center, New York.

1975   *Air Writing*
Three-channel video installation. Black and white. Sound. 40:00 min. cycle. Continuous. First exhibited at the Kitchen, New York, October 25–November 4.

*Fire Writing*
Performance with lasers, video camera, prerecorded audio text, with accumulating live vidicon burn calligraphy displayed on multiple monitors. Black and white. Sound. 40:00 min. First performed at the Kitchen, New York, October 26.

*Attention Focus and Motion*
Single-channel videotape. Black and white. Sound. 28:00 min.

1975–76   *Fire Writing I and II*
Single-channel videotapes resulting from live performances of *Fire Writing* at the Kitchen, New York, October 26, 1975, and the Everson Museum, Syracuse, New York, December 3, 1976. Black and white. Sound. 40:00 min.

*Dawn Burn*
Seven-channel video installation for seven monitors of stepped sizes in a freestanding, segmented sculptural form with color slide projection. Black and white. Silent. 30:00 min. Continuous. First exhibited at Anthology Film Archives, New York, April 17, 1976. Collection of the San Francisco Museum of Modern Art.

1977   *Untitled Display System*
Installation for burned vidicon tubes and videotape. Black and white. Silent. Continuous. First exhibited at and/or gallery, Seattle, Washington, May 6–8.

*A Burn for the Bigfoot/Sasquatch*
Three-channel video performance with slide projections. Black-and-white videotape. Sound. 30:00 min. First performed at and/or gallery, Seattle, Washington, May 7.

*Paris Dawn Burn*
Seven-channel video installation for seven monitors of stepped sizes arranged in a freestanding, segmented, sculptural form with single color slide projection. Black and white. Sound. 30:00 min. cycle. Continuous. Created for and first exhibited at *10e Biennale de Paris,* Musée d'art moderne de la ville de Paris, September 17–November 1.

*Laser Burning Video/Lasering*
Installation with live laser, camera, and videotape. Black and white. Silent. Continuous. First exhibited at the Hudson River Museum, Yonkers, New York, November 19, 1977–January 8, 1978.

1978    *XY*
Performance with two suspended slide projectors, suspended helium neon laser, and musical hose. First performed as part of *A Tower in the Auditorium of P.S. 1,* P.S. 1, Long Island City, New York, February 18, 19, and 25.

*Bird's Eye*
Single-channel videotape. Black and white. Sound, "Bird and Person Dyning" by Alvin Lucier. 10:00 min.

1979    *Equinox*
Seven-channel video installation for seven monitors of stepped sizes in a freestanding, segmented steel and wood structure. Color. Sound. 56:00 min. cycle. Continuous. Commissioned by the City University Graduate Center, New York. First exhibited at the City University Graduate Center Mall, New York, April 3–May 7.

*Two-Screen Writing Matrix*
Single-channel videotape. Black and white. Sound. 18:00 min.

1980    *Planet*
Single-channel video installation for five angled monitors of stepped sizes arranged in a concave arc within a triptych wall. Color. Silent. 15:15 min. cycle. Continuous. Commissioned by and first exhibited at the Hudson River Museum as part of the series *The Planetarium: An Alternative Space,* Yonkers, New York, April 12–July 6.

1981    *Denman's Col (Geometry)*
Two-channel video installation for five monitors in a zigzag wall. Color. Sound. 16:00 min. cycle. Continuous. First exhibited at the Whitney Museum of American Art, New York, November 7–29.

1983     *Ohio at Giverny*
Two-channel video installation for seven monitors of stepped sizes mounted in an arched configuration in a curved wall. Color. Sound. 18:30 min. cycle. Continuous. First exhibited in *1983 Biennial Exhibition,* Whitney Museum of American Art, New York, March 24–May 29. Collection, Whitney Museum of American Art, New York.

*Ohio at Giverny (composite)*
A videotape derived from the installation. In this composite version the two channels of video are displayed side by side on one screen. Color. Sound. 18:30 min.

*Ohio to Giverny: Memory of Light*
Single-channel videotape. Color. Sound. 19:00 min. First aired on *Video/Film Review,* WNET/Channel 13, New York, October 16. Public and private collections.

*Ohio at Giverny*
Photographic portfolio consisting of fifteen C-prints, each 16 × 20 inches. Public and private collections.

1984     *Wintergarden*
Two-channel video sculpture for six monitors embedded in individual geometric forms. Color. Sound. 11:11 min. cycle. Continuous. Commissioned by the Lower Manhattan Cultural Council. First exhibited at Chase Manhattan Plaza, New York, February 7–March 9.

*Wintergarden (composite)*
A videotape derived from the installation. In this composite version the two channels of video are displayed side by side on one screen. Color. Sound. 11:11 min.

1985     *Amphibian*
Dance/video collaboration with Elizabeth Streb for live performance with two channels of rear-projected videotape. Color. Sound. 10:00. Commissioned by the Harvard Summer Dance Center and first performed at the Loeb Drama Center, Harvard University, Cambridge, Massachusetts, July 12–13.

*Amphibian (composite)*
A videotape composite of the two channels of video used in performance. In this version the two channels are displayed side by side on one screen. Color. Sound. 10:00 min.

1986     *Wilderness*
Three-channel video installation for seven 25-inch video monitors mounted on faux classical pedestals in a stepped colonnade. Color. Sound. 21:00 min. cycle. Continuous. Commissioned by and first exhibited at the Rose Art Museum, Brandeis University, Waltham,

Massachusetts, January 12–February 16. National tour organized by the New England Foundation for the Arts. Private collection.

1986/91    *Asylum*
Three-part environment consisting of an indoor garden conservatory, a rustic toolshed, and a video/machine area with a single channel of videotape. Color video. Sound. 12:00 min. cycle. Continuous. Created during a residency at the Capp Street Project in San Francisco, California, and first exhibited May 28–June 28, 1986.

*Asylum (a Romance)*
A single-channel videotape used in the installation. Color. Sound. 12:00 min.

1987    *In the blink of an eye . . .*

*(amphibian dreams)*

*"If I could fly I would fly"*
Single-channel videotape. Choreography, Elizabeth Streb. Color. Sound. 25:11 min. First aired on *New Television,* WGBH Boston, May 1.

1990    *MASS*
*between a rock and a hard place*
Single-channel videotape. Collaboration with Elizabeth Streb. Color. Stereo sound. 11:00 min. Produced by *Alive from Off Center.* First aired on PBS, August 30.

1991    *MASS*
Three-channel video installation for vertical format projection onto large angled ramps. Collaboration with Elizabeth Streb. Color. Three-channel sound. 11:11 min. cycle. Continuous. First exhibited at the City Gallery of Contemporary Art, Raleigh, North Carolina, November 2–December 29. National tour.

1992    *Asylum*
Photographic portfolio consisting of ten 20¼ × 25-inch Cibachrome prints in rusted steel frames.

1992–93    *Noah's Raven*
Mixed-media, four-channel installation defined by a configuration of eight freestanding forklifts and tree trunks, each supporting a 32-inch monitor. A large skeletal form hangs overhead. Color and black-and-white video. Stereo sound. 26:00 min. Continuous. Commissioned by and first exhibited at the Toledo Museum of Art, February 7–May 9. National tour. Collection of ZKM/Center for Art and Media, Karlsruhe, Germany.

*Noah's Raven (composite)*
A videotape derived from the installation. In this composite version four channels of video are displayed in quadrants on one screen. Color and black and white. Sound. 26:00 min.

1993    *Oblique House (Valdez)*
Interactive video and sound installation with six channels of video on two projectors and four monitors incorporated into the architecture of a specially constructed, 23 × 26 × 26-foot house. Color video. Five-channel sound. Five laserdiscs. Continuous. Commissioned by Montage '93, International Festival of the Image, and first exhibited as part of the festival in the abandoned Hallman's Chevrolet showroom, Rochester, New York, July 11–August 7.

*Maps of Time*
Three framed video photographs. Laminated Cibachrome prints. Each, $19^{1}/2$ × 25 inches. First exhibited at the Rebecca Cooper Gallery, New York, September 1993.

*Rainforest*
Nine framed video photographs. Laminated Cibachrome prints. Each, $19^{1}/2$ × 25 inches. First exhibited at the Rebecca Cooper Gallery, New York, September 1993.

1994    *Maps of Time: Mother*
Two black-and-white video photographs. Each $14^{1}/4$ × $18^{3}/4$ inches. First exhibited at Lennon, Weinberg, Inc., New York, June 17–July 29.

*Maps of Time: Nancy*
Two black-and-white video photographs. Each panel $14^{1}/4$ × $18^{3}/4$ inches. First exhibited at Lennon, Weinberg, Inc., New York, June 17–July 29.

1995    *Last Rites (Positano)*
Interactive mixed media installation based on narratives about an episode in family history from the 1930s. Eight channels of interactive sound and video displayed on three monitors, two large-scale overlapping projections, and seven sound sources, with suspended furniture and photographs. Color video. Eight laserdiscs. Continuous. First exhibited at Lennon, Weinberg, Inc., New York, March 18–April 22.

*Botticelli*
A series of mixed-media portraits consisting of boxes, cabinets, and other containers in which layered text and personalized artifacts (including video and audio) offer clues to individual and couple identity as revealed through a list of questions based on the party game

Botticelli. Prototypes: *Portrait (Deanne and Richard)*, finished birch plywood boxes with movable partitions, hinged tops, frosted Lucite, translucent film sheets, electric lights, DAT player and sound system, and miscellaneous objects. First exhibited as part of *Living with Contemporary Art*, Aldrich Museum of Contemporary Art, Ridgefield, Connecticut, October 1, 1995–January 7, 1996.

1996     *FLOW*
A video projection installation for two projectors and four loudspeakers. Water images are projected on a wall, overlapping in such a way as to create a single elongated video mural. Barely audible underneath the soundtrack of rippling water is an intermittent autobiographical narrative spoken by an elderly woman recalling formative events in her past life. Color. Four laserdiscs. Multiple soundtracks. Continuous. First exhibited as part of *Reinterpreting Landscape*, Maier Museum of Art, Lynchburg, Virginia, January 20–March 17.

*Aspects of the Fossil Record, or From Here On Dance*
A video sculpture consisting of three suspended monitors and two loudspeakers, with three video loops depicting natural phenomena. Color video. Three monitor carriages for ceiling suspension. Exposed laserdisc player, audio amplifier, controller, and multicolored cables. First exhibited as part of *Natural Spectacles*, David Winton Bell Gallery, Brown University, Providence, Rhode Island, April 20–June 16.

1997     *House by the Water*
A mixed-media installation consisting of four video projections on the exterior sides of a houselike structure raised on stilts and surrounded by a cyclone fence in the center of a darkened warehouse. The video and sound juxtapose aspects of natural phenomena with vignettes shot at the Aiken-Rhett House in Charleston, South Carolina. House sculpture: steel posts, wood and shiplap siding, two blue lights. Color video. Four-channel sound. Four laserdiscs. 10:00 min. cycle. Continuous. Commissioned by and first exhibited as part of *Human/Nature: Art and Landscape in Charleston and the Low Country*, Spoleto Festival USA, Charleston, South Carolina, May 23–July 20.

1998     *Summer, or Grief*
A single-channel videotape alternating images with single words and short phrases in simple white font against a black background. Text excerpted from "A Conversation," by Allen Grossman. Color. Sound. 7:30 min.

1998/99   *Floodsongs*

A video and sound installation presenting a gallery of videotaped portraits of residents of Grand Forks, North Dakota, flanked at one end by continuous projection of the exteriors and interiors of flood-ravaged homes and, at the other, by a hanging cluster of domestic furniture salvaged from the flood. Color video. Seven laserdiscs. Six 32-inch video monitors. Ceiling-mounted video projector. Eight-channel sound. Sixteen loudspeakers. A chair, a stool, and a lamp. Continuous. Commissioned by and first exhibited at the North Dakota Museum of Art as part of *Mud and Roses,* December 6, 1998–January 31, 1999. Traveled to Museum of Modern Art, New York, March 13–June 20, 1999.

## Select Bibliography

*Note:* Essays included in this book in their entirety do not appear in the Bibliography.

### Articles, Reviews, Interviews, and Dissertations

Adams, Brooks. "Art on the Edge." *Vogue* (July 1990): 96–99.

Ancona, Victor. "Mary Lucier's Art: Light as Visual Image." *Videography* 4 (July 1979): 66–85.

———. "Video Fuses with Traditional Media at Whitney Biennial." *Videography* (May 1983): 72–75.

Anderson, Phil. "Paul Kos, Mary Lucier." *High Performance* 39, no. 3 (1987): 99–100.

Annas, Teresa. "New Yorker Lucier's Show Bustles with Sound, Vision." *Portsmouth Virginian Pilot and Ledger-Star,* October 11, 1992.

Artner, Alan G. "Video Veteran." *Chicago Tribune,* October 25, 1997.

Avgikos, Jan. "Video Installations Alter Usual Perceptions." *Atlanta Constitution,* April 25, 1985.

Barlow, Melinda. "Mary Lucier: Biographical Notes." In Sandra E. Knudsen, ed., *Noah's Raven: A Video Installation by Mary Lucier,* 41–48. Catalogue. Toledo: Toledo Museum of Art, 1993.

———. "Personal History, Cultural Memory: Mary Lucier's Ruminations on Body and Land." *Afterimage* (November 1993): 8–12.

———. "Fragments of a Memory." *Performing Arts Journal* 49 (January 1995): 49–53.

———. "Memory and Mortality in the Work of Mary Lucier." Ph.D. diss., Department of Cinema Studies, New York University, 1996.

Becker, Robert. "Videoview." *Interview* (September 1984): 188–92.

Belans, Linda. "Rising to the Challenge." *Raleigh (N.C.) News and Observer,* November 1, 1991.

Bell, Jane. "Biennial Directions." *ARTnews* (summer 1983): 76–79.

Bleznick, Susan R. "Noah's Raven Raises Tough Questions." *Montage* (Toledo) (March 1993): 6–7.

Bonetti, David. "American Beauties: Grafting Mashek and Lucier onto the Rose." *Boston Phoenix,* February 4, 1986, 5, 11, 12.

Brew, Kathy. "American Landscape Video." *Artcoast* (May–June 1989): 83–84.

———. "Mary Lucier." *Shift* 3, no. 2 (1989): 20–25.

Cassagnac, Jean-Paul. "Biennale, des Petits aux Grands." *Canal* (Paris), October 1977, 9.

Collins, William E. "'Realsculpture' at St. Clements." *Middletown (Conn.) Press,* November 5, 1971.

Conover, Kirsten A. "Tuning in to Video as an Art Medium." *Christian Science Monitor,* June 11, 1987.

Cornwell, Regina. "Mary Lucier." *Artscribe* (summer 1991): 67–68.

Cullinen, Helen. "Video Artists Serve Choice Repast of Works." *Cleveland Plain Dealer,* May 21, 1984.

———. "A Moving Video Artwork on Man's Earth at Toledo." *Cleveland Plain Dealer,* April 4, 1993.

Cyphers, Peggy. "Asylum." *ARTS Magazine* (April 1991): 96.

Daly, Ann. "Video Pays Homage to Monet." *Pittsburgh Press,* August 6, 1983.

Day, Jeffrey. "Artwork Opens Our Eyes to the Low Country." *The State* (Columbia, S.C.), June 8, 1997.

Ditlea, Steve. "Art from Picture Tubes." *New York Daily News,* August 12, 1992.

Dobrzynski, Judith H. "Anonymous Gifts for Art, So Women Creating It Aren't" *New York Times,* October 12, 1997.

Dougherty, Linda Johnson. "Human/Nature: Art and Landscape in Charleston and the Low Country." *Sculpture* 16 (October 1997): 70–71.

Drake, Nicholas. "Artist Uses Life Experiences as Basis for Mixed-Media Works." *Charleston (S.C.) Post and Courier,* May 29, 1997.

Duguet, Anne-Marie. "The Luminous Image: Video Installation." *Camera Obscura* 13/14 (1985): 29–49.

Enright, Robert. "Sounding the Depths of the See." *Border Crossings,* no. 69 (February 1997): 7.

Fargier, Jean-Paul. "La collection du Musée d'art moderne de New York." *Le Monde* (Paris), November 6, 1980.

Fox, Catherine. "Landscapes Speak in Spoleto." *Atlanta Constitution,* May 28, 1997.

Glueck, Grace. "Video Comes Into Its Own at the Whitney Biennial." *New York Times,* April 24, 1983.

———. "Video Work on Different Wavelengths." *New York Times,* February 26, 1984.

Goldberg, Vicki. "A Brave New World of Electronic Art and Images." *New York Times,* July 25, 1993.

Greenberg, Blue. "Enigmatic Images Will Endure." *Durham (N.C.) Herald Sun,* November 24, 1991.

Groot, Paul. "The Luminous Image." *Artforum* (January 1985): 97–98.

Grundberg, Andy. "Mary Lucier." *Artforum* (summer 1984): 90.

———. "Video Art: The Fabulous Chameleon." *ARTnews* (summer 1989): 118–23.

———. "Video is Making Waves in the Art World." *New York Times,* November 17, 1989.

———. "Mary Lucier: Asylum." *New York Times,* February 1, 1991.

Halpern, Max. "'Mass' Appeal: Video's Visceral Effect." *Raleigh (N.C.) News and Observer,* November 1991.

Heartney, Eleanor. "Ten for the 90's." *ARTnews* (April 1990): 144–45.

———. "New York." *Contemporanea* (May 1990): 54–55.

Hillyer, Lisa F. "Object Lessons." *Boston Phoenix,* July 23, 1985.

Hoberman, J. "Denman's Col (Geometry)." *Village Voice* (centerfold), November 18, 1981.

Holst, Lise. "Mary Lucier." *ARTnews* (February 1990): 161.

James, Caryn. "Out of the Shadows." *New York Times,* July 18, 1997.

Jones, Mablen. "Landscape versus Technology: Myth and Metaphor in the Work of Mary Lucier." *Center Quarterly* (fall 1987): 18–19.

Jones, Nancy. "Time Out." *New York Woman* (October 1989).

Kazanjian, Dodie, ed. *Arts Review.* National Endowment for the Arts, Washington, D.C. (spring 1987): 29–30.

Klein, Mason. "Shigeko Kubota and Mary Lucier." *Frieze* (November–December, 1995).

Kutner, Janet. "Monitoring Lucier's *Wilderness.*" *Dallas Morning News,* November 3, 1987.

Lane, Kathleen, and Timothy Volk. "Video Art: Impressions." *Video Systems* (January 1984): 58–61.

Liotta, Christine. "A Natural Order." *Sculpture* (September–October 1990): 64–65.

Loney, Glenn. "Video Artist Lightens Up the Whitney." *East Side Express,* April 14, 1983.

Love, Lynn. "Montage 93." *New Art Examiner* (January 1994): 47–49.

Mahoney, Robert. "Mary Lucier." *ARTS Magazine* (February 1990): 101.

McGivern, Shawn. "An Eloquent Plea in '*Wilderness.*'" *Boston Globe,* February 1, 1986.

McNally, Owen. "Video Artist Depicts Conflicts with Nature." *Hartford Courant,* March 26, 1986.

Mifflin, Margot. "New Media, New Art." *Elle* (May 1989): 178, 180.

Miller, Donald. "Visiting Monet's Home without Leaving Town." *Pittsburgh Post-Gazette,* July 23, 1983.

Miller, Sherry. "Video Art Makes It to Museum in Portland." *Maine Sunday Telegram,* September 14, 1986.

Miro, Marsha. "Multi-Media Show Gives Disturbing Images, Sounds of the Earth." *Detroit Free Press,* February 28, 1993.

Morgan, Marie. "The New Narrative. Video in the 80's." *Banff Letters* (winter/spring 1984).

Morgan, Robert. "Mary Lucier." *ARTS Magazine* (April 1989): 98.

——. "Mary Lucier: *Floodsongs.*" *Review* (June 1999): 14–15.

Morse, Margaret. "Mary Lucier: Burning and Shining." *Video Networks,* June 1986, 1, 6–7.

——. "Art and the Garden: Feminist Strategies in Postmodern Art and Discourse." *Cinematograph* 3 (1988): 51–56.

Nadelman, Cynthia. "Interview with Mary Lucier." Typescript, Archives of American Art, Smithsonian Institution, New York, N.Y., 1990.

Newhall, Edith. "Galleries." Fall Preview, *New York Magazine* (September 1989): 11.

Patin, Thomas. "Landscape: The Mirror of Nature." *Artspace* (November–December 1989).

Perlberg, Deborah. "New Directions in Video Art." *Videoscope* 2, no. 3 (1979): 17–23.

Preston, Malcolm. "High-Tech Impressionism." *Newsday,* January 2, 1984.

Raynor, Vivian. "Mary Lucier (Wadsworth Atheneum)." *New York Times,* May 11, 1986.

Reveaux, Anthony. "The Endangered Natural World." *Artweek,* June 14, 1986, 5.

——. "Breaking through Boundaries: Two Pioneer Videomakers." *Video Networks* (February–March 1995).

Rice, Shelley. "Mary Lucier." *Woman's Art Journal* (fall/winter 1984–85): 41–44.

Riddle, Mason. "Why the Latest Whitney Biennial Is More Satisfying." *New York Times,* March 25, 1983.

——. "Video Reaches Artistic Heights." *St. Paul Pioneer Press Dispatch,* May 17, 1987.

Schwan, Gary. "Video Art Basks in the Light of Success." *Miami Post,* May 18, 1985.

Schwendenwein, Jude. "Mary Lucier, *Asylum.*" *High Performance* 54 (summer 1991): 52.

Segal, Lewis. "Dance Videos Launch 'Arts for Television.'" *Los Angeles Times,* October 6, 1987.

Smith, Nancy C. "Ghosts of the Past." *Charleston (S.C.) Post and Courier,* June 4, 1997.

Sparks, Amy. "The Raven Returns: Mary Lucier's *Noah's Raven* in Toledo." *Dialogue: Arts in the Midwest* (March–April 1993): 8–9.

Suderberg, Erika. "Transcendent Landscapes." *Artweek,* March 5, 1988.

Talen, Julie. "Beyond Monovision." *Village Voice,* March 27, 1984.

Tamblyn, Christine. "Mary Lucier, *Asylum (A Romance)."* *High Performance* 35, no. 5 (1986): 98.

Taylor, Robert. "An Ecletic Collection at Brandeis." *Boston Globe,* January 19, 1986.

Tomkins, Calvin. "The Art World: Season's End." *New Yorker,* July 18, 1983, 80–83.

Towers, Deirdre. "Dance and Video." *DanceMagazine,* December 1985, 74.

———. "Dance and Video." *DanceMagazine,* July 1987, 56.

Upshaw, Reagan. "Mary Lucier at Lennon, Weinberg." *Art in America* (September 1995): 105–6.

Vagelatos, Alex. "Art in a Box." *Fort Wayne (Ind.) Journal-Gazette,* April 1993.

Vallongo, Sally. "Art, Nature, and Techonology Combine in Mary Lucier's Work." *Toledo Blade,* January 28, 1993.

Wiegand, Ingrid. "New Born or Old Hat." *SoHo Weekly News,* November 27, 1975, 16.

Wilkin, Karen. "At the Galleries." *Partisan Review,* no. 1 (1990).

———. "At the Galleries." *Partisan Review* 42, no. 3 (1995): 426–28.

———. "Disaster Relief." *New Criterion* (May 1999): 51–55.

Wooster, Ann-Sargent. "Planet." *Village Voice,* 1980.

———. "Manhattan Short Cuts: *Denman's Col (Geometry)."* *Afterimage* (February 1982): 19.

———. "Pop Prop Video." *East Village Eye,* March 1984, 47.

———. "The Garden in the Machine." *ARTS Magazine* (April 1992): 50–53.

Worden, John. "Violent Nature." *Rochester (N.Y.) Democrat and Chronicle,* July 14, 1993.

Zimmer, William. "Mary Lucier." *New York Times,* October 31, 1986.

———. "Wilderness at the Neuberger." *New York Times,* May 31, 1987.

———. "Adventerous Homeowners, Modern Look." *New York Times,* December 3, 1995.

### Exhibition Catalogues and Brochures

American Film Institute. *National Video Festival.* Catalogue. Los Angeles: AFI, 1987; 1983.

Balken, Debra Bricker. *Natural Spectacles.* Catalogue. Providence, R.I.: David Winton Bell Gallery, Brown University, 1996.

Beardsley, John. *Art and Landscape in Charleston and the Low Country.* Catalogue. Washington, D.C.: Spacemaker Press/Spoleto Festival USA, 1998.

Bianchi, Lois, ed. *Video Transformations.* Catalogue. New York: Independent Curators, 1985.

Bloemink, Barbara J., ed. *A Natural Order: The Experience of Landscape in Contemporary Sculpture.* Catalogue. Yonkers, N.Y.: Hudson River Museum, 1990.

Brew, Kathryn, ed. *Capp Street Project, 1985–1986.* Catalogue. San Francisco: Capp Street Project, 1987, 15–16, 40–43.

Circulo de Bellas Artes. *Festival Nacional de Video.* Catalogue. Madrid: Circulo de Bellas Artes, 1986.

Close, Timothy. *"MASS": Between a Rock and a Hard Place.* Newsletter and brochure. Portsmouth, Va.: Portsmouth Museums, September–November 1992.

Drew, Nancy. *So There, Orwell.* Catalogue. New Orleans: Louisiana World Exposition, 1984.

Feinstein, Roni. *Contemporary Diptychs: Divided Visions.* Catalogue. Stamford, Conn.: Whitney Museum of American Art, 1987.

Fine, Elsa Honig, ed. *American Women Artists.* Catalogue. Knoxville, Tenn.: Knoxville Museum of Art, 1990.

Graze, Sue. *Mary Lucier, "Wilderness."* Brochure. Dallas: Dallas Museum of Art, 1987.

Hanhardt, John G., ed. *Video Art: Expanded Forms.* Catalogue. New York: Whitney Museum of American Art at Equitable Center, 1988.

——, et al. *1983 Biennial Exhibition.* Catalog. New York: Whitney Museum of American Art, 1983.

Hanley, JoAnn, curator. *The First Generation: Women and Video, 1970–1975.* Catalogue. New York: Independent Curators, 1993.

Herzogenrath, Wulf, and Edith Decker, eds. *Video Skulptur retrospectiv und aktuell, 1963–1989.* Catalogue. Cologne: DuMont, 1989.

Huffman, Kathy Rae, and Dorine Mignot, eds. *The Arts for Television.* Catalogue. Los Angeles and Amsterdam: Museum of Contemporary Art and Stedelijk Museum, 1987.

Judson, William D. *Mary Lucier: Ohio at Giverny.* Brochure. Pittsburgh: Carnegie Museum of Art, 1983.

——, ed. *American Landscape Video.* Catalogue. Pittsburgh: Carnegie Museum of Art, 1988.

Marshall, Richard, ed. *Immaterial Objects.* Catalogue. New York: Whitney Museum of American Art, 1991.

Milano, Susan, ed. *Women's Video Festival.* Catalogue. New York: Women's Interart Center, 1976.

Miller, Nancy, ed. *Wilderness.* Catalogue. Cambridge, Mass.: Rose Art Museum and New England Foundation for the Arts, 1986.

Musée d'Art Moderne de la ville de Paris, Palais de Tokyo. *Femmes Cathodiques.* Catalog. Paris: Musée d'Art Moderne, 1989.

Musee d'Art Moderne de la ville de Paris. *10e Biennale de Paris.* Catalogue. Paris: Musée d'Art Moderne, 1977.

*New York City Video.* Catalogue. Surrey Hills, Australia: Artspace, 1986.

Noll, Anna C. *Earthly Delights: Garden Imagery in Contemporary Art.* Catalogue. Fort Wayne, Ind.: Fort Wayne Museum of Art, 1988.

Pardee, Hearne. *Reinterpreting Landscape.* Catalogue. Lynchburg, Va.: Maier Museum of Art, Randolph-Macon Woman's College, 1996.

Payant, Rene, ed. *Video.* Catalogue. Montreal: Artextes, 1986.

Philbrick, Harry, curator. *Living with Contemporary Art.* Catalogue. Aldrich, Conn.: Aldrich Museum of Contemporary Art, 1995.

Rice, Shelly. "Ohio at Giverny." In *The Luminous Image.* Catalogue. Amsterdam: Stedelijk Museum, 1984.

Spooner, Peter F., ed. *Behind the Screen: Five Video Artists.* Catalogue. Normal, Ill.: University Galleries, Illinois State University, 1990.

Vine, Naomi, ed. *A Certain Slant of Light: The Contemporary American Landscape.* Catalogue. Dayton, Ohio: Dayton Art Institute, 1989.

Walter Phillips Gallery, The Banff Centre School of Fine Arts. *The Second Link: Viewpoints on Video in the Eighties.* Catalogue. Banff, Alberta: Walter Phillips Gallery, 1983.

Weber, Bruce. *Mary Lucier Video Installations.* Brochure. West Palm Beach, Fla.: Norton Gallery of Art, 1985.

Weld, Alison, ed. *Contemporary Syntax: Light and Density.* Catalogue. Rutgers, N.J.: Robeson Center Gallery, Rutgers University, 1987.

Whiteside, Tom, ed. *MASS.* Catalogue. Raleigh, N.C.: City Gallery of Contemporary Art, 1991.

Wooster, Ann-Sargent. In Randy Rosen and Catherine C. Brawer, curators, *Making Their Mark: Women Artists Move in to the Mainstream, 1970–1985.* Catalogue. Ed. Nancy Grubb. New York: Abbeville Press, 1989.

### Books

Hall, Doug, and Sally Jo Fifer, eds. *Illuminating Video: An Essential Guide to Video Art.* New York: Aperture Books/Bay Area Video Coalition, 1991.

Hanhardt, John, ed. *Video Culture: A Critical Investigation.* New York: Peregrine Smith Books in association with Visual Studies Workshop Press, 1986.

Lischka, G. J. *Alles und Noch Viel Mehr.* Bern, Switzerland: Benteli Verlag, 1985.

Lovejoy, Margot. *Postmodern Currents: Art and Artists in the Age of Electronic Media.* Englewood Cliffs, N.J.: Prentice-Hall, 1996.

Muntadas, Bonet, et al., eds. *En Torno al Video.* Barcelona: Editorial Gustavo Gili, S.A., 1980.

Renov, Michael, and Erika Suderburg, eds. *Resolutions: Contemporary Video Practices.* Minneapolis: University of Minnesota Press, 1996.

Rump, Gerhard Charles. *Mediuum und Kunst.* Hildeshein, Germany: Georg Olms Verlag, 1978.

Sandler, Irving. *Art of the Postmodern Era: From the Late 1960s to the Early 1990s.* New York: Harper Collins, 1996.

Schneider, Ira, and Beryl Korot, eds.  *Video Art.* New York: Harcourt Brace Jovanovich, 1976. (Managing Editor, Mary Lucier.)

Zippay, Lori, ed.  *Electronic Arts Intermix Video.* New York, 1991.

### Works in Visual and Conceptual Anthologies

High, Kathy, and Liss Platt, eds.  *FELIX: A Journal of Media Arts and Communication* 2, no. 1 (1995): 134–37.

Knowles, Alison, and Anna Lockwood, eds.  *Women's Work.* Brooklyn: Print Center, 1975.

Kostelanetz, Richard, ed.  *Scenarios.* Brooklyn: Assembling Press, 1980, 88–89.

### Videotape Documentaries

*Convergence at the Avantgarde: Expanding the Visual Language.*  Produced by Forum Vidéo de Montreal. Distributed by the National Film Board of Canada, 1984.

*The Luminous Image.*  Stedelijk Museum, 1984. Produced by Rene Cochlo for Montevideo, Amsterdam, 1984.

*Video Skulptur: Restrospectiv und aktuell, 1963–1989.*  Produced by DuMont Buchverlag, Cologne, 1989.

*Mary Lucier: Video Installations.*  Interviewed by and videotape produced by Paul Tschinkel for ART/new york, 1991.

*Noah's Raven, by Mary Lucier.*  A documentary about the video exhibition *Noah's Raven,* by Mary Lucier, at the Toledo Museum of Art, 1993. Produced by Robert F. Arnold. A University of Toledo Film/Video Production, 1995.

## Permissions

Grateful acknowledgment is made for permission to reprint from the follow-
ing writers and publishers: to *Afterimage* for Melinda Barlow, "Mapping Space, Sculpting
Time: Mary Lucier and the Double Landscape," © 1997 by *Afterimage;* to *Aperture* for
Mary Lucier, "Light and Death," originally published in *Illuminating Video: An Essential
Guide to Video Art,* © 1991 by *Aperture;* to *Art and Cinema* for Mary Lucier, "Organic," ©
1978 by *Art and Cinema;* to *Artforum* for Jenifer B. Borum, "Mary Lucier, Lennon, Wein-
berg, Inc.," © 1995 by *Artforum;* to *Artforum* for Kirby Gookin, Mary Lucier," © 1991 by
*Artforum;* to *Artforum* for Charles Hagen, "Mary Lucier," © 1984 by *Artforum;* to *Artforum*
for Richard Lorber, "Mary Lucier, the Kitchen," © 1978 by *Artforum;* to *Artforum* for John
Miller, "Mary Lucier," © 1990 by *Artforum;* to *Art in America* for Nancy Princenthal,
"Mary Lucier at Lennon, Weinberg," © 1997 by Brant Publications, Inc.; to *Art in Amer-
ica* for Ann-Sargent Wooster, "Mary Lucier at the Whitney Museum," © 1982 by Brant
Publications, Inc.; to *Art Journal* for Melinda Barlow, "The Architecture of Image and
Sound: Dwelling in the Work of Mary Lucier," © 1995 by the College Art Association,
reprinted by permission; to Annette Barbier for a selection from a review of *Aspects of the
Fossil Record,* © 1996 by Annette Barbier; to the *Boston Globe* for Christine Temin, "Dar-
ing Mix of Water, Dance, Video," © 1987, reprinted courtesy of the *Boston Globe;* to Peter
Doroshenko for his interview with Mary Lucier, © 1990, originally published in the *Jour-
nal of Contemporary Art;* to Martha Gever for "Mary Lucier's Elemental Investigations:
*Planet*" and to *Afterimage,* © 1982 by *Afterimage;* to Eleanor Heartney for "*Noah's Raven*
and the Contradictions of Landscape" and to the Toledo Museum of Art, © 1993 by the
Toledo Museum of Art, originally published in *Noah's Raven: A Video Installation by Mary
Lucier;* to Bruce Jenkins for "Viewpoints: Mary Lucier" and to the Walker Art Center, ©
1987 by the Walker Art Center, originally published in *Viewpoints: Paul Kos, Mary Lucier;*
to Tom Johnson for "Concerts in Slow Motion," originally published in the *Village Voice,*
© 1972 by Tom Johnson; to Christopher Knight for "Exploring '*Wilderness*' of Electronic
Art," originally published in the *Los Angeles Herald Examiner,* © 1988; to Alvin Lucier for
"Hymn," © 1970 by Alvin Lucier; to Alvin Lucier for "I Am Sitting in a Room," © Alvin
Lucier 1980, originally published by Wesleyan University Press in *Chambers;* to the *Mid-
dletown Press* for a selection from William Collins, " 'Realsculpture' at St. Clements," ©
1971 by the *Middletown Press;* to *Millennium Film Journal* for Mary Lucier, "Virtually
Real," © 1995 by *Millennium Film Journal;* to the New England Foundation for the Arts
for Nancy Miller's interview with Mary Lucier, originally published in *Wilderness,* © 1986
by the New England Foundation for the Arts; to the *New York Times* for Grace Glueck,

Library of Congress Cataloging-in-Publication Data

Mary Lucier / edited by Melinda Barlow.
    p.   cm. — (PAJ books. Art + performance)
   Includes bibliographical references.
   ISBN 0-8018-6379-1 (alk. paper) — ISBN 0-8018-6380-5 (pbk. :
alk. paper)
   1. Lucier, Mary—Catalogs.   I. Barlow, Melinda.   II. Series.

   N6537.L83 A4 2000
   700'.92—dc21        99-087601